American Photography

1890–1965

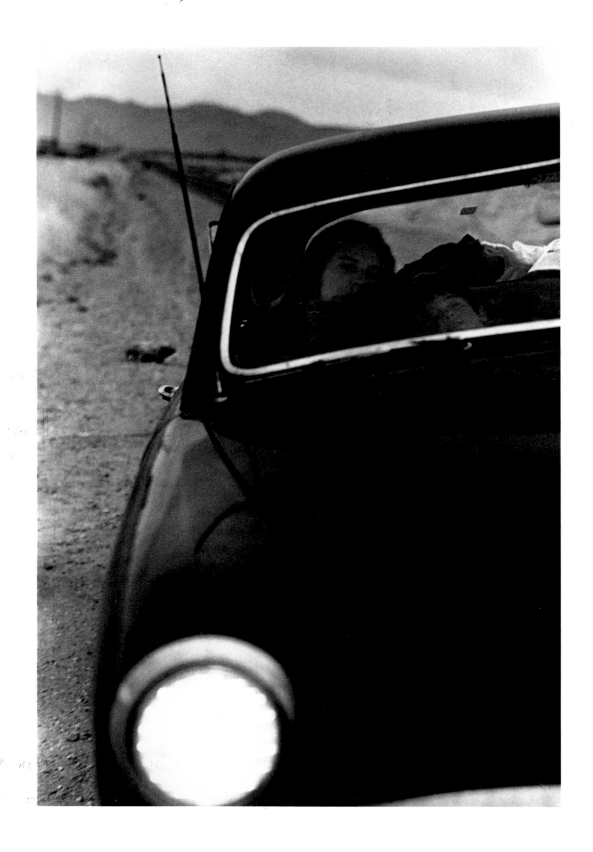

Robert Frank. *U.S. Number 61, Texas.* 1955

American Photography

1890–1965

FROM THE MUSEUM OF MODERN ART
NEW YORK

PETER GALASSI

with an essay by
LUC SANTE

The Museum of Modern Art, New York

Distributed by Harry N. Abrams, Inc., New York

Published on the occasion of the exhibition *American Photography 1890–1965 from The Museum of Modern Art, New York*, organized under the auspices of The International Council of The Museum of Modern Art by Peter Galassi, Chief Curator, Department of Photography.

Tour of the Exhibition

Staatliche Museen zu Berlin, Kunstbibliothek. Preussischer Kulturbesitz
April 24–June 12, 1995

Stedelijk Museum, Amsterdam
July 3–September 1, 1995

Scottish National Gallery of Modern Art, Edinburgh
October 5–November 26, 1995

Hasselblad Center, Göteborg, Sweden
January 6–February 25, 1996

Musée National d'Art Moderne—Centre de Création Industrielle, Centre Georges Pompidou, Paris
March 19–May 31, 1996

IVAM Centre Julio González, Valencia
June 22–September 15, 1996

Victoria & Albert Museum, London
November 14, 1996–January 26, 1997

Produced by the Department of Publications
The Museum of Modern Art, New York
Osa Brown, Director of Publications
Edited by Harriet Schoenholz Bee
Designed by Jody Hanson
Production by Amanda W. Freymann
Composition by U.S. Lithograph, typographers, New York
Tritone separations by Robert J. Hennessey
Printed and bound by Amilcare Pizzi, S.p.A., Milan

Published by The Museum of Modern Art
11 West 53 Street, New York, New York 10019

Clothbound edition distributed in the United States and Canada by Harry N. Abrams, Inc., New York,
A Times Mirror Company

Clothbound edition distributed outside the United States and Canada by Thames & Hudson, Ltd., London

Printed in Italy

Cover: Berenice Abbott. *Zito's Bakery, Bleecker Street, New York*. 1937. Gelatin-silver print. 9½ x 7⁷⁄₁₆" (24.1 x 18.9 cm). The Museum of Modern Art, New York. Given anonymously

Contents

Foreword

From its founding in 1929, The Museum of Modern Art has brought an international perspective to its collection and programs in New York and, in turn, has addressed its work to a broad, international audience. This book is published on the occasion of an exhibition selected from the Museum's collection, which has been organized for tour in Europe by the Museum's International Program.

The Museum of Modern Art was the first art museum anywhere to establish, in 1940, a curatorial department specifically dedicated to the art of photography. Happily, since then, museums around the world have recognized photography as an art to be collected, studied, and exhibited. In Europe, interest in photography has burgeoned over the past two decades. Leading museums, several of which are participating in the tour of the exhibition, have developed important programs and many younger European institutions have contributed to a greater appreciation and understanding of photography. Among the latter is the Hasselblad Center in Göteborg, Sweden, created in 1989 by The Erna and Victor Hasselblad Foundation. Established to support photography and scientific research, the Foundation in 1984 endowed The Erna and Victor Hasselblad Photography Study Center at The Museum of Modern Art, which serves hundreds of scholars, curators, and students each year. The close relationship between the Museum and the Foundation helped to initiate the present book and exhibition.

The Museum's photography collection is international in scope and ranges from the 1840s to the present. Not surprisingly, it is particularly strong in twentieth-century American work. The exhibition accompanied by this book offers the very welcome opportunity to share this rich aspect of our holdings with a large European public. We hope that visitors to the exhibition on its extensive tour and readers of the book everywhere will draw from them pleasure, stimulation, and some discoveries.

I wish to express our deep appreciation to the participating institutions that have made this tour possible and to Elizabeth Streibert, acting director of the Museum's International Program, for so ably organizing the tour. We are also most grateful to the members of The International Council of The Museum of Modern Art, who generously support the International Program.

Richard E. Oldenburg
Director
The Museum of Modern Art, New York
December 1994

Preface

This book surveys three-quarters of a century of American photography, from 1890 to 1965, as it is represented in the Museum's collection. (To be precise, the earliest picture was made by Jacob Riis in about 1888; the latest, by Diane Arbus in 1967.) The book does not include photographs made by foreigners on visits to the United States or by Americans (notably Man Ray) who did their principal work as expatriates. It does include pictures by foreign-born photographers who came to the United States and stayed; indeed it could hardly exist without them. Included also is the work of Tina Modotti, an Italian working in Mexico under the decisive influence of an American, Edward Weston.

The period of American photography surveyed here is marked as much by breadth and variety as by the depth and originality of its highest achievements. For every major figure there are several others whose distinctive work demands notice. Beyond this roster of distinguished photographers is the lively contribution of unnumbered amateurs, professionals, enthusiasts, and journeymen whose circumstances and motives are now as dimly known as they have been varied. In the selection of the pictures an attempt has been made to represent the importance of the leading photographers, and to suggest the evolution of long careers. The ultimate criterion, however, has been to favor the collective vitality of the whole over the accomplishment of the individual, no matter how impressive and influential.

The Museum's collection is a cumulative, continuing project to whose growth, care, and usefulness a great number of people have contributed in many different ways. An invaluable collective contribution has been made by photographers themselves, not even so much through their gifts of pictures, extraordinarily generous as these have been, as through their responsiveness to and encouragement of the Museum's work. Their contribution has been paralleled by the support of the Museum's Committee on Photography, under the dedicated leadership of its successive chairmen: David H. McAlpin, James Thrall Soby, Henry Allen Moe, Shirley C. Burden, Mrs. Henry Ives Cobb, and John Parkinson III. The Committee's current vice-chairmen, Robert B. Menschel and Paul F. Walter, also have played vital roles.

This book and the exhibition it accompanies, like all public expressions of the Museum's programs, deeply depend upon the skill and dedication of the Museum's staff: the people who care for, catalogue, frame, and hang the works of art, and the people who, in a large and cumbersome institution, manage to make it run. In the case of this book I am particularly thankful to Jody Hanson, who designed it; to Amanda Freymann and independent craftsman Robert J. Hennessey, who are responsible for the extraordinary quality of its reproductions; to Harriet Schoenholz Bee, who edited the text; and to Thomas W. Collins, Jr., the Beaumont and Nancy Newhall Curatorial Fellow in the Department of Photography, and Jennifer Liese, my assistant, who did practically everything else. I am grateful also to Luc Sante, whose essay, like photography itself, looks outward.

Peter Galassi

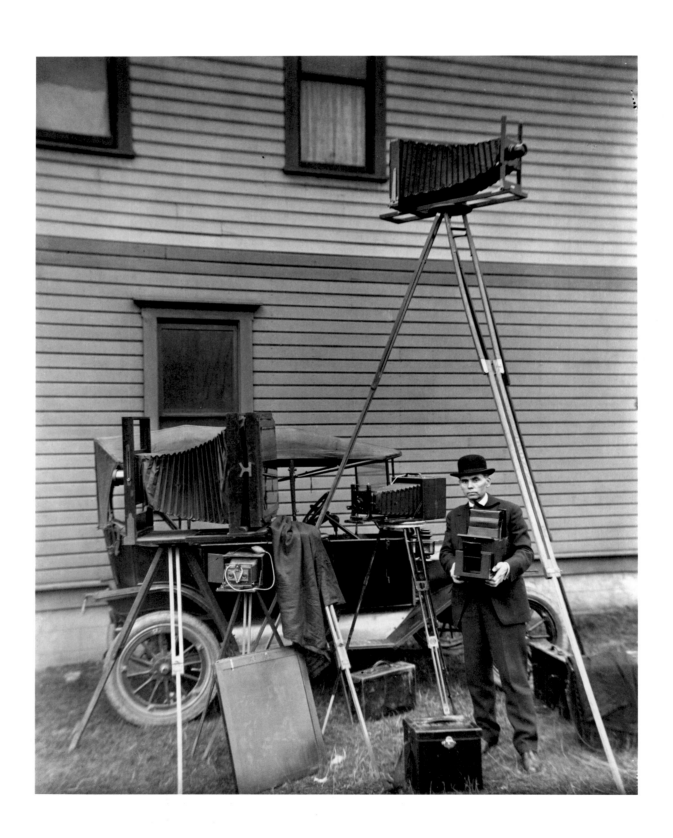

Two Stories

PETER GALASSI

I

In August 1951 The Museum of Modern Art opened *Forgotten Photographers*, an exhibition of more than one hundred photographs from the Library of Congress, where they had been registered to protect copyright. In other words, the pictures had been made not as works of art but to serve a variety of practical, often commercial, purposes. Selected by the photographer Edward Steichen, then director of the Museum's Department of Photography, the exhibition represented more than fifty photographers, including Edward S. Curtis, Erwin E. Smith, Frances Benjamin Johnston, and Darius Kinsey (see pages 60, 61, 67, and 75). Introducing the exhibition, Steichen wrote: "Included in this selection there are remarkably fine examples of photography, some of them forecasting various phases of contemporary photography."

All but a few of the photographs in the exhibition had been made at the turn of the century, that is, precisely when Steichen himself had begun to make photographs. His own early work, however, was very different from the work in the exhibition. While still a teenager Steichen had styled himself an aesthete (page 82), and by 1902, at the age of twenty-three, he had joined Alfred Stieglitz and others in founding the Photo-Secession, a small, sophisticated group determined to claim the status of high art for photography. Modeling their work on the fashionable paintings of James McNeill Whistler and his epigones, members of the group produced pictures that could not be mistaken for anything but works of art (see pages 81–93). Through exhibitions, manifestos, and their luxurious journal, *Camera Work*, the Photo-Secessionists also promulgated the exclusivity of their mission. If some photographs were to deserve the status of high art it was essential that others should not, those others being just the sort of ordinary photographs that Steichen was to exhibit half a century later in *Forgotten Photographers*.

Thus the emergence of a high-art tradition created a rift in American photography. Taking that rift as its starting point, this book surveys the following three quarters of a century, from 1890 to 1965.

Steichen's concern in *Forgotten Photographers* for a branch of historical photography so alien to his own early work is explained in part by his intervening career. By the 1920s he already had shed the hothouse aesthetic of the Photo-Secession to embrace its virtual opposite. In 1923 he became chief photographer for the publisher Condé Nast, and he soon defined an imposing standard for the new field of commercial and fashion photography in the illustrated magazines. The verve and worldly competence embodied in his self-portrait of 1929 (page 16) could hardly be more remote from the fragile refinement he had projected in 1898. Before arriving at The Museum of Modern Art in 1947, Steichen had worked as a photographer for

Darius Kinsey.
Self-Portrait. 1914

the army in World War I and for the navy in World War II. If his 1951 exhibition proposed that modern photography should not be understood narrowly—as the achievement of a self-absorbed artistic elite—his own diverse career is the proof of that proposal.

After *Forgotten Photographers* closed, the photographers (and the exhibition) were promptly forgotten again, for the simple reason that there was hardly anyone to remember them. In 1951 the Museum's Department of Photography, the first such department in a museum of art, was only eleven years old. There did not yet exist, as there does today, a broad audience concerned with the history and art of photography or a community of institutions devoted to that concern. As that audience and community grew and flourished in the decades that followed, they adopted as established principles two central lessons embodied in Steichen's exhibition: that photographers who had not presented themselves as artists nevertheless had produced "remarkably fine examples of photography" and that this work had forecast "various phases of contemporary photography"—that it had played and continued to play a vital role in the modern tradition of American photography.

◆

The founding of the Photo-Secession marked the beginning of a continuous tradition of self-consciously artistic photography in the United States. Thereafter, thanks to the exhortations and energies of Stieglitz and his associates, it was possible for a photographer to recognize him- or herself as an artist, even if that recognition was shared by only a handful of intimates. With this new identity came a sense of solidarity with others and a confidence that one's art had a future as well as a past.

Thus the Photo-Secession also marked the beginning of a persistent estrangement between artistic photography and all other kinds—professional, commercial, practical, amateur: *vernacular* (meaning native, common, and functional as opposed to foreign and aesthetically refined). This distinction, fundamental to American culture, had existed earlier in photography; the truculence of Photo-Secession rhetoric—and the quality of its artistic achievement—transformed it into a schism. Consider the abyss that separates the cultivated Edwardian persona of Steichen's friend and fellow Photo-Secessionist, Gertrude Käsebier (page 13), from the can-do spirit of Darius Kinsey, whose self-portrait (page 10) brooks no dissent from his claim that he was ready to "take pictures every day in the year, rain or shine, except on Sunday."[1] Born in Iowa in 1852 and raised in Colorado Territory, Käsebier was no less a child of the frontier than was Kinsey, and her resourcefulness as an artist was less remote from Kinsey's pragmatic professionalism than Stieglitz would have liked to admit. By the first decade of the twentieth century, however, the two occupied opposing sides of a cultural divide.

That divide provides the organizing principle under which the photographs here have been selected and organized. Broadly speaking, groupings of photographs conceived as works of high art alternate with groupings of pictures made to serve a myriad of other motives. If followed blindly, this simple scheme would impose many a Solomon's choice because the relationship between photography's vernacular and high-art traditions involved exchange as well as opposition. It is the central hypothesis of this book, however, that the lasting contentions created by the divide, as well as the animating sparks that leapt across it, propelled the ceaseless renewal of modern American photography.

◆

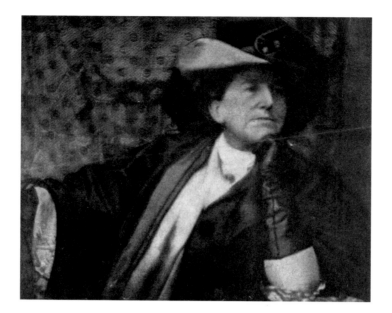

In 1890 photography was half a century old but was only just then achieving the ease and ubiquity that we now regard as among its most essential attributes. The key technical advance was the dry-plate negative, so named because before it was invented each negative was exposed and developed while still wet with fresh emulsion. This meant that the photographer was obliged to transport the darkroom to the site of the photograph; the dry plate freed the photographer from the darkroom and the camera from the tripod. The result was that for the first time a photograph could be made anywhere, of anything, by anybody.[2]

The crucial term here is the last. Before the late 1880s, the overwhelming majority of photographs had been made by paid professionals. By 1890 anyone could do it. The most celebrated instance of the radical new availability of photography was the introduction, in 1888, of the Kodak No. 1, the first mass-produced snapshot camera. In fact, the army of amateurs recording family outings and newborn babies represented only one part of the vast expansion of photography's applications and practitioners. Between the untutored snapshooter and the studio portraitist, with his painted backgrounds and overstuffed chairs, there burgeoned an unclassifiably heterogeneous multiplicity of people who made photographs. The diversity of motive, training, and outlook of photography's new practitioners yielded a sprawling diversity of new pictures.

The journalist Jacob Riis, for example, enlisted photography in a project of social reform that he had conceived without reference to photography (page 73). The teacher Lewis W. Hine first made photographs as an aid to classroom pedagogy, then for the National Child Labor Committee (page 74). Neither had set out to be a photographer, and neither followed the standards or motives of other photographers. Within the limitations of photographic technology, their pictures were formed by the task at hand and by the attempt of an individual to master it. To compare the cold eye of Riis to the animating affection of Hine's regard for his subjects is to recognize photography's capacity not only to get the job done but to mold its evidence to the shape of a singular sensibility.

Just as photographs were becoming radically easier to make, they were also becoming radically easier to disseminate to larger and larger audiences. Since the invention of the medium in the 1830s, efforts had been made to translate the chemical photographic image into printer's ink and to do so mechanically, that is, without the intervention of the human hand. At last, in

the 1890s photomechanical reproduction began to become practical and economic on a significant scale, and photographs, rather than hand engravings after photographs, began to appear with some frequency in the printed press. The results at first were crude, and it was not until the 1920s that the photomechanical revolution finally triumphed over handmade illustration. But the ultimate consequences were profound, because it became possible to multiply photographic images in vastly greater quantities and, still more important, to combine image and text, and to disseminate the new whole to a growing mass audience.

Before World War I, professional photographers distributed their pictures as original (chemical) prints to a limited, usually local, audience. Typical of such professionals were Kinsey, who photographed the logging industry in the Pacific Northwest (page 75); Henry Hamilton Bennett, who helped to promote the Wisconsin Dells as a vacation retreat (pages 58–59); and William H. Rau, who pictured the scenic routes of the Lehigh Valley Railroad (page 64). In the 1920s and 1930s James Van Der Zee was working in the same way for a still smaller market in Harlem, New York (page 128), but by then the photomechanical revolution had rendered such a market antiquated. From the 1920s onward the typical professional worked for the large audiences created by the photomechanical revolution. Grancel Fitz's suave advertisements (page 123), Margaret Bourke-White's polemical reportage (page 149), Weegee's daily dispatches of mayhem and madness (pages 166 and 167), and Richard Avedon's brilliant encapsulations of celebrity and chic (pages 229 and 230) all were made for the printed page. Even the fabled photographic unit of the Farm Security Administration owed its existence to the photomechanical revolution. It was only through the distribution of its photographs to newspapers and magazines that the government's alarm of rural draught and depression could reach a mass audience.

The growth of the fine-art movement in photography in the 1890s, leading to the still more exclusive Photo-Secession in 1902, may be explained in part as an expression of the new availability of photography. The membership of the pictorialist societies was swelled by amateurs whose enthusiasm hardened into genuine artistic ambition. Here, too, the photomechanical revolution played an important role, because it made possible the wide and rapid diffusion of the new aesthetic. The 1887 edition of *The American Annual of Photography* included fewer than half a dozen photographic illustrations. Ten years later the annual boasted more than two hundred photomechanical reproductions, including thirteen illustrations to a single article by Stieglitz. These reproductions brought an elite international movement to Steichen, then a young lithographer's apprentice in Milwaukee, Wisconsin, and to future Photo-Secessionist Clarence H. White, a bookkeeper for a wholesale grocer in still more provincial Newark, Ohio.

If the fine-art movement was in part an expression of the new availability of photography, it was also a vigorous reaction against it. The name Photo-Secession is telling in itself. Borrowed from the Vienna Secession, it announced a yearning for European sophistication. But, unlike the European artists who were seceding from a moribund academic tradition, the American photographers were attempting to establish a new academy by seceding from what they regarded as the sprawling, undisciplined diversity of photography. This goal led the Photo-Secessionists to elect as their enemies not only the casual amateur and the seasoned professional but also the accomplished amateur artist, for whom mastery of craft and artistic achievement were all but interchangeable. To the high-minded ambitions of the Photo-Secession such a compromise was intolerable.

The work served by this polemic was both cloistered and superb. Dominated by themes of nature (including the nude) and domestic leisure (again including the nude, as well as the

ubiquitous portrait of the fellow aesthete), pictorialist imagery is heavy with pious sentiment and romantic metaphor. The prints favored chiaroscuro over precise detail and were executed on platinum paper, prized for its rich tones and velvet surface, or in gum bichromate or other elaborate processes that invited the intervention of the artist's hand. To justify their polemic, the Photo-Secessionists enclosed themselves in an aesthetic ivory tower. Although the aesthetic soon changed, the mood of withdrawal persisted for decades.

The pictorialist movement in Europe, with which the Photo-Secessionists had enjoyed a clubbish solidarity, withered in the tower. In Europe, the irreverent modernism of the 1920s and 1930s emerged virtually without debt to the pictorialist precedent, indeed often without knowledge of it. In the United States, a very different modernist aesthetic began to form earlier and largely did so, remarkably, under the aegis of Stieglitz's elite academy. By 1910 Stieglitz's own work had become leaner (page 92), and by 1917 Charles Sheeler (pages 101 and 102) and Paul Strand (page 99) had made photographs whose directness and spare graphic economy swiftly relegated the Photo-Secessionist achievement to the past.

Beginning in 1908 the Little Galleries of the Photo-Secession at 291 Fifth Avenue served as the unlikely venue for the first New York exhibitions of Matisse, Picasso, Brancusi, and Braque (page 97). The proximate cause and transatlantic link was the garrulous Steichen, often in Europe and ready for anything. But Stieglitz was not known for blind acquiescence to the enthusiasms of his friends. Nearly alone among the keepers of high American culture, he unflinchingly embraced the new European art, whose brazen inventions offered a stark comparison to the salon Symbolism he had championed a few years earlier.

In 1913, only a decade after he had founded *Camera Work*, Stieglitz advised aspiring artists in photography "not to be ashamed to have their photographs look like photographs. A smudge in 'gum' has less value from an aesthetic point of view than an ordinary tintype."[3] This was a rallying cry for what soon came to be called the "straight aesthetic." In 1917 Strand wrote that photography "finds its raison d'être, like all media, in a complete uniqueness of means. This is an absolute unqualified objectivity. Unlike the other arts which are really anti-photographic, this objectivity is of the very essence of photography, its contribution and at the same time its limitation."[4]

To call a photograph painterly, so recently the highest of compliments, soon became the most withering of criticisms. In other words, although the relationship to painting had shifted abruptly, advanced photographers remained preoccupied with it. Like many other modernist pronouncements, the urgent rhetoric that announced the new purity of photography functioned principally as mutual encouragement to a small band of devotees, whose artistic status was barely more secure in 1920 than it had been in 1900. Thus it is as wrong to dismiss their rhetoric as hollow bombast as to accept it at face value.

Falling into the latter trap, many then and since have misinterpreted a palace revolution for the discovery of photography's essence. One prominent continuity with the pictorialist past was the virtual religion of craft entailed by the new aesthetic. The new craft standard required a large negative, generally eight by ten inches, which could only be made by a view camera, a bellows box mounted on a tripod. (An example is the camera atop a tall tripod in Kinsey's self-portrait on page 10). The negative was printed by contact, meaning that it met the paper directly, yielding a print of utmost precision and subtlety. This, however, was the same craft method that thousands of ordinary professionals had used for decades. Moreover, when platinum paper was retired from the market in the mid-1920s, the artist-photographers found themselves using gelatin-silver paper—the same uniform, industrial product that, for example,

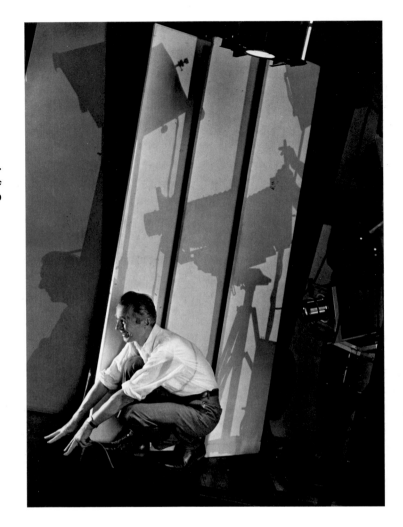

employees of New York City had used to survey the condition of Manhattan's sidewalks (page 78). In compensation, the artists mustered all of their considerable skill to coax from this mass-produced material an exquisite clarity of detail and a luxurious subtlety of tone, from brilliant highlights to translucent shadows. Their prints were no less voluptuous than the ones that had graced the pictorialist salons.

Nor did the straight aesthetic, for all its claims of objectivity, inspire a curiosity for new subjects. The grit and social provocation of Strand's early street encounters with the poor (page 99) receded from the vocabulary of modern artistic photography as suddenly as it had appeared and did not return until more than a decade later. The sole new subject in the 1920s was the machine, but it was never a machine in use, greasy, or in need of repair. Like Edward Weston's shapely pepper (page 110), Strand's gleaming motion-picture camera (page 112) is the faultless embodiment of a Platonic ideal, larger than life. As if to make up for a surfeit of descriptive precision, the photographer's frame has contracted upon the exquisite specimen: the bold modernist detail is also a retreat. Weston's companion Tina Modotti expressed her genuine proletarian sympathies within the same constricted, impersonal format (page 109).

Looking with admiration at the noble authority and daring innovations of the traditional arts, and with wary condescension at the common vernacular, Strand, Sheeler, Stieglitz, and Weston created the first distinctly American photographic style. Caught between those two poles, their work is magnificent, even heroic, but it is also solemn and insular, withdrawn from

the anxieties and complexities of modern life. In the midst of the turmoil of the Depression, Stieglitz photographed Rockefeller Center as an unpeopled citadel, from the high isolation of his rooms in the Shelton Hotel (pages 118 and 119). Also unpeopled, as if not yet sullied by original sin, is the pristine wilderness of Ansel Adams, whom Stieglitz took under his wing in the 1930s (pages 117, 120, 121, and 186).

But the narrowness of modernist photography in America also enabled a gathering of forces. The vernacular tradition was inventive because a panoply of practical challenges spawned a multiplicity of unpredictable solutions; the artistic tradition was inventive because the imperative of modern art was to invent. Drawing on the collective momentum set in motion by that imperative, the straight aesthetic flourished as it matured. The work of Stieglitz and Adams is indeed insular, but it is also supple, beautifully alert to variation. After the mid-1930s Weston progressively expanded the scope of his art, both literally and metaphorically. The tightly framed detail gave way to the broad vista (page 116); the natural landscape became populated with telephone poles, automobiles, and advertisements; and the earnest sobriety of his art was leavened with humor and irony (page 153). Through the 1950s the modernist aesthetic welcomed and nourished the distinctive sensibilities of an impressive roster of fresh recruits, among them Harry Callahan, Aaron Siskind, Frederick Sommer, Eliot Porter, Minor White, and Paul Caponigro.

◆

In opposing the self-conscious artist to the practical professional, it is easy to make the mistake of crediting the artist with the comfort of a received tradition while reserving for the professional the familiar image of American independence and resolve. The professionals at least were paid, and they worked for an audience, which, after the advent of the magazines, could number in the millions. Steichen became famous as well as rich at *Vanity Fair*; the tabloid genius Weegee,

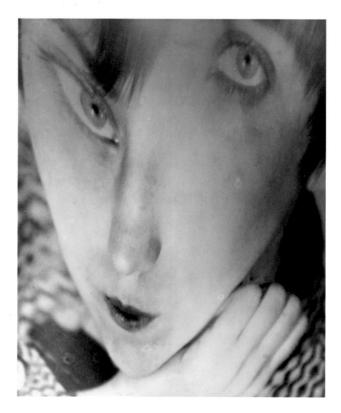

Berenice Abbott.
Portrait of the Author as a
Young Woman. c. 1930

17

while never rich, justifiably called himself "Weegee the Famous"; and Richard Avedon, at the age of forty-three, was immortalized by Fred Astaire in *Funny Face*, a Hollywood musical. Among the independent artists, only Stieglitz was wealthy. They worked almost entirely for themselves and for a minuscule community of enthusiasts. It was not until the 1970s that an artist-photographer, if lucky, could begin to count on print sales as a reliable source of income.

The United States is very large, and the community of true believers was very small. Edward Weston (Carmel, California), Clarence John Laughlin (New Orleans, Louisiana), Harry Callahan (Detroit, Michigan), Frederick Sommer (Prescott, Arizona), and Minor White (Portland, Oregon) were a long way from Alfred Stieglitz in New York. In 1952, thirty-five years after the demise of *Camera Work*, White (by then in Rochester, New York) launched the journal's first worthy successor: *Aperture*. In the first issue, White and his collaborators explained: "Most of the generating ideas in photography now spread through personal contact. Growth can be slow and hard when you are groping alone."[5]

For half a century before Stieglitz's death in 1946, a pilgrimage to his lair had been an obligatory rite of passage for the aspiring artist in photography. Even Walker Evans submitted to this ritual. The last major figure to do so was Callahan. College dropout, clerk for the Chrysler Corporation, and member of the sleepy Detroit Camera Club, Callahan wasted not a minute after Ansel Adams showed his photographs on a visit to the Club in 1941. "They completely freed me," was Callahan's later remark, an understatement.[6] By 1946, when the good sense of a friend brought Callahan to teach at László Moholy-Nagy's Institute of Design in Chicago, the work of this untutored provincial had rejuvenated the straight aesthetic with an improbable admixture of a severe talent for perfection and an irrepressible taste for experiment. Three years before encountering Moholy-Nagy, Callahan had mastered the art of multiple exposure

Ralph Steiner.
Self-Portrait. **1930**

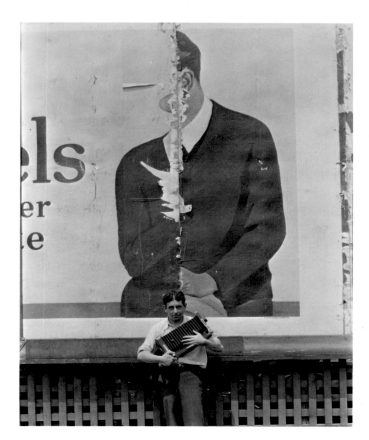

18

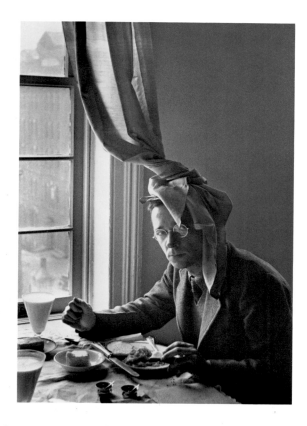

(page 182), a familiar technique of European modernism but rare to extinction in the American tradition. At just the same time, Sommer was melding the mutually incompatible precedents of Edward Weston and Max Ernst into a highly original artistic alloy (pages 176 and 177).

◆

In 1969, at the age of sixty-six, Walker Evans wrote: "Stieglitz was important enough and strong enough to engender a whole field of reaction against himself, as well as a school inspired by and following him. As example of the former, Stieglitz's veritably screaming aestheticism, his personal artiness, veered many younger camera artists to the straight documentary style; to the documentary approach for itself alone, not for journalism. Stieglitz's significance may have lain in his resounding, crafty fight for recognition, as much as it lay in his *oeuvre*."[7]

Evans himself was the most prominent among those who had reacted against Stieglitz. Returning in 1928 from France, where he had tried and failed to transform his passion for Flaubert and Baudelaire into a vocation for writing, Evans turned to photography. Like Berenice Abbott's *El at Columbus Avenue and Broadway* (page 134), his earliest pictures speak with the accent of advanced European work: the alert glance at life in the street (page 137) and the graphic surprise of the view from above or below (page 135). Very soon Evans found his true subject and voice, both of them drawn from the unvarnished American vernacular. From Stieglitz, as Evans acknowledged, arose the tenacity of Evans's artistic identity and convictions; from Evans arose a durable alternative to the tradition whose hermetic authority Stieglitz had worked so hard to maintain.

Like Stieglitz—and like Steichen, whose flamboyant commercial success was repellent to Stieglitz and Evans equally—Evans made the eight-by-ten-inch gelatin-silver contact print the cornerstone of his aesthetic. Unlike the two older men, he was happy to recognize in this craft

standard an affinity with the plainspoken photography of Kinsey (page 75) or Charles H. Currier (page 70). To the workmanlike candor of their example, Evans brought the formal rigor of modernism.

Evans's *Penny Picture Display* (page 144) is indeed a modernist picture—crisp, planar, as resolutely self-contained as Sheeler's *White Barn* (page 101). But instead of reconfirming a timeless ideal, it engages a contemporary particular, rooted in history. Like much of Evans's work, it is a two-edged sword: simultaneously an emblem of the promise of equality and of the specter of uniformity; the photographer takes no side. The picture is also an artistic manifesto, identifying Evans's enterprise with the unembellished functional work of the unnamed provincial portraitist. Evans's own portraits (page 145) are like enlargements from the window of the Savannah studio.

Like all the signal achievements of modern art, Evans's work is both complete in itself and prodigious in its implications for the work of others. From its origins in the Photo-Secession, artistically self-conscious photography had been founded on an opposition to the banal realism of the vernacular. Embracing the vernacular as a model, Evans dispensed with the sophisticated markers of craft that distinguished the artistic photograph from all others and swept away the barrier that had encircled modernist photography's privileged subjects. For the first time, the photograph-as-a-work-of-art could look exactly like any other photograph—and it could show us anything, from a torn movie poster (page 133) to a graveyard overlooking a steel mill (page 140). The photograph's claim of artistic distinction relied solely upon the clarity, intelligence, and originality of the photographer's perception. This profoundly radical idea, more than the example of Evans's work itself, is the wellspring from which later flowed the very different work of Robert Frank, Garry Winogrand, Diane Arbus, and Lee Friedlander. For

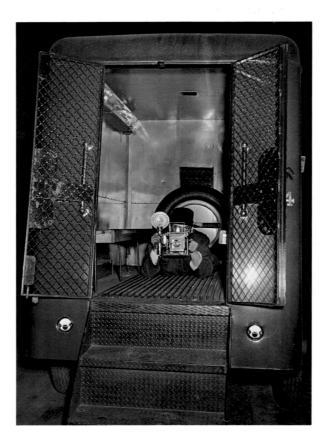

Weegee (Arthur Fellig).
***Self-Portrait.* c. 1940**

Irving Penn.
Vogue Photographers. 1946
(left to right: Serge Balkin, Cecil
Beaton, George Platt Lynes,
Constantin Joffe, the model
Dorian Leigh, Horst, John
Rawlings, Irving Penn, and Erwin
Blumenfeld)

them, neither the choice of what to look at, nor the way in which to look at it, nor the sense of what it might mean to look at such a thing in such a way was dictated by a preordained rule.

This conception of photography also had profound implications for the photographic past. If there was no distinction *in principle* between artistic and vernacular photography, then there was no reason not to recognize artistic achievement in the vernacular work of the past—in the work of amateurs such as Adam Clark Vroman (page 62), as well as professionals such as Kinsey or Rau—or to extend that achievement in artistic work of the present. Presumably this is what Steichen later meant when he wrote that his exhibition *Forgotten Photographers* included "remarkably fine examples of photography, some of them forecasting various phases of contemporary photography." By then Steichen was a curator, but most of the archaeological spade work had been done by photographers. From the 1920s onward the discovery of the vernacular past and present—of the work of Eugène Atget by Man Ray and Berenice Abbott in the 1920s, of Jacob Riis (page 73) by Alexander Alland in the 1940s, or of Ernest J. Bellocq (page 71) by Lee Friedlander in the 1960s—has repeatedly enlivened the unfinished business of photography's present.

◆

Walker Evans was very lucky in the early enthusiasts and interpreters of his work, especially in Lincoln Kirstein, through whose efforts the work was exhibited and published by the fledgling Museum of Modern Art. Perhaps it could also be said that Evans was lucky in his association with the Farm Security Administration (FSA), the government agency for which he worked from 1935 to 1938, because in those years he made many of his best photographs. Nevertheless,

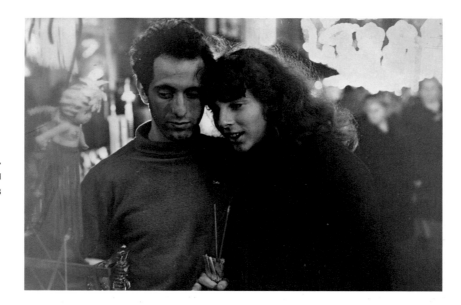

**Louis Faurer.
Untitled (Robert and
Mary Frank). c. 1948**

despite Evans's efforts to renounce it, the FSA label fostered a tenacious misunderstanding of his work and of the radical aesthetic it embodied.

The photographic unit of the FSA was a propaganda agency whose mission was to call attention to the dire misfortune of America's farmers in the period of the Great Depression. At various times between 1935 and 1942, it employed more than a few talented photographers, including two outstanding artists: Evans and Dorothea Lange. Not since the 1850s in France, when Napoleon III employed Gustave Le Gray and Charles Nègre, had such superb photographers of self-conscious artistic ambition worked for a government. The result in both cases was a splendid if unstable concord between photography's artistic identity and its worldly applications.

Like Evans, Lange had achieved a mature outlook and style before joining the FSA (see page 136), but the similarity ends there. Evans approached contemporary America as if he were a disinterested historian sifting the shards of a vanished civilization. Lange was a passionate idealist, who aimed to provoke social change through her work. (She succeeded, for example, when the publication of *Migrant Mother* [page 148] brought swift aid to the camp where the picture had been made.) In the popular consciousness, and in the coffee shops where photographers met, Lange's definition prevailed. Over Evans's patient objections, the term "documentary photography" entered the American dictionary as the label not of an artistic style but of a tool of social advocacy.

In 1936, within a year of the creation of the FSA, *Life* magazine was launched. The new field of magazine photojournalism eagerly nourished the budding confusion between photographic fact and moral truth. In magazines of the postwar period the photography of social life almost invariably promulgated a social ideal—by pointing at a problem in need of a solution (the troubled youth of Gordon Parks's *Harlem Gang Wars* [page 199]) or by applauding an exemplar of the way things ought to be (the everyday heroism of W. Eugene Smith's "Country Doctor" [page 196]). When Robert Frank's book *The Americans* appeared at the end of the 1950s (frontispiece and pages 215–217), the hostility it aroused may have had less to do with Frank's bitter image of a drab and lonely country than with his refusal to adopt the prevailing optimism of armchair humanism. His book offered no succor to those who believed that all problems could be solved, if only we cared enough. In this respect as in others, Frank was the successor of Evans.[8]

The artistic legacy of Stieglitz, Strand, and Weston is easily traced through the work of

Adams, Callahan, Siskind, and White because the continuity of outlook is manifested as a coherent evolution of style. The legacy of Evans is less readily grasped because the most potent bequest of his documentary idea was the photographer's freedom from the superficial rhetoric of a particular style. Like Evans, Frank extracted persuasive symbols from raw fact and did so by fashioning a consistent poetic voice from the potent resource of an undisciplined vernacular. The difference is that, between Evans's return to the United States in 1928 and Frank's arrival from Switzerland two decades later, the vernacular had taken a dramatically different form. By 1950, thanks largely to the influence of the magazines, the standard of realism in American photography had shifted from the steady gaze of the tripod-bound view camera to the fleeting glance of the small hand-held camera. The mark of candor and authenticity was no longer the seamless description of a stable object but the blur and grain of a picture caught on the run.

This photographic vocabulary, like picture journalism itself, had originated in Europe in the work of such photographers as Erich Salomon, Martin Munkacsi, André Kertész, and Henri Cartier-Bresson. In the mid-1930s Cartier-Bresson visited the United States, and Kertész (page 158), John Gutmann (page 160) and Lisette Model (page 161) came to stay. At the same time Evans and Helen Levitt (pages 137, 157, and 159) were translating the new vocabulary into a local idiom, but it did not become the lingua franca of American photography until after the war. Eventually, fed by the manic vitality of Weegee and his newspaper cohorts, it fostered an indisputably American aesthetic: reckless, vulgar, just shy of anarchic. In the hands of such young turks as William Klein (page 219), Louis Faurer (page 221), Leon Levinstein (page 223), and Ted Croner (page 218), it was an aesthetic of the city, preoccupied with energy and speed.

◆

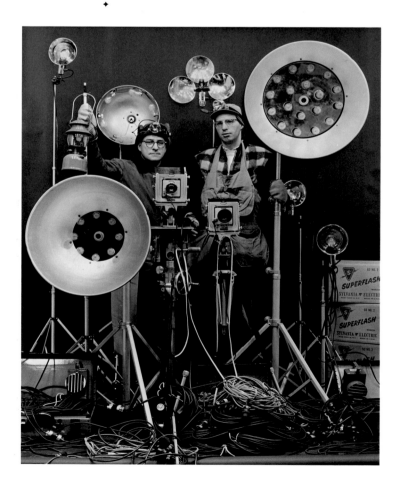

O. Winston Link.
O. Winston Link and George
Thom with Part of the
Equipment Used in Making
Night Scenes with Synchronized
Flash. 1956

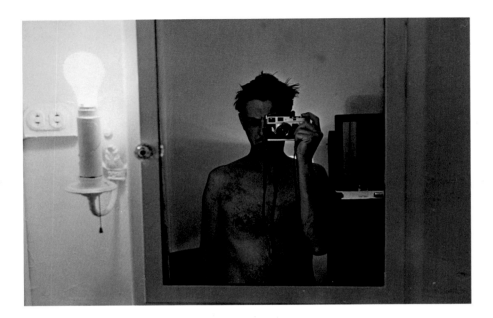

The 1950s also witnessed a sea change in American photography, far more profound than a revolution in style. Half a century earlier, the Photo-Secessionists had set out to erect an unpassable barrier between the unkempt diversity of applied photography and the cultivated singularity of photography as a medium of art. Their mission required an obvious marker of difference, and their work provided it. Already in the early 1920s, however, the gap had narrowed considerably. Although aimed to seduce the consumer rather than the aesthete, the advertisements of Paul Outerbridge and Grancel Fitz (pages 122 and 123) echo the voluptuous simplicity of contemporaneous photographs by Stieglitz and Strand (pages 105 and 112). Just so, in the wake of World War II, the private meditations of Harry Callahan, at once limpid and austere (pages 180 and 181), are first cousins to the equally rigorous photographs that Irving Penn made for millions of readers of *Vogue* (pages 193–195). Moreover, among the tiny audience dedicated to serious photography, Penn's artistic achievement was applauded as quickly and loudly as Callahan's.

Eventually, as the stylistic exchanges between aesthetic and applied photography continued to multiply, the distinction between artist and professional was eroded. The rich collective achievement of the 1950s owed a great deal to this new flexibility. One example is the contribution of Dan Weiner, whose personal work (page 220) is stylistically continuous with the larger body of excellent work he did for the magazines (page 198). Indeed the term "personal work" arose at this time to distinguish between the two roles that a single photographer often played.

Robert Frank's *The Americans* was the most powerful and original body of work to emerge from the fecund convergence of photography's high-art and vernacular traditions in the 1950s. But the fierce independence of the book and its author also made it a bellwether for the divergence that rapidly ensued, inflecting the term "personal work" with a tone of derision for any other kind. Robert Frank, Louis Faurer, Garry Winogrand, Lee Friedlander, Diane Arbus, and Elliott Erwitt all did more than a little work on assignment, and all of them did their best and most original work for themselves.

This was something new, and it profoundly changed American photography. From William H. Rau at work for the railroad, James Van Der Zee at work for the residents of Harlem, and Weegee at work for the tabloids, to W. Eugene Smith and Richard Avedon on assignment for the magazines, the job had been more of an opportunity than a burden. For

three quarters of a century the marketplace had fed the resourcefulness and vitality of photography because it had provided the photographer with sufficient autonomy to meet and redefine the professional standard by construing it as a rewarding challenge. Lange was repeatedly fired by the FSA, and Smith repeatedly resigned from *Life*, but both repeatedly returned because the artistic compensations of the work offset its bureaucratic frustrations. By the 1960s, especially to new arrivals, the marketplace seemed increasingly alien, a domain of corporate authority and homogenous committees, inhospitable to experiment and individual outlook. Even Penn and Avedon, while continuing to make their art directors look brilliant, began to give more and more time to independent projects. In other spheres of applied photography, too, fresh opportunity gradually settled into routine, as the demands of each assignment became increasingly predictable. As young photographers of talent and desire progressively withdrew from the engagement, the long productive interplay between photography's functional applications and its high-art ambitions began to subside.

At about the same time, photography's autonomy from the traditional arts began to erode. In comparison to Europe, advanced American photography had developed to a considerable degree in isolation. European avant-garde photography of the 1920s and 1930s had lacked the orthodox authority of a Stieglitz and had enjoyed a far more fluid exchange with both popular and high art. Among the ways this fluidity expressed itself was in the medium of photographic collage, which was practiced enthusiastically by a wide range of artists, photographers, illustrators, and propagandists. Such cut-and-paste abandon was rare in the United States, where the experimental modernist and the steady professional both worked within the four-square frame. This unspoken pact, a source of coherence amid diversity, was broken about 1960 by Robert Rauschenberg, Andy Warhol, and other American artists, who bore no allegiance to photographic traditions. These artists seized upon piles of yellowing newspapers and magazines—full of photographs of movie stars, murderers, winners, and losers—as if they had discovered a gold mine.

They had. Walker Evans in the 1930s (page 133), William Klein in the 1950s (page 219), and a host of others had celebrated the same vital vernacular without revising their conception of photography as an art of perception. Although Rauschenberg and Warhol both made photographs, they turned to the vernacular not principally as a model for photographs of their own but as a bottomless resource of raw material, and as a process for replicating, digesting, and recombining its riches. In 1965 Evans's successors—Arbus, Winogrand, and Friedlander—still had their best work ahead of them, which would again reinvigorate American photography's tradition of headlong engagement with the world of experience. Henceforth that tradition coexisted, competed, and interacted with the tradition of Rauschenberg and Warhol, for whom the world already had been photographed.

◆

It is difficult to avoid noticing that the seventy-five years spanned by the photographs presented here coincide precisely with the abbreviated American Century of economic and military might and untrammeled self-confidence. It is difficult to avoid noticing also that the maturity of American photography blossomed most fully just as self-doubt was beginning to take hold in the nation's collective mentality. The photographs that close this book confront moral uncertainty with seasoned artistic authority. This might be regarded as an irony, but perhaps it is not. Perhaps it is an embodiment of Judge Learned Hand's proposition that "the spirit of liberty is the spirit which is not too sure that it is right."[9]

▐▐

In May 1929 Miss Lillie P. Bliss, Mrs. John D. (Abby Aldrich) Rockefeller, Jr., and Mrs. Cornelius J. Sullivan joined with four others to form a committee to found The Museum of Modern Art. Alfred H. Barr, Jr., then twenty-seven years old, was appointed director of the Museum, which opened to the public in November. Over the summer the committee had issued a brochure outlining its intention to present exhibitions and, ultimately, to acquire a collection of "the best modern works of art," which naturally meant works in the traditional mediums of painting and sculpture. The prospectus also stated: "In time the Museum would expand . . . to include other phases of modern art."

This phrase disguised the young director's most radical ambitions for the new museum. In a draft for the brochure Barr had written: "In time the Museum would probably expand beyond the narrow limits of painting and sculpture in order to include departments devoted to drawings, prints, and photography, typography, the arts of design in commerce and industry, architecture (a collection of *projets* and *maquettes*), stage designing, furniture and the decorative arts. Not the least important collection might be the *filmotek*, a library of films."[10]

In 1929 many still regarded the work of Picasso and Matisse as alien or even ridiculous, but enthusiasm for the new painting and sculpture was hardly unknown. Nor, as Barr himself pointed out, was it unprecedented to extend that enthusiasm to modern mechanical mediums such as film and photography. (His use of the word *filmotek* suggests a particular alertness to European precedents, notably the comprehensive curriculum of the Bauhaus.) What was new was the attempt to give this inclusive outlook a permanent institutional form, based in a collection and founded on the conviction that, for all its boldness of innovation, modern art constituted a coherent, unfolding tradition.

Despite the daunting challenge of creating a functioning museum from scratch, and despite the primacy of the program for painting and sculpture, virtually every other aspect of Barr's wide-ranging scheme soon began to take root in the Museum, at first through acquisitions and exhibitions, and eventually in the form of curatorial departments: Architecture (1932), Film (1935), Industrial Design (1940), Photography (1940), and Dance and Theater Design (1944). Today the Museum comprises six curatorial departments: Painting and Sculpture, Drawings, Prints and Illustrated Books, Architecture and Design, Film and Video, and Photography.

In 1933 the Museum also inaugurated the Department of Circulating Exhibitions. Only four years old, still without a collection to speak of, the institution thus announced an intention to broadcast its programs, to develop a wide audience for modern art. Indeed, over the next two decades many of the Museum's exhibitions, including a majority of its photography exhibitions, traveled extensively. For example, between October 1939 and May 1941, at a fee of thirty dollars for a two-week showing, the exhibition *Seven American Photographers* toured seventeen venues, including Kaufmann's Department Stores, Pittsburgh, Pennsylvania; the College of Mines and Metallurgy, El Paso, Texas; and The Darlington School, Rome, Georgia.

◆

What follows here is an attempt to trace the development of the Museum's program in photography, with little regard to the evolution of the institution as a whole.[11] Thus the story told here is both a limited and a distorted one because the single most significant characteristic of the photography program is its presence in an art museum devoted broadly to modern visual

culture. With that said, however, it needs saying also that each of the Museum's various programs developed to a considerable degree in isolation, especially in the early years.

Barr's plan proposed that its various components were related one to another, but it did not say just how. Indeed, it was to avoid a premature answer to that question that Barr opposed a central curatorial administration in favor of independent departments, whose interrelationships could develop and change over time. Today, two generations later, the nature of those interrelationships remains a subject of lively argument. At the outset of the Museum it was challenging enough to build programs and collections that might serve to advance the argument, without attempting to resolve it. What the Museum's programs most shared, beyond an often fervent sense of mission, was the turmoil, frustration, and failure that inevitably accompanied their triumphs and leaps of faith.

Since the turn of the century, thanks in part to Stieglitz and his associates, New York had been the scene of considerable activity concerned with photography, including exhibitions, lectures, and criticism.[12] Virtually all of this activity, however, was focused on new photography; even work of the recent past rapidly disappeared from view. In a lecture of 1923 Paul Strand lamented the fact. Praising Stieglitz's personal effort to collect and preserve the work of the Photo-Secessionists and their European counterparts, Strand urged young photographers to make use of Stieglitz's collection, "that is, use all this experiment, not to imitate but as a means of clarifying their own work, of growing, as the painter who is also an artist can use his tradition. Photographers have no other access to their tradition, to the experimental work of the past. For whereas the painter may acquaint himself with the development of the medium, such is not the case for the student-worker in photography. There is no place where you can see the work of [David Octavius] Hill, [Clarence H.] White, [Gertrude] Käsebier, [Frank] Eugene, Stieglitz, as well as the work of Europe, on permanent exhibition."[13]

Strand's remarks defined the essential function that the Museum's photography program, by fits and starts, eventually came to serve. Today the central aim of that program is to encourage a vital dialogue between the experiments of the present and the achievements of the past.

Alfred Barr, himself an extraordinary curator and scholar, was adept at involving other remarkable people in the work of the Museum. Preoccupied with developing exhibitions and publications on painting and sculpture, and with the still more demanding task of forming a collection, he made a place for photography largely by encouraging the contributions of others. In the first two decades of the Museum the key participants were talented, energetic, diverse in outlook, and few: Lincoln Kirstein, Beaumont and Nancy Newhall, David H. McAlpin, Ansel Adams, James Thrall Soby, and Edward Steichen.

The early organization of the Museum included the Advisory Committee, which seems to have functioned much as President Roosevelt's kitchen cabinet soon would, allowing individuals with no formal authority to play a variety of instrumental roles. Among its most active initial members was the twenty-two-year-old Kirstein, who, while still an undergraduate, had founded the Harvard Society for Contemporary Art (a harbinger of the Museum) and the avant-garde literary journal *Hound and Horn*. The breathtaking range of Kirstein's enthusiasms included photography, and his early friendship and collaboration with Walker Evans were decisive for the young Museum. Kirstein's precocity is neatly summarized in Evans's recollection: "This undergraduate was *teaching* me something about what I was doing—it was a typical Kirstein switcheroo, all permeated with tremendous spirit and flash, dash, and a kind of seeming high jinks that covered a really penetrating intelligence. . . . It was immensely helpful and hilariously audacious."[14]

In 1932 Kirstein organized *Murals by American Painters and Photographers*, the first exhibition at the Museum to include photography. In 1933 (the same year that he altered the history of ballet by bringing George Balanchine to the United States) he organized the first one-person photography exhibition, *Walker Evans: Photographs of Nineteenth Century Houses*, a body of work he had commissioned and which he donated to the Museum. Five years later, Kirstein was the force behind the Museum's publication of Evans's *American Photographs*, for which he wrote one of modern art's exemplary pieces of contemporaneous interpretation. Although it accompanied an exhibition, *American Photographs* was not a catalogue but a substantial book and the first of its kind. Its excellent reproductions were presented neither as a portfolio of the photographer's best work nor as illustrations to a text or theme but as a poetic whole. In the half century since, books based on this model have been a vital medium of the art of photography, in many respects more important than exhibitions.

Kirstein's role in photography at the Museum did not end in 1938. In 1965, for one example among others, he gave to the Museum Frances Benjamin Johnston's splendid *Hampton Album* of 168 platinum prints (see page 67), again writing for the book that accompanied its exhibition. His earliest efforts were the most crucial, however, not merely because they introduced photography to the Museum but because they engaged contemporary work with a seriousness and adventurousness that have yet to be surpassed.

At the Museum, Kirstein was an inspired free lance; the quality of his contribution was in part a function of his independence from bureaucratic responsibility. The prospect of a sustained program in photography had first arisen in 1935, when Barr hired Beaumont Newhall, another scion of Harvard, to head the Museum library. The choice was a resourceful sleight of hand. The Museum's trustees would not be prepared to pay the salary of a photography curator for many years to come, but they agreed that a library was essential. Barr knew that Newhall, virtually alone among trained art historians, had developed a deep interest in photography. Although he remained in charge of the library until 1942, devising its cataloguing system and compiling meticulous bibliographies for Barr's ground-breaking publications, Newhall soon had the opportunity to exercise that interest on an ambitious scale. In March 1937, at Barr's invitation, he organized the exhibition *Photography 1839–1937*. Comprised of 841 objects, it was the first attempt in a museum of art to trace the history of photography, not as a chronicle of technical improvements but as the evolution of a new species of picture. The catalogue of the exhibition served as the basis for Newhall's book *The History of Photography*, which was published by the Museum in 1949 and remained the standard text for decades and which, two editions later, is still in print.

Newhall did not learn for many years that he owed his great opportunity not only to Barr but also to David H. McAlpin. An investment banker and amateur photographer, McAlpin had conceived a deep interest in advanced photography after visiting Stieglitz's gallery, where he formed a friendship with Georgia O'Keeffe as well as with Stieglitz. Linked to the Museum by his Rockefeller relations, McAlpin had approached Barr with an offer of $5,000 to pay for a major photography exhibition. The result was Newhall's ambitious historical survey.

Unlike most European museums, most museums in the United States have been created and sustained by private individuals rather than by national or local governments. The list of significant contributors to the Museum's photography programs and collection is by now very long. Prominent on that list are photographers themselves, and not only for gifts of their own work. (For example, the photograph by Stieglitz on page 97 is the gift of Sheeler; the Modotti on page 107 is the gift of Weston; the Evans on page 144 is the gift of Willard Van Dyke.) In

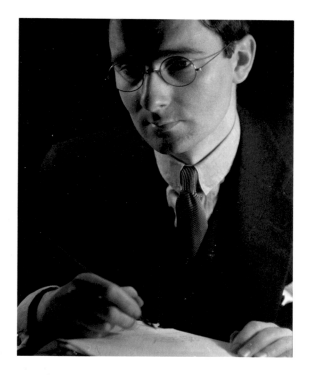

Jay Leyda.
Alfred H. Barr, Jr., New York.
1931–33

1967 Lee Friedlander undertook to establish The Ben Schultz Memorial Collection, persuading twenty-three photographers to give the Museum a total of fifty-seven prints in memory of an inspired picture editor at Time-Life. In 1979 Ansel and Virginia Adams endowed a permanent staff position in the department, The Beaumont and Nancy Newhall Curatorial Fellowship.

In the Museum's early years, however, its photography program was sustained by only a handful of people. The budding collection was enriched by important gifts from Samuel M. Kootz and Albert M. Bender and, most notably, James Thrall Soby, who in 1940 gave the Museum more than one hundred photographs by Man Ray. Soby was just beginning an extraordinary career at the Museum, in which he eventually served as trustee, curator, administrator, collector, organizer of exhibitions, and author of the publications that accompanied them. Although most of his energies were devoted to painting and sculpture, his farsighted concern for photography, incorporating a lively enthusiasm for contemporary work, was deeply influential.

But McAlpin was the mainstay. He volunteered to pay for exhibitions, acquisitions, and even the stipend of $1,000 that accompanied the Museum's first (and, as it turned out, only) Photographer's Fellowship, awarded to Helen Levitt in 1946. Along with Soby, he was a crucial advocate for photography in the high councils of the Museum. Above all, he took the decisive step that created the Department of Photography when he agreed to guarantee its initial operating expenses. The importance of his role can be appreciated fully only in the light of the Museum's policy that programs such as photography or film could exist at all only if they paid for themselves, including their staff salaries. Although apparently not enforced rigorously, the policy was still in place two decades after the founding of the Museum. Without McAlpin, Barr and Newhall might have waited many years before they were able to transform a pattern of sporadic achievement into a coherent program.

The Department of Photography, with Newhall as curator, was formally established in December 1940. The Committee on Photography, formed to oversee the new department, was

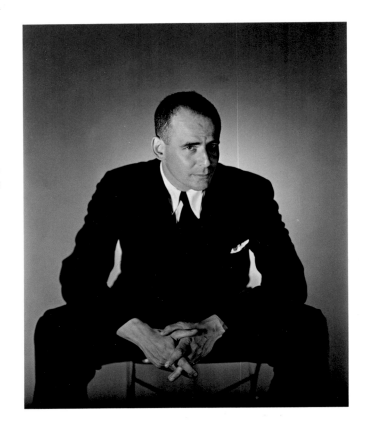

George Platt Lynes.
Lincoln Kirstein. c. 1940

led by McAlpin, its first chairman, and Soby. Another key member was California photographer Ansel Adams, the committee's vice-chairman.

Adams joined the committee at the urging of McAlpin, who offered to pay the expense of bringing him to New York for six months to help get the department underway. The two had met in 1936, when Adams was in New York for an exhibition of his work at Stieglitz's gallery. By 1939 their close friendship had blossomed into a bicoastal circle of photography enthusiasts, which also included Beaumont and Nancy Newhall and Edward and Charis Weston. Thus the formation of a professional curatorial program was also an intimate personal collaboration.

Throughout his life Adams was a tireless organizer, letter writer, and champion of causes, and he undertook his role at the Museum with zeal. A devoted acolyte of Stieglitz, Adams encouraged Newhall to set a high standard for photography as a medium of artistic expression. Newhall's deepening allegiance to Stieglitz won little praise from the aloof old master, who disdained the Museum as a socially powerful latecomer to his cause, but it played a significant role in the Museum's photography program. To celebrate the founding of the Department of Photography, Adams and Newhall together organized *Sixty Photographs: A Survey of Camera Aesthetics*, nearly half of which was drawn from the collection.[15] In its spare selectivity and stringent modernism the exhibition offered a blunt contrast to the sprawling history exhibition Newhall had organized three years earlier, and it announced a photography program in close parallel to Barr's program for painting and sculpture.

In August 1942, less than two years after the founding of the Department of Photography, Beaumont Newhall took a leave of absence from the Museum to serve as a photo-interpreter in the Army Air Force. His wife Nancy, who had become an increasingly active informal collaborator in his work, served as acting curator until his return more than three years later. By 1947, despite the disruption of World War II, the Newhalls had mounted major exhibitions of the work

of Paul Strand (1945), Edward Weston (1946), and Henri Cartier-Bresson (1947), each accompanied by an exemplary catalogue; and James Johnson Sweeney, recently head of the Department of Painting and Sculpture, had organized a large Stieglitz retrospective in 1947. An ambitious plan for a survey of American photography since 1918 was abandoned for lack of funds, but the Department of Photography regularly mounted general historical surveys from the collection, independently and in association with museumwide installations. In 1944 and 1946 the Newhalls organized the first of what they planned as a series of group exhibitions comprised of individual bodies of recent work. Among the photographers introduced to the public by these exhibitions were Harry Callahan, Lisette Model, Arnold Newman, Aaron Siskind, and Frederick Sommer. In other exhibitions the Newhalls had presented groups of photographs by Berenice Abbott, Harold Edgerton, Helen Levitt, Man Ray, Eliot Porter, Ralph Steiner, and Brett Weston.

Like Barr, the Newhalls also worked hard to build the collection, and by 1945 the Museum owned more than two thousand photographs. Given that there were hardly any purchase funds apart from McAlpin's contributions, this is an impressive figure. Gathering steam just as the advent of the war was closing Europe, the collecting effort inevitably favored American photography, including outstanding work by Adams, Imogen Cunningham, Evans, Arnold Genthe, Lange, Modotti, Porter, Sheeler, Stieglitz, Strand, Weegee, Weston, and Clarence H. White, as well as important nineteenth-century photographs by Mathew Brady, Alexander Gardner, and Timothy O'Sullivan. Even so, the collection also included key works by Manuel Alvarez Bravo, Brassaï, Cartier-Bresson, and Christian Schad as well as Soby's superb Man Rays and a group of forty-one photographs by László Moholy-Nagy that Beaumont Newhall had purchased in 1939 with funds provided by McAlpin. Viewed as a whole, the Newhalls' program of exhibitions, publications, and acquisitions expressed both a vigorous embrace of photographic modernism and a concerted effort to view photography in historical perspective. The pride of place given to advanced contemporary work was consistent with the Museum's central mission, and a particular attachment to the school of Stieglitz, Weston, Strand, and Adams had not precluded an enthusiastic response to the very different work of Cartier-Bresson and Moholy-Nagy.

This highly condensed summary represents only one of two narratives that were unfolding simultaneously. The other culminated in 1947 with the arrival of Edward Steichen as director of the Department of Photography and with the departure of Newhall, who declined to remain at the Museum under Steichen.

◆

The entry of the United States into World War II, in December 1941, had a profound effect on the Museum in general and on the Department of Photography in particular. Nancy Newhall undertook her role as acting curator with energy and competence, but her authority was less certain, as were her resources. The Museum's operating budget diminished by nearly twenty percent in 1942, with severe consequences for those programs, including photography, that were expected largely to pay for themselves. Finally, like many other public institutions, the Museum vigorously applied itself to the war effort. Prominent among the new programs were a number of exhibitions frankly designed to build national morale rather than to pursue aesthetic inquiry. Photography was an obvious and effective conscript to this effort, beginning in 1940 with the exhibition, *War Comes to the People, A Story Written with the Lens by Therese Bonney*, which was followed by *Britain at War* (1941) and *Road to Victory* (1942), an unapologetic patriotic prophecy organized by Edward Steichen, acting as guest curator.

The pressures of the war brought into open and eventually bitter conflict at the Museum an unresolved contradiction latent in Barr's original plan, and indeed in modern photography itself. By 1929 avant-garde photography, in full flower on both sides of the Atlantic, had earned a place among the high achievements of modern art. Certainly Barr meant to recognize this when he planned to include photography in the Museum. But he also meant something different and much broader. A product of the industrial revolution, photography had so profoundly shaped modern life that the medium was an inevitable concern of the Museum, no matter whether or in what particular cases it might be regarded as a medium of high art.

The intellectual framework of Barr's plan was capacious enough to accommodate these divergent understandings of photography's role in modern culture. By the early 1940s, however, they had hardened into opposing positions in a struggle over photography's place in the Museum. The struggle was exacerbated by the precarious financial circumstance of the photography program. Those who wished to broaden the program beyond what they regarded as the cramped elitism of the Newhalls and Adams justified their populist proposals in part by claiming an expectation of financial support from the photographic industry and from a large audience of amateur photographers.

The first test of that expectation was the creation, in November 1943, of the Photography Center in an apartment building across the street from the Museum's garden. Beaumont Newhall had been away for more than a year, and Willard Morgan, husband of photographer Barbara Morgan, publisher of photography manuals, and contributing editor to *Life* magazine, was appointed the first director of the Department of Photography. The Center was conceived

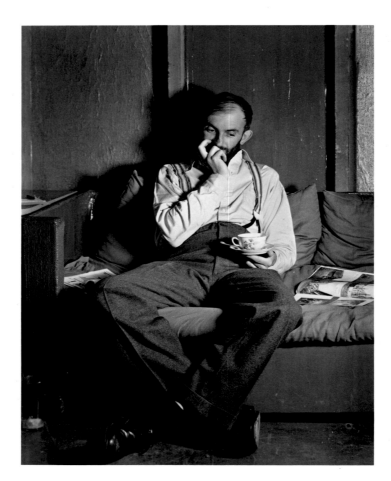

Willard Van Dyke.
Ansel Adams at 683 Brockhurst,
San Francisco. **1932**

32

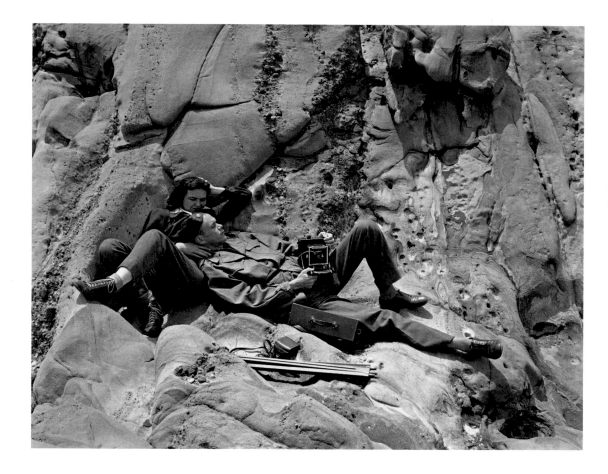

as an ambitious expansion of the photography program, including the first workable study center and plans for lectures and commissions to photographers, as well as exhibitions and publications. In February 1944 Morgan organized *The American Snapshot*, an exhibition sponsored by Eastman Kodak and drawn from the company's files of amateur photographs that had been submitted to its competitions. Less an examination of the unpretentious snapshot than an advertisement for Kodak, the exhibition was regarded from all sides as a failure. The Photography Center closed in the summer of 1944, the plans associated with it were abandoned, and Morgan soon left the Museum.

In the light of this dispiriting episode, it is not surprising that Beaumont and Nancy Newhall, corresponding with each other across the ocean, felt increasingly embattled.[16] They had the support of McAlpin and Barr, but McAlpin was serving in the navy and Barr had been fired as the Museum's director in 1943—a clear sign that the troubles of the Department of Photography were only a small part of the young Museum's turbulent growing pains. (Barr did not leave, however; he was named Director of Research and, in 1947, Director of Museum Collections.) While the Newhalls construed the fragility of the photography program as an incitement to fight all the more fiercely for the recognition of photography as a high art, the trustees looked upon the same circumstance as requiring a substantial overhaul. Despite the bitter and embarrassing failure of the Photography Center, the view persisted that the best hopes for the Department of Photography lay in the prospect of an expanded and more popular program that would attract support from the industry.

That view played a crucial role in the decision of the trustees to hire Edward Steichen as

director of the Department of Photography. In 1945 Steichen had organized *Power in the Pacific*, his second successful war exhibition at the Museum, and with the death of Stieglitz in 1946 he became a figure of unrivaled prestige in American photography. The notion that he might take charge of photography at the Museum had first arisen late in 1944, not long after Morgan's departure, and soon was linked to an ambitious scheme for expansion, very similar to earlier plans for the Photography Center and equally dependent upon large contributions from the industry. Exhibitions were to be installed in a Quonset hut (a semipermanent structure developed by the navy during the war) to be erected in the Museum's garden, and the Museum was to publish a quarterly journal on photography. Perhaps the most unrealistic aspect of the scheme, whose principal promoter was Steichen's friend Tom Maloney, editor of *U.S. Camera* magazine, was the idea that Newhall would remain under Steichen, to care for the collection and organize historical exhibitions. Nevertheless, neither Newhall nor the Committee on Photography was consulted, and in March 1946, soon after learning that the Steichen plan had been adopted, Newhall submitted his resignation.

Steichen did not assume his new post until July 1947, more than a year after Newhall's departure. The work of the department had come nearly to a standstill, and for two years or more Steichen's position was barely more secure than Newhall's had been. Steichen and Maloney never did succeed in soliciting significant support from the industry; the Quonset hut was sold at a loss; and the expansion plan remained unrealized. Eventually, however, Steichen fulfilled the dreams of the populist camp beyond expectation.

Steichen had long since repudiated the ambitions he once had shared with Stieglitz, and he increasingly viewed photography not as a medium of artistic expression but as a vehicle of mass communication. In 1969, at the age of ninety, he recalled: "When I first became interested in photography, I thought it was the whole cheese. My idea was to have it recognized as one of the fine arts. Today I don't give a hoot in hell about that."[17] Beginning with *Road to Victory* in 1941, he had pursued a concept of exhibition that, like a layout in a vast, walk-in magazine, subordinated the individual photograph to the sweeping orchestral message of the whole. This concept culminated in 1955 in *The Family of Man*, an enormous display comprised of 503 photographs made by 273 photographers from 68 countries. Circulated overseas by the United States Information Agency, the exhibition eventually was seen by more than seven million people.[18]

By its very nature, *The Family of Man* was inhospitable to the distinctive sensibilities of individual photographers and is thus a poor basis on which to judge Steichen's response to contemporary work. Even such contemporary survey exhibitions as *In and Out of Focus* (1948) and *Always the Young Strangers* (1953), despite the absence of an overarching message, tended toward homogeneity. In a steady program of smaller group exhibitions, however, each comprised of individual bodies of work, Steichen demonstrated a keen eye for the diverse achievements of photographers who were younger, often decades younger than he. His two favorites were Harry Callahan and Robert Frank, the most original and influential American photographers of the 1950s, whose work he paired in one of his last exhibitions for the Museum, in 1962. The exhibition was to have been the sixth in a series titled Diogenes with a Camera until Frank, pointing out that the ancient Greek seeker of truth had never made a photograph, insisted that the exhibition bear the photographers' names. Under the Diogenes label Steichen had presented the work of (among others) Edward Weston, Frederick Sommer, Eliot Porter, W. Eugene Smith, Ansel Adams, Dorothea Lange, Aaron Siskind, Man Ray, Manuel Alvarez Bravo, Walker Evans, August Sander, and Bill Brandt. In a variety of other exhibitions, Steichen showed enthusiasm for the photography of Richard Avedon, Roy DeCarava, Ted Croner, Louis Faurer,

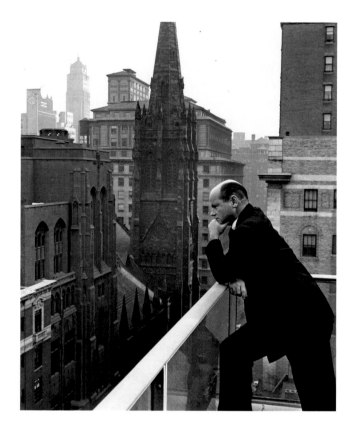

Edward Weston.
David H. McAlpin. 1941

Leon Levinstein, Lisette Model, and Irving Penn. In 1952 he purchased for the Museum two photographs by Robert Rauschenberg (see page 210), the first two works by Rauschenberg in any medium to enter any museum collection. Steichen was then seventy-three years old; Rauschenberg was twenty-seven.

Steichen's historical exhibitions were few and unrelated to one another, and the collection grew very slowly, without apparent plan. The book that accompanied *The Family of Man* is still in print and has sold far more copies than any other photography book, generating a purchase fund that has since added hundreds of works to the collection; but it was one of only two books that issued from the Department of Photography under his leadership. (The other was *Steichen the Photographer*, the catalogue of a major retrospective organized in 1961.) As Steichen himself would have wished, his tenure at the Museum is remembered principally for his grand thematic displays, above all *The Family of Man*.

In 1955 the Department of Photography was only fifteen years old, and its road had been a rocky one. *The Family of Man* brought to photography a scale of popular acclaim that hardly could have been anticipated; doubtless it also brought to the department a degree of stability it had not yet enjoyed. Nevertheless, the exhibition was an aberration. All curators select and arrange works of art, and in *The Family of Man* Steichen did so brilliantly. His decisions, however, were guided not by an attempt to recognize the photographers' individual achievements or to explore the particular meanings that might arise from those achievements but by the need to illustrate a moral message of his own conception: that the trials and joys of all people are everywhere and always the same.

Like the nineteenth-century French architect Eugène Viollet-le-Duc, who did not hesitate to revise the medieval buildings he was charged to restore, Steichen at the Museum approached photography not as a disinterested student but as the active participant he always

had been. His work as curator is also the remarkable closing chapter of his long and extraordinary career as an artist. In both respects the photography program under his tenure evolved in a continuous present, with little regard for the past. The choice between Newhall and Steichen had turned out to be a choice not so much between a narrower and a broader view of photography as between the traditional functions of an art museum and a lively workshop of mass communication under the direction of a passionate sensibility.

That the Museum could accommodate such a project was a sign of youth and eagerness for a broad public, as well as of uncertainty about how to deal with the young medium of photography. By the time Steichen retired in 1962, however, the Museum was no longer an upstart experiment but a mature institution, and it was inevitable that the Department of Photography eventually would return to the functions that Barr and Newhall had begun to establish more than two decades earlier.

◆

In 1949 Beaumont Newhall was appointed curator of the newly founded George Eastman House in Rochester, New York, a museum devoted entirely to photography and film. Soon there existed growing photography programs at several other American museums, notably The Art Institute of Chicago and the San Francisco Museum of Modern Art. Nevertheless, in 1962 a career as a curator of photography remained an unlikely aspiration, and The Museum of Modern Art again turned to a photographer to lead its photography program.

John Szarkowski, who served as director of the Department of Photography from 1962 to 1991, promptly distinguished his mission from Steichen's precedent by titling his first exhibition of contemporary work *Five Unrelated Photographers*. (The five were Ken Heyman, George Krause, Jerome Liebling, Minor White, and Garry Winogrand.) Four years later, in 1967, he organized the exhibition *New Documents*, which elected Winogrand, Diane Arbus, and Lee Friedlander the exemplary new talents of the 1960s. Among those who regard contemporary art as a horse race, in which the curator's job is to bet on the winner, that exhibition is credited now as an excellent wager. On the same basis, Szarkowski has been criticized for failing to appreciate the work of other artists. The compliment and the criticism, each alone, fail to consider that a museum—especially a museum concerned in part with contemporary art—ought to inspire both.

In Szarkowski's view, a useful debate hardly could proceed without an active review of the individual achievements that had defined modern photography. Except for Steichen's survey of his own career, in 1961, the Museum had not mounted a one-person exhibition since 1947. Within the first decade of Szarkowski's tenure, the department organized major exhibitions of the work of André Kertész (1964), Dorothea Lange (1966), Henri Cartier-Bresson (1968), Brassaï (1968), Bill Brandt (1969), Eugène Atget (1969), Walker Evans (1971), Clarence H. White (1971), and Diane Arbus (1972). In the same period, the department also presented twenty smaller exhibitions devoted to individual photographers, among them Berenice Abbott, Paul Caponigro, Marie Cosindas, Bruce Davidson, Elliott Erwitt, Jacques-Henri Lartigue, Ray K. Metzker, Duane Michals, Barbara Morgan, August Sander, Aaron Siskind, and Jerry N. Uelsmann.[19]

Under Szarkowski the department's programs for publications and acquisitions also flourished. Between 1964 and 1973 the Museum published more photography books and catalogues than it had in the preceding thirty-five years. The landmark year for the collection was 1968, when McAlpin gave to the Museum 324 photographs by Adams, Weston, Sheeler, Stieglitz, and others; and when, after years of trying, Szarkowski succeeded in raising the money to purchase

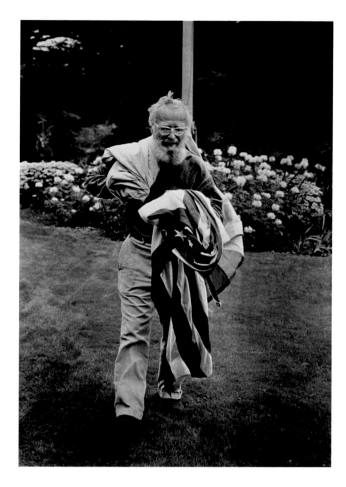

Bruce Davidson.
Edward Steichen. 1963

the collection of nearly five thousand photographs by Eugène Atget that Berenice Abbott had heroically preserved for more than forty years.

The department was still very small, and a large proportion of its energy was devoted to exhibitions. In a period when few other museums concerned themselves with photography, the exhibition program played a vital role in building an active and critical audience for photography. But the steady growth of the collection was perhaps more important. No art collection that aims to be comprehensive ever can be complete; indeed, one of the most valuable functions of such a collection is that the works it contains point to the absence of others. During Szarkowski's tenure the Museum's photography collection first achieved a density and variety that enabled it to serve that function, and which made it an indispensable resource not only for the Museum's own work but also for a diverse community of artists, curators, scholars, and students.

Upon the founding of the Department of Photography in 1940, the Museum had allocated space in which to exhibit photographs from the collection. The space was very small, however, and apparently not always used for its designated purpose. It was not until 1964 that a major expansion of the Museum finally created adequate permanent galleries in which to display an historical survey of photography drawn from the collection. A further expansion in 1984 more than doubled those galleries, which now accommodate some two hundred photographs. Each new installation of these galleries, selected from a collection that now includes more than twenty thousand prints, provides a provisional outline of photography's historical achievements. In other words, the galleries are designed to offer not only works of outstanding quality but also (to paraphrase Paul Strand) a coherent guide to past experiments—to a living tradition.

As long as that tradition indeed remains alive and useful to each new generation, its content and shape will remain a matter of debate. Szarkowski's work both nurtured the relevance of the past to the unfolding present and clarified the terms of the debate.

In addition to many one-person exhibitions, Szarkowski organized a series of synthetic exhibitions devoted to what he regarded as fundamental issues in the study of photography. Among them were *The Photo Essay* (1965) and *Once Invisible* (1967), an examination of photographic records of phenomena invisible to the unaided eye. The most important was *The Photographer's Eye* (1964); the accompanying book appeared two years later. The exhibition proposed to see photography whole, as a distinct pictorial language, and to provide a basic set of tools for analyzing it. The relative success or failure of this proposition is less significant than the way in which it was framed.

The Photographer's Eye included a very wide range of pictures, among them anonymous documents of the journeyman professional, magazine photojournalism, amateur snapshots, and the masterpieces of self-conscious artists. In one sense, there was nothing new in this. Beginning with Newhall's history exhibition of 1937, however, it had been common to divide photography into expedient categories, based in turn on function, style, period, or formal resemblance: press photography, scientific photography, documentary photography, abstract photography, and so forth. As long as photography was divided in this way, it was not necessary to consider how the various parts were related to one another. In Szarkowski's exhibition all of the photographs, from the most ordinary vernacular to the most refined expression of cultivated sensibility, were presented on a single plane.

This curatorial strategy has been mistaken for an answer, when in fact it was a question, which has grown more rather than less interesting over the past thirty years. The nature of the relationship between photography's vernacular and fine-art traditions is a splendid puzzle that remains to be solved. As scholars and curators proliferate in the new university and museum programs for photography, they find that puzzle at the center of their work.

◆

In December 1941 The Museum of Modern Art presented an exhibition titled *American Photographs at $10*, which included one picture by each of nine photographers: Berenice Abbott, Ansel Adams, Walker Evans, Helen Levitt, Arnold Newman, László Moholy-Nagy (who had come to the United States in 1937), Charles Sheeler, and Brett and Edward Weston. Printed in editions of ten, the photographs were offered for sale, with all proceeds to go to the photographers. By mid-January only fourteen of the ninety prints had been sold, including three to the Museum itself and two to David H. McAlpin. In an apologetic letter to Moholy-Nagy, who had sold one print, Beaumont Newhall wrote: "The sale was frankly an experiment. Perhaps we shall have better success another year."

Today it would be inappropriate for the Museum to make such an effort to help photographers to sell their work, precisely because there is no longer any need. In itself the failure of Newhall's experiment explains the worthiness of the attempt, and it calls attention to how greatly the circumstance of photography has changed. In the 1960s, when John Szarkowski embarked on a rapid succession of one-person exhibitions, New York had never seen major retrospectives of the work of Kertész, Lange, Brassaï, or Brandt. Today, three decades later, the many public institutions and the still more numerous commercial galleries that exhibit photography display collectively at any one time in New York alone such a vast array of pictures, new and old, that even the most dedicated observer could not absorb all of it.

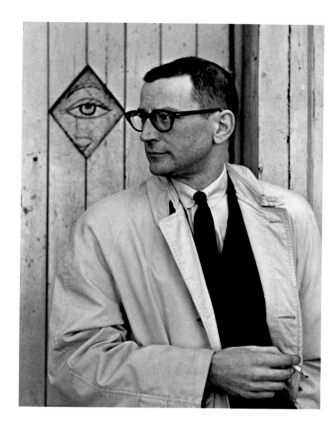

André Kertész.
John Szarkowski. 1963

In answer to the new audience that the Museum did so much to foster, its program for contemporary photography has continued to grow. Over the past decade, in its New Photography series and in other exhibitions, the Museum has presented more than sixty individual bodies of recent photographic work. The Museum also continues to introduce unfamiliar work of the past; exhibitions devoted to the photography of Grancel Fitz (1986) and William H. Rau (1987), for example, were the first in any museum. Nevertheless, in broad terms, the mission of the Department of Photography is no longer so much to make photography known and to encourage applause for it as to consider and clarify photography's diverse achievements and to encourage a deeper understanding of them.

That mission addresses two principal challenges, one contemporary and one historical, which are linked to each other. With the wide recognition of photography as an art has come an erosion of the distinction between photography and other mediums. This welcome development has contributed to the unprecedented complexity of contemporary art, in the forms it takes, in the concerns it advances, and in the paths by which it has reached those forms and concerns. To approach contemporary art as a homogenous whole is to forego in advance any hope of charting its complexity. From the viewpoint of the present, the idea of photography as a distinct category of pictorial practice, with its own traditions, is at once inadequate and indispensable.

For those who find this contradiction frustrating, there is no help in turning back. It is precisely the progressive flowering of photography in modern art that has widened our attention to photography's obstreperous past. In consequence this book, like the collection upon which it draws, contains many photographs that were not made as works of art. Uprooted from the worldly functions that brought them into being, these pictures resist a settled role in their new surroundings. Their presence in the Museum changes them but they in turn change the Museum, introducing a healthy irritant to our notions of what art has been and can be.

Notes

1. From a Kinsey newspaper advertisement, reproduced in Dave Bohn and Rodolfo Petschek, *Kinsey Photographer* (San Francisco: Scrimshaw Press, 1975), vol. 1, p. 48.

2. The rich consequences of the advent of the dry plate and of the photomechanical revolution are explored in depth in John Szarkowski, *Photography Until Now* (New York: The Museum of Modern Art, 1989), pp. 125–245.

3. Quoted in Mary Panzer, *Philadelphia Naturalistic Photography 1865–1906* (New Haven: Yale University Art Gallery, 1982), p. 22. Panzer's essay is valuable for its demonstration of the degree of Stieglitz's hostility to serious amateur artists whose ambitions he did not consider worthy of his own.

4. Paul Strand, "Photography," reprinted from *Seven Arts* in *Camera Work*, nos. 49–50 (June 1917), p. 3.

5. *Aperture*, vol. 1, no. 1 (1952), p. 3.

6. Harry Callahan, "Harry Callahan: A Life in Photography," in Keith F. Davis, ed., *Harry Callahan* (Kansas City, Missouri: Hallmark Cards, 1981), p. 50. An edited transcription of a videotape interview at the Center for Creative Photography, Tucson, Arizona, this remarkable text begins: "My parents were farmers."

7. In Louis Kronenberger, ed., *Quality: Its Image in the Arts* (New York: Atheneum, 1969), p. 170.

8. The significance of the relationship between Evans's work and Frank's is considered in Tod Papageorge, *Walker Evans and Robert Frank: An Essay on Influence* (New Haven: Yale University Art Gallery, 1981).

9. Speech given during the annual "I Am an American Day" celebration in Central Park, New York City, May 21, 1944; variously reprinted thereafter, most recently in Gerald Gunther, *Learned Hand: The Man and the Judge* (New York: Alfred A. Knopf, 1994), p. 549.

10. Alfred H. Barr, Jr., "Chronicle of the Collection of Painting and Sculpture," in *Painting and Sculpture in The Museum of Modern Art 1929–1967* (New York: The Museum of Modern Art, 1977), p. 620.

11. On the general history of the Museum, see Russell Lynes, *Good Old Modern: An Intimate Portrait of The Museum of Modern Art* (New York: Atheneum, 1973), and *The Museum of Modern Art, New York: The History and the Collection* (New York: Harry N. Abrams in association with The Museum of Modern Art, 1984).

12. This activity is thoroughly documented in Maria Morris Hambourg, "From 291 to The Museum of Modern Art: Photography in New York, 1910–1937," in *The New Vision: Photography Between the World Wars* (New York: The Metropolitan Museum of Art, 1989), pp. 3–63.

13. Paul Strand, "The Art Motive in Photography," lecture delivered at the Clarence White School of Photography in 1923; in Vicki Goldberg, ed., *Photography in Print: Writings from 1816 to the Present* (New York: Simon and Schuster, 1981), p. 282. Stieglitz later gave his collection to The Metropolitan Museum of Art, New York.

14. In Leslie Katz and Walker Evans, "Interview with Walker Evans," *Art in America*, vol. 59, no. 2 (March–April 1971), p. 83.

15. *The Bulletin of The Museum of Modern Art*, vol. 8, no. 2 (December 1940–January 1941), served as a catalogue of the exhibition and an announcement of the creation of the Department of Photography.

Ascribing the breadth of *Photography 1839–1937* in part to the influence of László Moholy-Nagy's expansive view of photography as a universal language, Christopher Phillips has suggested that Newhall had begun to turn toward Stieglitz's narrower aesthetic by 1938. See his "The Judgment Seat of Photography," *October*, no. 22 (Fall 1982), pp. 27–63.

16. Generous excerpts from these letters are provided in Beaumont Newhall, *Focus: Memoirs of a Life in Photography* (Boston: Bulfinch, 1993), pp. 111–34.

17. Quoted in ibid., p. 149, n. 32.

18. The exhibition and the circumstances under which it arose are considered in John Szarkowski, "The Family of Man," *Studies in Modern Art*, no. 4 (December 1994). One of the traveling versions of the exhibition was installed permanently at the Château de Clervaux, Luxembourg, in 1994. See Jean Back and Gabriel Bauret, eds., *The Family of Man: Témoignages et documents* (Luxembourg: Editions Artevents; Ministère des Affaires Culturelles, Centre National de l'Audiovisuel, 1994).

19. Several of these exhibitions, including the Clarence H. White retrospective, were organized by Peter C. Bunnell, who joined the staff as curator in 1966 and played a valuable role in the Department of Photography until he left in 1972 to accept a professorship in the history of photography that David H. McAlpin had endowed at Princeton University. With minor exceptions, the department had spoken with a single curatorial voice from its founding in 1940 until 1958, when Edward Steichen hired Grace M. Mayer as curator. Among Mayer's important contributions was the first installation of the photography collection galleries on the occasion of the expansion of the Museum in 1964. Ever since her arrival in 1958 the department's program has been a collaborative effort.

List of Illustrations to the Text

All works are in the collection of The Museum of Modern Art, New York.

Page 10: Darius Kinsey. *Self-Portrait.* 1914. Gelatin-silver print, printed by Jesse E. Ebert, 1962. 13⅛ x 10⅛" (33.3 x 26.2 cm). Purchase

Page 13: Edward Steichen. *Gertrude Käsebier.* c. 1907. Platinum print. 4⅜ x 5¼" (11 x 13.3 cm). Gift of Miss Mina Turner

Page 16: Edward Steichen. *Self-Portrait with Photographic Paraphernalia, New York.* 1929. Gelatin-silver print. 9½ x 6⅞" (24.2 x 17.5 cm). Gift of the photographer

Page 17: Berenice Abbott. *Portrait of the Author as a Young Woman.* c. 1930. Gelatin-silver print. 12⅞ x 10⅛" (32.6 x 25.7 cm). Gift of Frances Keech in honor of Monroe Wheeler

Page 18: Ralph Steiner. *Self-Portrait.* 1930. Gelatin-silver print. 9⁹⁄₁₆ x 7⅝" (24.2 x 19.3 cm). Gift of Samuel M. Kootz

Page 19: Helen Levitt. *Walker Evans, New York.* c. 1940. Gelatin-silver print, printed c. 1983. 9⅛ x 6⁵⁄₁₆" (23.1 x 16 cm). Gift of William H. Levitt

Page 20: Weegee (Arthur Fellig). *Self-Portrait.* c. 1940. Gelatin-silver print. 12⅝ x 9" (32 x 22.8 cm). Gift of the photographer

Page 21: Irving Penn. *Vogue Photographers.* 1946. Gelatin-silver print. 7½ x 9⅜" (19 x 23.7 cm). Gift of Monroe Wheeler

Page 22: Louis Faurer. Untitled (Robert and Mary Frank). c. 1948. Gelatin-silver print. 9¹⁄₁₆ x 13⁵⁄₁₆" (22.9 x 33.7 cm). Gift of the photographer

Page 23: O. Winston Link. *O. Winston Link and George Thom with Part of the Equipment Used in Making Night Scenes with Synchronized Flash.* 1956. Gelatin-silver print, printed 1976. 13½ x 10⅞" (34.2 x 27.5 cm). Purchase

Page 24: Lee Friedlander. *Self-Portrait.* 1965. Gelatin-silver print. 4⅜ x 6¹³⁄₁₆" (11.1 x 17.2 cm). The Ben Schultz Memorial Collection. Gift of the photographer

Page 29: Jay Leyda. *Alfred H. Barr, Jr., New York.* 1931–33. Gelatin-silver print. 4¾ x 3⅝" (12.1 x 9.2 cm). Gift of the photographer

Page 30: George Platt Lynes. *Lincoln Kirstein.* c. 1940. Gelatin-silver print. 9⁹⁄₁₆ x 7¾" (24.2 x 19.6 cm). Gift of Russell Lynes

Page 32: Willard Van Dyke. *Ansel Adams at 683 Brockhurst, San Francisco.* 1932. Gelatin-silver print. 9⁵⁄₁₆ x 7¼" (23.6 x 18.4 cm). Gift of the photographer

Page 33: Edward Weston. *Beaumont and Nancy Newhall, Point Lobos, California.* 1945. Gelatin-silver print. 7⁷⁄₁₆ x 9⁹⁄₁₆" (19.1 x 24.2 cm). Gift of Beaumont and Nancy Newhall

Page 35: Edward Weston. *David H. McAlpin.* 1941. Gelatin-silver print. 9½ x 7⁹⁄₁₆" (24.1 x 19.1 cm). Gift of David H. McAlpin

Page 37: Bruce Davidson. *Edward Steichen.* 1963. Gelatin-silver print. 13½ x 9⅛" (34.3 x 23.1 cm). Gift of the photographer

Page 39: André Kertész. *John Szarkowski.* 1963. Gelatin-silver print, printed 1994. 8⅜ x 6⅜" (24.4 x 16.2 cm). Gift of the Mission du Patrimoine Photographique, France (copyright Ministry of Culture, France)

A Nation of Pictures

LUC SANTE

The Americans did not invent photography, and perhaps this has always rankled just a bit. After all, the list of American discoveries during the nineteenth century is extraordinary: the carpet sweeper and the machine gun, the sleeping car and the harvester-thresher, the electric iron and the incandescent light, the phonograph and the safety razor, linotype and vulcanized rubber, to name just a few. For another thing, the United States, just twenty-four years old at the century's start, was busy inventing itself, and photography—discovered in France by Nicéphore Niépce and developed there by Louis Daguerre and independently in England by William Henry Fox Talbot—would prove to be an essential tool in that process of self-creation. But just as the national identity could compose itself from the synthesis of many nationalities, and just as the American language—based on English, itself a welding together of Latin and Germanic strains—would become an omnivorous and ever-expanding construct that could take in borrowings from virtually every language, so the art and science of photography were effortlessly adopted by the fledgling nation, which could almost persuade itself of its ownership.

For much of the nineteenth century the arts in America were an item of contention between, on the one hand, those self-consciously shadowed by European tradition and, on the other hand, those who set out to create a new agenda specific to their own surroundings and history. The former were long the more powerful and prestigious, at least in literature and music. In literature in particular the neglect of the genuinely new by contemporary American critics is well known. Edgar Allan Poe was for a long time more famous in France than at home; Herman Melville died in poverty and obscurity, and his works were not accorded much real attention or respect until the 1920s; the greater part of Emily Dickinson's corpus was not even published until midway through the twentieth century. (In music the battle is far from over even now, as the work of such major American composers of this century as Duke Ellington and Thelonious Monk continues to be relegated to the status of popular entertainment.) The visual arts enjoyed a somewhat different fate, for reasons that had a great deal to do with the relation of Americans to their own landscape. The scale of the American vista demanded representation in ways that had few antecedents in European painting, and those painters who could deliver the goods became popular in a fashion that cut across class lines, whether their subjects were the familiar valleys of the East Coast or the titanic panoramas of the far West. Frederic Edwin Church's massive canvas *Niagara* (1857; The Corcoran Gallery of Art, Washington, D.C.) is a famous but hardly unique example of a painting that could draw large crowds without sacrificing anything in the way of artistic integrity.

By the time photography was technically capable of taking in the grandeur of western landscapes its audience was already well prepared; but before this came an event that did much to establish the importance of photography in America: the Civil War. This astonishingly bloody struggle (nearly half a million dead on both sides between 1861 and 1865), which not

only divided the nation but divided states and counties and even families, was without question the defining experience of the century. It was also, as no war had been up to that time (with only the partial exception of the Crimean War), extensively documented by photographers, in particular by Mathew Brady and his associates, including Alexander Gardner and Timothy O'Sullivan. Their work altered forever the representation of war, virtually killing off the heroic ideal of military painting, and it brought the sickening news home to remote northern villages and isolated farmsteads, where it could not be denied in the name of patriotism or wishful thinking. Albums of war scenes were sold by subscription, establishing a market that would later be adapted to the sale of collections of photographs in the wake of major disasters, from the Johnstown (Pennsylvania) flood of 1889 to the San Francisco earthquake and fire of 1906.

After the war, western expansion resumed in earnest, and the United States government began its ambitious surveying expeditions of the uncharted territories between the Great Plains and the Pacific Coast, such as Clarence King's "Geological Exploration of the Fortieth Parallel" and Lieutenant George Wheeler's "Survey West of the One Hundredth Meridian," both of which employed O'Sullivan as official photographer, and Dr. Ferdinand Vandeveer Hayden's "Survey of the Territories," which hired photographer William Henry Jackson. Their photographs, as well as those of independent commercial operators such as Carleton Watkins, had a galvanizing effect on the American public, which had perhaps taken in such sights in the paintings of Albert Bierstadt but not quite believed they were real. It was a direct result of these pictures that a movement to preserve natural splendors detached itself from the general enterprise of exploitation; Jackson's photographs, for example, persuaded the government to declare the astonishing collection of topographical phenomena known as Yellowstone as the first national park, in 1872.

Another major development in the use of photography in the late nineteenth century took much longer to achieve fruition. On March 4, 1880, the *New York Daily Graphic* became the first newspaper to print a photograph in halftone. This picture, a view of a New York shantytown by Henry J. Newton, was perhaps crude by later standards in its reproduction, but nevertheless perfectly intelligible, although the time and expense then required by the process meant that twenty years would pass before newspaper use of photographs would become routine, during which time newspapers continued to rely upon wood engravings for illustration purposes. The work of the photographer Jacob Riis is the most striking example of the effects of this technological lapse. Beginning sometime in 1887, Riis, accompanied by the amateur photographers Richard Hoe Lawrence and Henry G. Piffard, started photographing the denatured-alcohol saloons and the verminous lodgings of the most desperate of the poor in New York City, mostly working in the middle of the night, employing a novelty: the magnesium-powder flash. Riis also wrote about what he saw, and his work was published first in the *New York Sun* and then in a series of books beginning with *How the Other Half Lives* (1890). He concurrently lectured on the subject of poverty and the slums, and his work had real, measurable effects, leading to the destruction of the worst rookeries and their replacement by settlement houses, schools, and parks. His photographs, however, were first seen by the public as bare approximations in the form of outline sketches, which gave nothing of the detail he was so brilliant at capturing: the material detail of dirt, crumbling masonry, and decaying mattresses, and the human detail of proud, beaten, innocent, or hardened faces belonging to the victims of social conditions. These crucial elements could be appreciated only by those who cared enough to buy his books or attend his lantern-slide lectures. Even after he had achieved prominence, the importance of his work as photography continued to be neglected. It was not

set right until the photographer Alexander Alland tracked down those of his plates that had survived, made new prints, and exhibited them in 1947 (see page 73).

Another radical turn in the history of photography occurred in 1888, with George Eastman's development of the box camera and the establishment of his Eastman Kodak Company. Suddenly photographs could be made by all. The apparatus was lightweight (twenty-two ounces), small, easy to use, and the problems of developing and printing were circumvented by the simple expedient of sending the entire machine to Eastman Kodak—as the advertisement went: "You press the button; We do the rest."[1] The camera went on the market early in the year, and by September 13,000 had been sold. Family photograph albums, formerly comprised of pages with die-cut windows for the insertion of cartes de visite or cabinet cards, now had pages of black uncoated stock with slits at angles to fit the corners of the cards that bore the distinctive round pictures of the early Kodaks.

Around the same time another development with far-reaching consequences was invisibly taking place. Thomas Alva Edison, not taking the matter too seriously, was working on the Kinetoscope, which he patented in 1891, a peep-show cabinet for the viewing of motion pictures. On a revolving convertible stage on the grounds of his West Orange, New Jersey, laboratories, he shot film of diverse subjects—clowns and lovers and Buffalo Bill—and in April 1894, the first parlor for the exhibition of these films opened on Broadway in New York City. The first screen show occurred two years later in a cabaret on Twenty-third Street and featured, among other things, film of crashing waves (which apparently caused a small panic among the innocent spectators, who could not quite convince themselves that the water was confined to the picture), of Kaiser Wilhelm reviewing his troops, of a dancer whose butterfly wings were hand-tinted on the film. Edison so scorned his invention that he did not bother to patent it in Europe, with the result that it was refined and developed by French and English experimenters.

By the mid-1890s, the westward propulsion that had driven the country for more than a century had all but ended. There was no longer any frontier to push toward. Oklahoma Territory, to which the Cherokees and many other Native American tribes from different parts of the country had been forcibly relocated, was opened to settlers of European stock in 1889, in disregard of treaties between the United States government and the Native American tribes. At noon on April 22, revolvers were fired, and some fifty thousand people raced to stake their claims; within twenty-four hours two million acres had been taken. The last major battle of the Indian Wars occurred the following year, at Wounded Knee, South Dakota, an uneven struggle that resulted in the deaths of about two hundred Native American men, women, and children. By the time Edward S. Curtis first undertook his massive twenty-volume documentary project *The North American Indian* in 1896 (not to be finished until 1930), the indigenous culture of his subjects was becoming a memory (page 60), and Curtis is known to have persuaded fully westernized Comanches and Sioux to don garments and headdresses they had not worn in many years for the benefit of his camera, and to have retouched his prints to excise such objects as clocks and lamps. Matters were slightly different in the Southwest, where peace-loving tribes such as the Hopi and Zuni lived relatively unmolested on desert tracts that white settlers did not much want anyway. The photographs of Adam Clark Vroman, for one, had an effect both as anthropological records and as documents of the Pueblo aesthetic (page 62), which was to have considerable impact on American modernism.

The 1890s were still a time of innocent fascination, when unfreighted beauty could be a subject for straight photography, as in Henry Hamilton Bennett's nearly lifelong study of the idyllic Wisconsin Dells (pages 58–59), and when ethnological description could be imbued

with both humanist concern and painterly delicacy, as in Arnold Genthe's photographs of Asians in Japan and in San Francisco's Chinatown (page 72). The relative naiveté of such approaches was not to remain viable much longer, however. Bennett's view of pristine nature was even then finding an answering descant in the work of Darius Kinsey, who was in the business of documenting the logging trade, not commenting on the defoliation of the American wilderness; nevertheless his pictures are the first systematic record of the exploitation of nature in the West (page 75). Likewise, Genthe's straightforward and respectful interest in types would soon be overtaken by changing attitudes. His contemporary Frances Benjamin Johnston, a feminist and a niece of President Grover Cleveland, produced in *The Hampton Album* a pioneering photographic plea for racial equality (page 67). Her serene, poised pictures of African-American students at Hampton Institute in Virginia, studying such subjects as the architecture of the English cathedral towns, formed a particularly understated document of social protest in a culture where lynchings continued for another half century and more.

The turn of the century, however imprecise a date, nevertheless stands as a sort of alchemical gateway past which life was transformed. On its far side stood the nascent modern world. The United States, having expelled Spain from Cuba, Puerto Rico, and the Philippines, was now a world power as well as a colonial power. In 1903 the treaty with Panama was signed that would allow the United States to build and own a canal through the isthmus, and that same year Orville and Wilbur Wright made their first successful flight in an airplane, at Kitty Hawk, North Carolina. One year earlier, in 1902, the Flatiron Building was completed in New York City, not the first edifice to be called a skyscraper but, with its exaggerated wedge shape, certainly the most striking. It quickly became a point of photographic reference, as it was shot in turn by Alfred Stieglitz (page 83), Edward Steichen, Alvin Langdon Coburn, much later by Berenice Abbott, and in between by hundreds of postcard and stereograph photographers and thousands of amateurs, all from virtually the same angle. The pictorialists were thus linked with the most rough-hewn of vernacular photographers in their mutual contemplation of a single icon. Even as the Photo-Secessionists entered a plea for photography to be considered an equal to painting in the oligarchy of the arts, and not a mere mechanic's profession, they stood to pay homage to that building, at once a work of art and of engineering. This could be said to be one of the formative episodes of modernism.

This does not, of course, diminish the great confections of Stieglitz, Steichen, Coburn, Gertrude Käsebier, Clarence H. White, and John G. Bullock, among others. Their work is not only beautiful in itself but represents one of the classic American course corrections. The American temperament, headstrong and hell-bent, has always tacked toward one bank and been forcibly redirected toward the other, veering at intervals between the raw and the cooked, the sacred and the profane, the high and the low. The Photo-Secessionist search for the sublime through the compromised means of a mechanical process parallels the dialectic between the Virgin and the Dynamo that the historian and critic Henry Adams found in the Gothic cathedrals and described in his *Mont Saint Michel and Chartres* (1904). Early modernism could be said to concern the search for the soul in the midst of the wind tunnel of progress; in any event it certainly did involve the enjambment of contradictions, which were beginning to multiply ferociously. Stieglitz in particular was a lightning rod of contradictions, both as photographer and as impresario; he could in his enthusiasms encompass both the ethereal loveliness of White's abstracted Ophelias and the upended urinal of Marcel Duchamp's *Fountain*, which he in fact photographed for the Dada journal *The Blind Man* in 1917.

Perhaps even more radical in his leaps was Edward Steichen, who might seem to have

reinvented himself in every decade, from Post-Impressionist, making landscapes that seem barely possible as products of a camera, to portraitist of glamour for fashionable magazines, to document maker for the United States Navy by the time of World War II. Paul Strand, in a different way, was able to embody the highest ideals of the pictorialists and to join them with a photographic tendency that Stieglitz otherwise seems to have scorned: social documentation. But Strand's depiction of the poor on the city streets is formal, disengaged, a bit chilly. These qualities are especially striking when his work is compared to that of Lewis W. Hine, a photographer with whom Strand studied but whose contemporary existence the other Photo-Secessionists do not appear to have registered. Hine's subjects are always returning the photographer's stare. Hine had taken up the mantle of Jacob Riis as the recording eye of the reform movement that was labeled, at first disparagingly, "muckraking." His photographs of young children working in mines and factories provided evidence of the widespread abuse of child labor laws, and generated an outrage that led to a protracted struggle for the passage of an enforceable national law, something that did not, however, occur until 1938.

Strand's photographs did not share this crusading mission, but they were frank about the actual look of the streets and the people who inhabited them, in this way perhaps demonstrating a common purpose with the painters of the so-called Ashcan school, otherwise known as The Eight. These painters, who included Robert Henri, George Luks, William Glackens, and John Sloan, were anti-academics who, while not terribly modernist in technique, sought their subjects in the alleys and saloons, among the lowlife and crowds of New York City. They were in their own way reaffirming the importance of depicting unmistakably American scenes, the old struggle revived once again, and they did not shy away from showing billboards, rubbish, newsstands, elevated trains, boxing matches, and other determinedly nonpicturesque matters. This Americanism did not, however, prevent them from participating in the Armory Show in 1913, the watershed of modernism in America, which brought to a large stateside audience for the first time the work of Picasso and Braque, and most provocatively, Duchamp's *Nude Descending a Staircase* (1912; Philadelphia Museum of Art). On the field of American taste, the battle of modernism was joined.

And yet a native antecedent was lying close at hand. In 1910 the young painters Charles Sheeler and Morton Schamberg began renting a stone farmhouse, built in 1768, in Doylestown, Pennsylvania. The house was plain and rectilinear in the most traditional American style, a style that achieved its look through the combination of practical necessity and Puritan self-denial. Not a trace of ornament found its way into or onto the house, nor on any of its furniture. Its stonework marked it as an example of the particular style that had grown up among the Quaker settlements along the lower Delaware River, but it shared many other traits with regional modes of construction of the seventeenth, eighteenth, and early nineteenth centuries throughout the northeastern United States. Within a few years of moving in Sheeler began to photograph the house's details (page 102), recognizing a strength of line shared with such modernist inspirations as machinery and African sculpture. Eventually he was to find the purest expression in the history of American design in the work of the Shakers, a millenarian sect that split off from the Quakers in England in the mid-eighteenth century but was fully realized in upstate New York under the direction of Mother Ann Lee beginning in 1774. The Shakers, who were celibate and communitarian, believed in achieving grace through simplicity and harmony of line; their buildings and furnishings look absolutely timeless. Sheeler's interest in this neglected American style coincided with the work of the Arts and Crafts movement, actually a complex of separate tendencies that arose simultaneously around the turn of the century in different parts

of the United States. These tendencies shared the influence of the English poet, designer, and theorist William Morris, who espoused a return to medieval craftsmanship as a reaction against industrialism. In America the movement's chief products included the clean, spare furniture of Gustav Stickley and the exquisitely printed if vacuous books of Elbert Hubbard. Today their ideology is virtually forgotten, but their strong designs remain influential. The sense of line and the search for an American form they shared with Sheeler exemplify the paradoxical link between modernism and antimodernism during the fertile period before World War I.

Sheeler's interests also seem to have been anticipated by the photographer and illustrator Clifton Johnson, about whom little is known (page 63). But then, many isolated artists and visionary eccentrics flourished at this time, inspired to action by the ease and availability of equipment and perhaps by stray bits of information about current tendencies blown by newspaper accounts across the countryside. The first two decades of the century saw an unprecedented mushrooming of amateur photographic activity in every corner of the country. While every town of any size had its camera club, whose members dutifully read *Wilson's Photographic Magazine*, and perhaps *Camera Work*, and produced exquisite and boring pictorial compositions based on the latest strictures emanating from New York, there were also numerous practitioners whose ambitions were plainer and more naive, and whose work in many cases appears the stronger today. A change in postal regulations in 1905 led to a boom in the production of photographic postcards that lasted until about 1918. Amateurs and professionals alike turned these out, the latter in part benefiting from the yet undeveloped state of halftone reproduction in newspapers, and thus documenting fires, floods, tornadoes, barn raisings, train wrecks, store openings, county fairs, hail storms, parades, and the incursion by the United States Army into Mexico between 1912 and 1916, in editions that ranged from several dozen to several thousand. (One of these professionals was the young Edward Weston, who began his career in 1906–07 as a door-to-door postcard photographer in Tropico, California.) Amateurs, too, made pictures of friends, family, landscapes, and houses with a straightforwardness that did not look like a style then but often does to latter-day eyes. The extraordinary embellishments of Charles Norman Sladen in his album of holiday photographs (page 77) represent one particular extreme of this amateur aesthetic, although a surprising number of Americans possess albums taken by their fathers or grandfathers circa 1912 that seem not much less self-conscious in their formalism. It was a time when the medium not only appeared available to all, but when the rules of snapshot-making remained unwritten, encouraging experimentation.

Another singular artist of the period was Ernest J. Bellocq, whose work was generally unknown until its discovery by Lee Friedlander in the 1960s. Bellocq was sort of a Toulouse-Lautrec of the New Orleans red-light district known as Storyville, the largest such in the country until its suppression in 1917, following an order by the United States secretary of war prohibiting open prostitution within five miles of an army camp and a similar ruling by the secretary of the navy. Bellocq's portraits of whores are eloquent and grave (page 71), and if anything show the sadness of the women, quite distinct from what is often written about the neighborhood, which was also, beginning in the mid-1890s, the birthplace of modern jazz, the place where Louis Armstrong, Jelly Roll Morton, Sidney Bechet, and their older mentors, including Buddy Bolden and Freddy Keppard, first played in cabarets and whorehouse parlors. Storyville was also racially integrated, as during the period was much of New Orleans, an exhilarating setting no doubt, for all but the inmates of the *soi-disant* houses of joy. These latter were released into scullery work as a consequence of World War I, which also had such effects upon the American public, directly or not, as the prohibition of alcoholic beverages, the crackdown

upon and deportation of subversive elements, and the ending of the carefree, venturesome period that had preceded it. A new spirit of conformity was in the air, an apt illustration of which is Arthur S. Mole and John D. Thomas's *The Human U.S. Shield* (page 79), one of many such photographic demonstrations of esprit de corps during that time.

In 1925 President Calvin Coolidge announced: "The business of America is business,"[2] and so it was, although it could take such diverse forms as bootlegging, public relations, mail-order chicanery, moviemaking, tent-show revival preaching, and grinding factory labor. The photographs of the 1920s, for all their dissimilarity in other respects, share an iconic quality, perhaps in part because everyone was searching for some kind of consolidation and in part because everyone had been affected by the rise of the print media, in the form of magazines and illustrated newspapers, to the extent of searching for a clear, swift, visual shorthand. *The New York Daily News* was launched in 1919, the first of the tabloids, small-format populist newspapers that emphasized visual punch over textual content and even coherence; this was labeled "jazz journalism." A year later Condé Nast inaugurated *Vanity Fair*, a magazine that could retail Hollywood, high fashion, and James Joyce all in the same breath. Steichen's portrait of Gloria Swanson (page 125) ran in its pages, as well as his indelible images of Greta Garbo, and Nickolas Muray's image of possibly the most famous baseball player of all time, Babe Ruth (page 124). In retrospect, Lewis Hine's *Steamfitter* would not have seemed out of place there either (page 129). Unlike his earlier pictures of child laborers and immigrants at Ellis Island, this is not an angry or anguished image but one almost imbued with glamour, as were, in the following decade, his shots of workers constructing the upper stories of the Empire State Building, which can look like an aerial ballet. His view that labor is not merely dignified but heroic and beautiful anticipates themes that occupied Soviet photographers a bit later in the decade. In the same way, Paul Outerbridge's *Ide Collar* of 1922 (page 122), made for an advertisement, could slide effortlessly into any line-up of images produced by the Bauhaus-influenced German photographers a few years later. The excitement of dynamism, force, and speed now can clearly be seen as having spanned the ideological spectrum, uniting the tools of capitalism and their opponents in a delirium of modernity for a brief while before the worldwide economic collapse of 1929.

These disparate manifestations also, of course, reflected the lessons of Cubism, absorbed by many, if unconsciously, by 1921. Cubism, ridiculed by critics for a few years following the Armory Show of 1913, had found its American voice, not only in the paintings of Joseph Stella and Marsden Hartley but in a wide range of less obvious places, from George Herriman's comic strip *Krazy Kat* and its slapstick mysticism set in the Arizona desert to the frantic polyphony of New Orleans jazz to the stop-and-go rhythms of Charlie Chaplin's silent comedies. Gilbert Seldes's influential polemic *The Seven Lively Arts* (1924) swept all these things, along with vaudeville and burlesque, into a single breathless phenomenon, and closed by linking it all to the work of Picasso. The book has not aged well, but its insights were prescient. Numerous American artists came to a similar conclusion: that the slashing geometry and simultaneity and jarring juxtaposition European artists had to work for were already effortlessly present in the lights of Broadway and the steel mills of Pennsylvania and even in the small-town Main Street, which seemed to exist in several eras at once.

Many Americans had to go abroad to be able to see their country in its freshest light, free from the distraction of its poltroons and reactionaries, its Ku Klux Klan, Elks Club, and American Legion, its Bible-thumpers who in 1923 put a man on trial in Tennessee for the crime of having taught the theory of evolution to a high-school class. The photographers Edward

Weston and Tina Modotti went to Mexico in 1921 perhaps in search of adventure and romance but also to learn how to look at things (pages 107–109), the way Ernest Hemingway, F. Scott Fitzgerald, and Gertrude Stein went to France, T. S. Eliot to England, and Ezra Pound to Italy. Weston came back to California before the end of the decade with a new ambition to record the objects and landscapes around him with a clear eye. Similarly, the first fruit of Hemingway's life in France was the purified vision of American life he expressed in *In Our Time* (1925). The year 1925, in fact, saw a great outpouring of literary works that went to the heart of the American experience: John Dos Passos's *Manhattan Transfer* made a huge cubist canvas of newspaper headlines, radio voices, and small dramas on the street; Fitzgerald's *The Great Gatsby* eulogized the myth of success; William Carlos Williams's *In the American Grain* reimagined American history as a vast collage; Gertrude Stein's *The Making of Americans* broke a family history up into a million tiny pieces. This new vision was enthusiastic but also dry and undeceived. Thus it was that when Stieglitz called his last gallery An American Place in 1930, the name could be free of any hint of jingoism but full of the critical spirit that reclaimed the nation from its Babbitts.

By that time, American photographers had begun to look at their surroundings in a larger way that served popular culture up in its entirety, not just as fragments. If Weston's *Torso of Neil* and Strand's *Akeley Motion Picture Camera* (pages 106 and 112) could in their purity have been taken, at least in theory, in Iceland or Australia, the same could not be said for the work of Ralph Steiner, or of Walker Evans and Berenice Abbott, fresh from Paris and the lessons of Eugène Atget. Even Sheeler in his love of native American construction and strength of line would have stopped short of depicting the chewing-tobacco advertisement on the side of the barn. Paul Strand might have done so; he showed billboards in his Truckman's House series of 1920, but as formal details, not as the main subject. Steiner, on the other hand, made an enormous Camel cigarettes advertisement the center of a picture as early as 1923. What was happening, in part, was the phenomenon described and for that matter advocated by Gilbert Seldes: the blurring of the line of demarcation between high and low culture. It could, of course, be said that this process has long been underway in America, that it was simply a matter of people being slow to recognize it. Could Herriman's *Krazy Kat* even be considered popular culture? It was a comic strip, it ran in a daily newspaper, and its characters were anthropomorphized cats and mice and dogs and geese; but, on the other hand, it was anything but obvious in its meaning, more of a continuing Zen parable, and its mass popularity was so wanting that it remained in the pages of newspapers for decades only because William Randolph Hearst himself was a fan.

The movies were what raised the stakes. Almost immediately upon their introduction in the 1890s the movies were considered not merely silly but actively disreputable. For years theaters were concentrated in poor neighborhoods, and, even if producers tried to raise their tone by featuring inert tableaux starring the likes of Sarah Bernhardt, the public vastly preferred simple telegraphic slapstick. D. W. Griffith, after making hundreds of two-reelers in every genre, managed to achieve respectability with his epics *The Birth of a Nation* (1915) and *Intolerance* (1916), even if the former now looks racist and the latter terribly windy. Griffith's struggle, for all the virtues of his films, was at least in his mind being enacted on the field of theater, literature, and painting. Meanwhile Charles Chaplin was starting to make real art in his deceptively simple comedies, which assumed no formal antecedents but took the moviemaking process as a given. The mass audience understood him perfectly, having been faster than the critics at absorbing the cinematic vocabulary of cuts and pans and wipes and zooms, the innately modern aesthetic of fragmentation and collage. The 1920s saw an efflorescence of brilliance in

the movies, made and appreciated by people who had grown up with the medium and did not need to make excuses for it. By the second half of the 1920s there were few people left who could dismiss the movies as brainless trash. Indeed, the movies of the period include some of the most sublime ever made: Erich von Stroheim's *Greed* (1924), Chaplin's *The Gold Rush* (1925), Buster Keaton's *The General* (1927), King Vidor's *The Crowd* (1928), and F. W. Murnau's *Sunrise* (1927). The movies were becoming almost too artistic for their own good; the critic John Grierson remarked, after seeing an early film by Josef von Sternberg: "When a director dies, he becomes a photographer."[3] Just in time, though, the movies were restored to vulgarity by the introduction of sound, as of 1928.

A year later, the stock market crashed, with worldwide repercussions. Suddenly people who had been attending the opera and decorating their homes with Viennese bibelots were reduced to reading *Spicy Stories* and visiting burlesque houses when they could scrape together twenty-five cents. The pretensions of a good part of the nation were leveled by circumstances. It now became not only possible but necessary for modernists to look down from the wonderfully detailed setbacks of skyscrapers and see the quick-lunch stands that tenanted the ground floors. The demotic was now not just haphazardly beautiful in bits and pieces but exhilarating in its total effect. Other forces were at work as well. Around 1927 and 1928 recording companies started taking an interest in the native music of the American people, finally making commercially available the blues and hillbilly songs that had been around for decades, or even centuries, for the first time in the thirty-year history of recorded sound. It also became apparent in the midst of sweeping change that progress was a two-way street, that as dynamic new things were being made and built, not just outmoded junk but eloquent expressions of premodern sensibility were being ruthlessly swept away.

Abbott had carried this latter point back to New York from her exposure to Atget's great photographic project describing France in the early twentieth century, and she set about documenting the city in transition with a zeal that encompassed construction and demolition, skyscrapers and slums, window displays and boarded-up storefronts (page 143). Evans had learned how to see not only from the Cubists but from the vernacular photography that was being made in his youth. The two influences gave him an outlook that could take in the most heterogeneous subjects, and the confidence—with possibly also an inherited Yankee plainness—to register them in head-on, unmitigated fashion. His first published work was apparently *Brooklyn Bridge* (page 135), which appeared as the frontispiece to the first edition of Hart Crane's great poem "The Bridge" (1930). He made his most famous work, however, between 1935 and 1938 as an employee of the Farm Security Administration.

Upon being elected president in 1932, Franklin D. Roosevelt was faced with the worst of the delayed effects of the Great Depression. The morning of his inauguration, March 4, 1933, was coincidentally an enforced national bank holiday; the system was close to breaking down altogether. Roosevelt took control of Congress and within three months had forced the passage of fifteen new laws, which established an unprecedented network of government agencies, often referred to as "alphabet soup." Among these were the Federal Insurance Deposit Administration (FIDA), which insured bank deposits; the Federal Housing Authority (FHA), which stopped foreclosures on homes; the Tennessee Valley Authority (TVA), which built dams and generated hydroelectric power in the neglected Tennessee valley; the National Recovery Act (NRA), which regulated prices and wages; the Civilian Conservation Corps (CCC), which put two and a half million unemployed men to work at conservation and reforestation; the Public Works Administration (PWA), which built government structures from dams and ports to zoos and

swimming pools; the Works Progress Administration (WPA), which employed artists, writers, theater people, and composers; and the Farm Security Administration (FSA), which supported crop prices, assisted farmers with equipment, feed, and seed, and, if all else was unavailing, helped resettle farm families. Secretary of Agriculture Rexford Tugwell, who oversaw the FSA, instituted an historical unit to provide documentation of conditions in the rural United States. Under the supervision of Roy Stryker, photographers such as Evans, Dorothea Lange, Ben Shahn, Arthur Rothstein, Russell Lee, Carl Mydans, and Marion Post Wolcott, among others, were given lists of suggested topics (which many of them ignored). Their total output, at least as it currently stands in the FSA archive in the Library of Congress, comes to some 75,000 prints.

The program seems to have been constantly subject to the volatile mix of temperaments of those involved. Evans was finally fired, and Lange was fired and reinstated several times. All of them traveled a great deal: Lange mostly concentrated on California and Arizona, but she also worked in Georgia, the Carolinas, and Mississippi, while Evans covered most of the South, with particular emphasis on Alabama. While Lange purposely pointed her pictures toward a moral conclusion, Evans was deliberately nonjudgmental and avoided anything that smacked of didacticism. Some of Evans's Alabama pictures from the summer of 1936 had an additional purpose. He and the writer James Agee had been commissioned by *Fortune* magazine to do a series of articles on the daily lives of tenant farmers in the South. For about six weeks they lived with the families of Floyd Burroughs, Frank Tengle, and Bud Fields. Their work was rejected by *Fortune*, a lavishly produced periodical devoted to financial matters that was later to hire Evans as an associate editor, but an expanded version was published, in 1941, as the book *Let Us Now Praise Famous Men*. The volume began with sixty-one uncaptioned pages of Evans's photographs, followed by some four hundred pages of Agee's prose, somber, exhaustive, impassioned, and Biblical in its rhythms. It sold only about six hundred copies in its first year of publication, but a decade later was considered a classic work of American literature.

Fortune was published by Henry R. Luce, the publisher of *Time* magazine, who in 1936 launched *Life*, a picture magazine that may have owed something to such foreign predecessors as the *Münchner Illustrierte Presse* and *The Illustrated London News*, but in its large budget, relentless optimism, and corporate identity represented something very new and very American. Its tone is fairly well caught by a superior example of the photographic work it published, Margaret Bourke-White's *At the Time of the Louisville Flood* (page 149), a picture whose aphoristic terseness, hortatory power, and easy irony are utterly indivisible from one another. *Life* specialized in the kind of pictures that are used to sum up entire eras and mores in potted histories, such as the numerous summary picture books published by Time, Inc. After the war, it was fortunate enough to enlist the services of W. Eugene Smith, a passionate moralist whose photojournalistic method required absolute commitment to his subjects (pages 196 and 200). A very different form of photojournalism was practiced by Weegee (Arthur Fellig), which might be considered the highest example of the tabloid style. In Weegee's hands this cynicism is so extreme it almost becomes a kind of innocence, the visual equivalent of the verbal styles of the New York tough guys played by James Cagney and sentimentalized in the stories of Damon Runyon (pages 166 and 167).

With the rise of fascism in Europe a new wave of immigration occurred, consisting primarily of Jewish, leftist, and free-thinking artists and intellectuals. Among the photographers who were part of this influx were the Austrian-born Lisette Model (page 161) and the German-born John Gutmann, whose photographic vocation was actually a consequence of his decision to leave Europe—it was a means for him to earn a living abroad (page 160). These emigrés

inevitably brought with them a sensibility honed by the prevailing winds of the Weimar era, as well as the surprise of encountering the oversized popular culture and landscape of the United States. Emigrés in general promptly got busy in America, founding The New School for Social Research in New York and the Chicago Institute of Design (originally the New Bauhaus); revitalizing the faculties of such institutions as the University of Chicago and the physics department at Princeton University; and making earnest if often stymied attempts to broaden the output of the Hollywood movie studios (if the movies defeated Bertolt Brecht and Arnold Schönberg, they were mastered by more flexible temperaments, such as those of Fritz Lang and Billy Wilder). Another major export, as of the early 1940s, was Surrealism. André Breton settled in New York, and Marcel Duchamp returned there; Max Ernst found his way to New Mexico and Yves Tanguy to Connecticut. Among their more visible manifestations were the shows at the Julien Levy Gallery in New York and the magazines *View* and *VVV*, which began a sort of dialogue between the French luminaries and their American counterparts, whose best work was, as in the boxes of Joseph Cornell and the photographs of Clarence John Laughlin, an indigenous American parallel rather than a mere following of orders (pages 175 and 179). The work of George Platt Lynes, too, has its Surrealist aspect, although issuing from the context of New York's dance and theater world (pages 164 and 174) and therefore reflecting the influence of the critical impresario Lincoln Kirstein, who had earlier and in a different way guided the young Walker Evans. The Italian-born Frederick Sommer, meanwhile, met Ernst in the Southwest and found his own version of Surrealism in the bleached detritus of the desert (pages 176 and 177).

This was a long way from the vision of the West nurtured and propounded by Ansel Adams over the course of his nearly sixty-year career (pages 117, 120, 121, and 186). Adams's name is probably known to more Americans than that of any other photographer, and he achieved genuine widespread affection, the populist equivalent of national-treasure status, of a sort that Americans rarely accord to fine artists. Adams's epic photographs of the West evoke the virgin continent in a credible way and inspire awe while avoiding sentimentality. They present landscapes as unaltered as those in the pictures of O'Sullivan and Jackson, although even as they were being taken these landscapes were being hemmed in, domesticated, invaded by tourists, loggers, and mining concerns. Adams, born in San Francisco in 1902, had begun photographing in Yosemite at the age of fourteen, so he came about his vision honestly. After him landscape photographers would either have to work in smaller scales, as is true of Paul Caponigro and to a certain extent Minor White, for example, or, as in the current school pioneered by Robert Adams, would perforce have to present a vitiated terrain, strip-mined and dotted with tract houses.

The new prosperity of the country after the war also broadened the readership of the fashion magazines. *Harper's Bazaar* and the American edition of *Vogue*, formerly in thrall to Paris and read generally only by the rich and by people in the trades, began striking off in new directions under the guidance of such adventurous editors as Diana Vreeland and Carmel Snow, as well as Condé Nast's art director of many years, Alexander Liberman, himself a modernist sculptor born in Russia and trained in Paris. Among their decisive hirings were Irving Penn and Richard Avedon, both of whom studied design under the vastly influential photographer Alexey Brodovitch (later art director for *Harper's Bazaar*). The coincidence of Penn's and Avedon's parallel careers has led to their frequently being lumped together, an unfortunate tendency which masks their very individual approaches. It might be said in the roughest way, for example, that where Avedon in his fashion work was sunlit and expansive, Penn was concentrated and smokey.

In any event, they established themselves in polar positions, which determined the field within which fashion photography would develop through the 1950s and 1960s.

The popular impression of the 1950s, based on the imagery of the period, as retailed by such pictorial magazines of the era as *Collier's* and *The Saturday Evening Post* as well as by television, is of a safe, dull period, kept quiet by either repression or contentment. The photography of the postwar era, however, acts as a corrective to this cliché, beginning with Ted Croner's speeding car, taken at the tail end of the 1940s, an appropriately ambiguous icon (page 218). The large American automobile, the country's preeminent synecdoche of ease and success, is here transformed into a spectral blur that calls up death's skeletal horse. Similarly at odds with received ideas of how life was lived are, for example, Dan Weiner's frantic suburbanites and Bruce Davidson's ghostly teenagers, as are, in a different way, Leon Levinstein's African-American family and Roy DeCarava's children, taken at a time when American blacks were represented even in the liberal press mostly as symbols or as the focus of controversies. Where we can see the mythic 1950s is in O. Winston Link's *Hot Shot East Bound at Iager, West Virginia*, a photograph which—in its deliberately theatrical lighting and its stripped-in movie-screen image—is a thoroughgoing confection (page 232). Its aura of simultaneous expectation and nostalgia marks it as a kind of apotheosis of the decade's wish imagery.

All of which partly accounts for the reception accorded Robert Frank's *The Americans*—the seminal photography book of the decade—upon its publication in the United States in 1959. Frank, who came to the United States from Switzerland in 1947, traveled through the country in 1955 and 1956, his odyssey funded by a Guggenheim Foundation Fellowship. (These grants had been a major source of financial support for photographers since Weston became the first practitioner to receive one in 1937, and so they continue to be today.) He took pictures in all parts of the nation, of diverse subjects, including citizens from all walks of life. There was poverty in his pictures but also wealth, degradation and dignity, loneliness and conviviality, youth and age, black and white, respectability and its opposite. When it came out it was pilloried. Photography magazines, among others, published reviews that spoke of "a warped objectivity," claimed that it was "marred by spite, bitterness, and narrow prejudice," called it "a sad poem for sick people."[4] There were formal reasons for this vitriol: no image was sharp and rounded, nothing about them was fixed or definite, and everything was provisional, indeterminate. There was no question of a decisive moment; these were the moments in between. But surely the reaction owed part of its particular force to the fact that the images were nearly all of that nameless thing in the weeds behind the billboard of American life. Even the images that spoke of prosperity, ceremony, and families caught those qualities at uncomposed instants. The book was not an attack, but it refused to be comforting. Somehow, in the hour of its greatest strength, the American nation badly needed reassurance.

The book, of course, became not only a classic but a touchstone. The introduction of the American edition was written by Jack Kerouac (it was first published in France, with a lengthy introductory text assembled by the poet Alain Bosquet). It was not Kerouac's finest piece of writing, maybe, but it agreed with the reviewer at least in calling the book a poem, and as such allied with the pursuit of real freedom, truth, and spirituality that engaged the Beats. Frank's later collaboration with the Beats included the antic 1960 film *Pull My Daisy*, which feels, at least, like one of the most spontaneous movies ever made. In spite of the fact that the 1950s saw a flowering of independent and avant-garde film in America, few photographers, perhaps surprisingly, were involved. The slim tradition of movies by photographers in the United States begins with Sheeler and Strand's extraordinary but little-shown *Manhatta* (1921), a panoramic

documentary of New York City with text from Walt Whitman's poems. Ralph Steiner shot Pare Lorentz's FSA documentary *The Plow That Broke the Plains* (1936) with Strand and made *H₂O* (1929) and *Pie in the Sky* (1934), the latter in collaboration with the young Elia Kazan. Helen Levitt, with Janice Loeb and James Agee, made *In the Street* (1952), which successfully extends the premises of her still photographs into motion-picture form, and Rudy Burckhardt's various documentary shorts, beginning in the late 1940s, likewise are of a piece with his photographs (pages 154 and 155). In 1948 Weegee produced *Weegee's New York*, an odd movie of two unequal halves, the first an entertainingly goofy voyeuristic look at Coney Island and the second a profoundly boring patchwork of nighttime shots of the city through assorted filters and distorting lenses. The sole photographer of note to have made the transition to commercial cinema is Gordon Parks. After more than two decades on the staff of *Life* magazine, Parks directed the film version of his children's book *The Learning Tree* (1968), and then went on to write and direct *Shaft* and *Shaft's Big Score* (1971 and 1972).

A new skepticism crept into the American picture between the late 1950s and the early 1960s. A generational change was taking place, and among other things young people had been saturated with photographic images. Television was by then universal in the United States, and the first generation to have grown up with it was also the first to reject its dubious authority. The period also brought with it too much information and a surfeit of events. It might seem in retrospect as if little happened in the earlier part of the 1950s; even the Korean War seemed to evanesce, at least in the eyes of those who were not conscripted. The thunder began to gather in the distance, with the squashed liberation movement in Hungary in 1956, and then the Suez Canal crisis in 1957, and finally the launch of the first Sputnik, which awoke a complex of fears in America. After the inauguration of John F. Kennedy as president in 1961 the rush of events was headlong. The civil rights movement, which had been gathering strength since the enforced integration of the all-white Central High School in Little Rock, Arkansas, in 1957, achieved momentum under the leadership of Reverend Martin Luther King, Jr. Marches, sit-ins, and voter-registration campaigns were conducted, often with violent interference by police and white mobs, throughout the South but with particular intensity in Alabama and Mississippi. The aborted invasion of Cuba by American-backed exiles in 1961 was followed by a close brush with war after a build-up of Soviet missiles on the island was discovered late in 1962. The United States space program began in earnest with its first manned flight in 1961. The Vietnam War started almost invisibly, as American advisors were first given permission to respond to fire with fire in 1962 and then large numbers of troops were sent from the United States in 1963. On November 22 of that year Kennedy was assassinated in Dallas.

While all this was going on, American culture was undergoing a crisis of its own. Hollywood, which had flourished artistically during the 1950s even as its demise was broadly predicted as a result of the rise of television, issuing such spectacular if often unlikely films as Nicholas Ray's *Johnny Guitar* and *Rebel Without a Cause*, Orson Welles's *Touch of Evil*, Billy Wilder's *Some Like It Hot*, and Alfred Hitchcock's *North by Northwest*, saw in the new decade with Hitchcock's traumatic *Psycho* and then seemed to roll over and expire. Popular music was inert, and even jazz was undergoing an uneasy period of transition. Not much was occurring in literature, with the single if impressive exception of Thomas Pynchon's strange and daunting novel *V*. The one real area of concentrated activity was visual art. In 1962 the mass audience woke up to Pop art, which it both understood and did not. The work of Claes Oldenburg, Andy Warhol, Roy Lichtenstein, James Rosenquist, and their contemporaries Robert Rauschenberg and Jasper Johns was able to appall the bourgeoisie, perhaps the last time this reactive body was

taken unawares and cared enough to show its confusion. Pop art, among its other achievements, fed back to American culture its own vacuity in altered form, making its emptiest images both exhilarating and deadly.

This was a strong strategy not all that distant from Robert Frank's, and by then younger photographers could understand the connection. Garry Winogrand's street scenes, zoo crowds, and jagged two-shots, which had been building over the last half of the previous decade, made perfect sense as portraits of the shell-shocked and anomic society, wandering through public structures with no clear destination (pages 227 and 245). Lee Friedlander's implacable shadow attempted to prove its own existence, and his oddly silent urban landscapes seemed like pictures of an abandoned country (page 242). Diane Arbus, meanwhile, took portraits of the last humans. Her people were the ones August Sander, at the end of his exhaustive typology of humanity, could not have foreseen or imagined. They were the final, conclusive products of the twentieth century, inheritors of progress, war, commerce, mass culture, and all the rest of it. If they had never been seen before, it was maybe because they hadn't existed (page 237).

If there was anything at all outside this purview, it was to be found in the rapidly shrinking and gravely imperiled wilderness. The best-selling nonfiction book of 1962 was Rachel Carson's *Silent Spring*, which was the first loud warning of the danger the earth faced to be heard in America, and that same year Eliot Porter's *In Wilderness Is the Preservation of the World* became one of the largest-selling books of photographs in the nation's history. It took many years for either of them to have a noticeable effect, and yet they could hardly be said to be ahead of their time, since the despoilment and pollution of the environment was already then in an advanced state. Maybe it was simply that each canceled out the other or that the consumers who paid their money believed in that action as a magical rite that would fix everything.

It might seem that twentieth-century America was invented by its photographers, that each shot was not so much a record as a prediction, or an enactment. It is hard to imagine the century's history without these photographs, even if their direct relationship to history—wars, droughts, inventions, and fads—is not always obvious. The United States has made itself up of images, and it has a stock of photographic icons that it will replay when it feels uncertain of its own identity. The raising of the flag on Iwo Jima, Marilyn Monroe holding her skirt down as the rising steam attempts to blow it upward, Neil Armstrong walking on the moon, Dorothea Lange's migrant mother—these are totems of the American nation. The history they recorded has now entered these photographs, where it hangs suspended. The course of photography in the United States has at least in the twentieth century engaged in a relationship with this civic religion that has alternated constantly among acceptance, denial, challenge, and disregard. The nation has gradually learned to respond by absorbing all photographic images, granting them equal citizenship. Photography, by nature the most democratic art, has no choice but to accept.

Notes

1. Quoted in John Szarkowski, *Photography Until Now* (New York: The Museum of Modern Art, 1989), p. 144.

2. Quoted in *Webster's American Biographies* (Springfield, Mass.: Merriam-Webster, 1984), p. 221.

3. Quoted in Andrew Sarris, *The Films of Josef von Sternberg* (New York: The Museum of Modern Art, 1966), p. 13.

4. Quoted in John Szarkowski, *Mirrors and Windows: American Photography Since 1960* (New York: The Museum of Modern Art, 1978), p. 19.

William B. Post. *Aspens.* c. 1905

Henry Hamilton Bennett. *Panorama from the Overhanging Cliff, Wisconsin Dells.* 1897–98

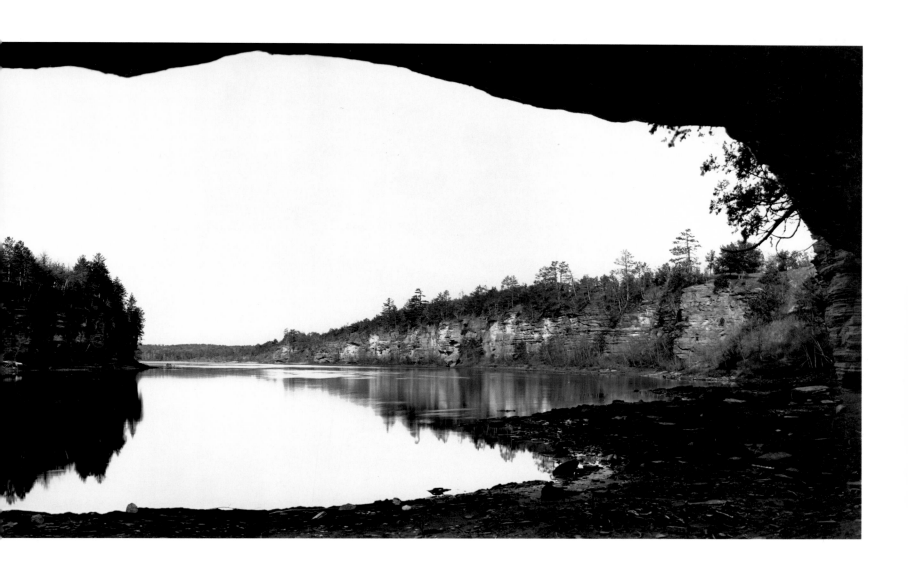

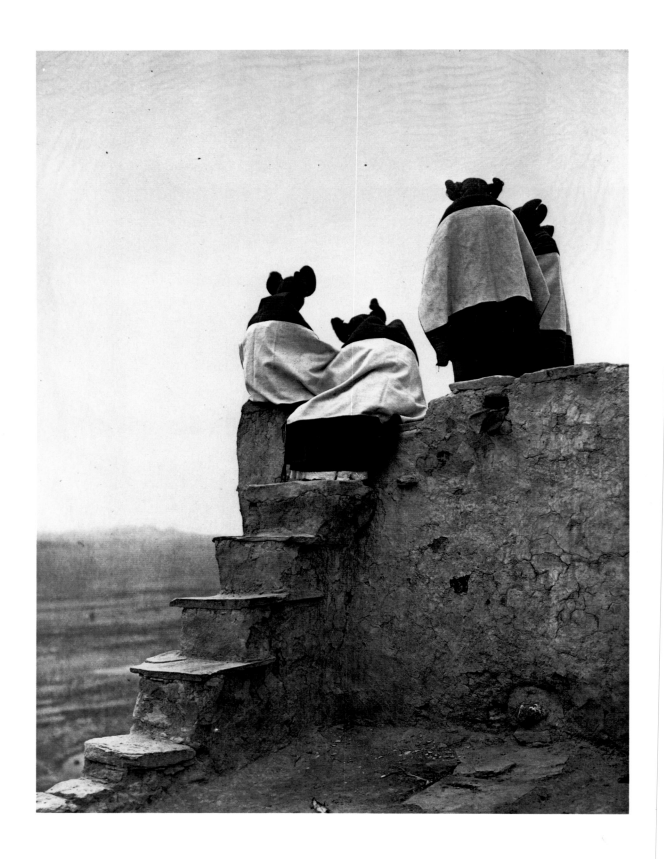

Edward S. Curtis. *Watching the Dancers — Hopi.* 1906

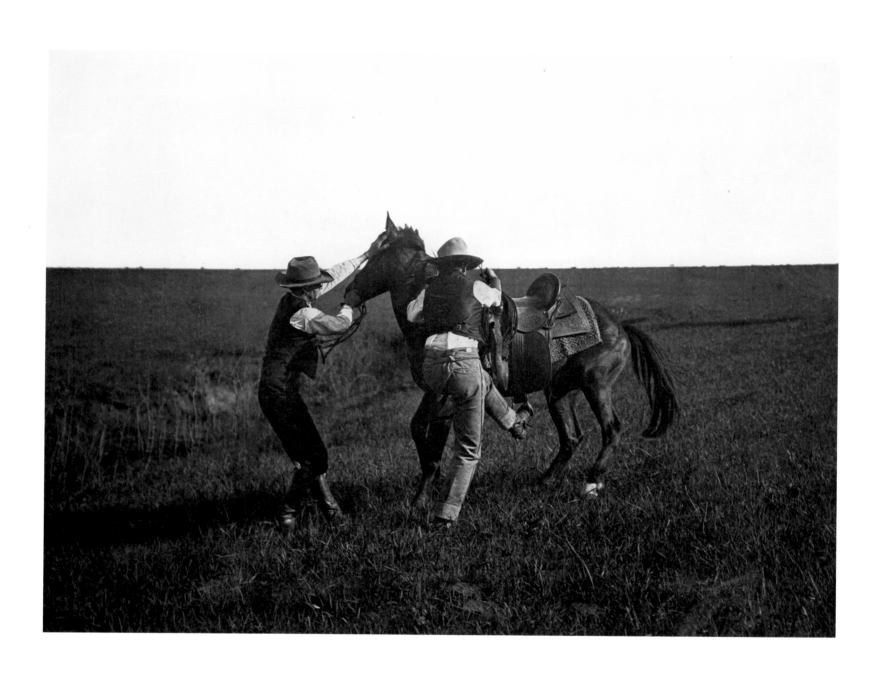

Erwin E. Smith. *Mounting a Bronc.* c. 1910

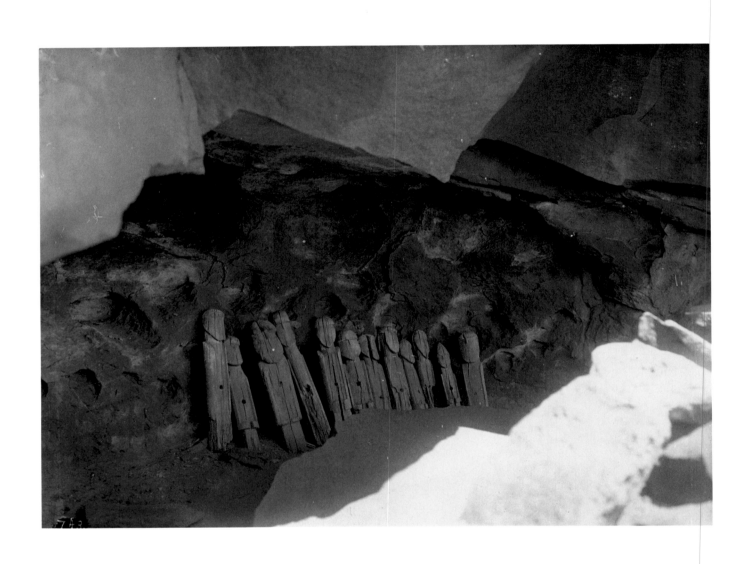

Adam Clark Vroman. *"Pueblo of Zuni" (Sacred Shrine of Taäyallona)*. 1899

Clifton Johnson. *Barred Door, Rocky Hill Meeting House.* c. 1910

William H. Rau. *Picturesque Susquehanna Near Laceyville.* 1891–92

Henry Hamilton Bennett. *Layton Art Gallery, Milwaukee, Wisconsin.* c. 1890

Edwin Hale Lincoln. *Thistle*. 1893–1907

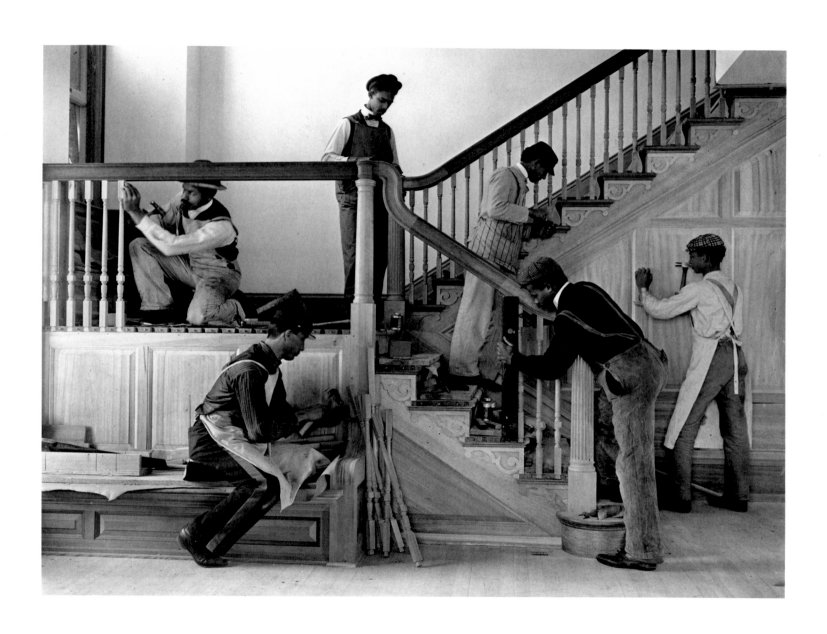

Frances Benjamin Johnston. *Stairway of Treasurer's Residence, Students at Work, The Hampton Institute, Hampton, Virginia.* 1899–1900

L. S. Glover. *In the Heart of the Copper Country, Calumet, Michigan.* 1905

Charles H. Currier. *Kitchen in the Vicinity of Boston, Massachusetts.* c. 1900

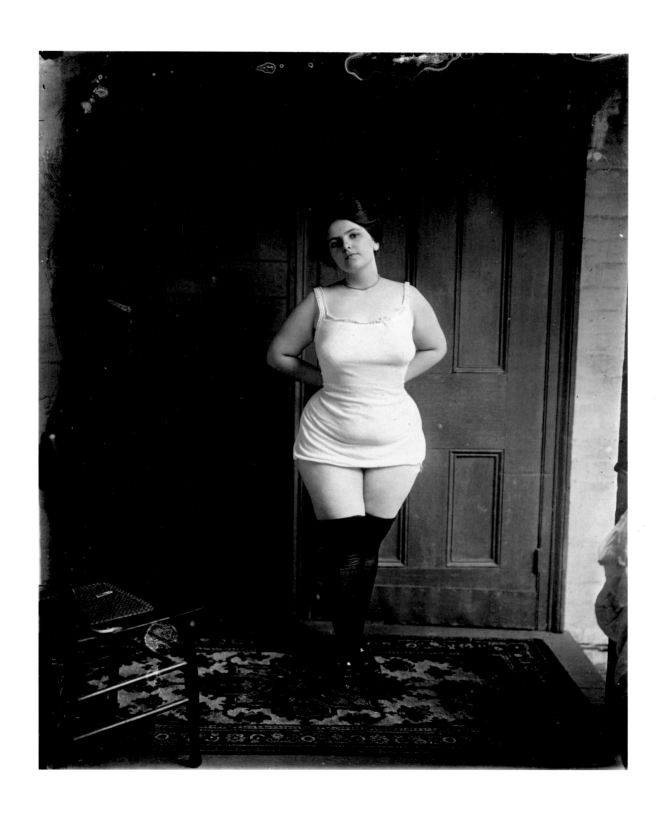

Ernest J. Bellocq. Untitled. c. 1912

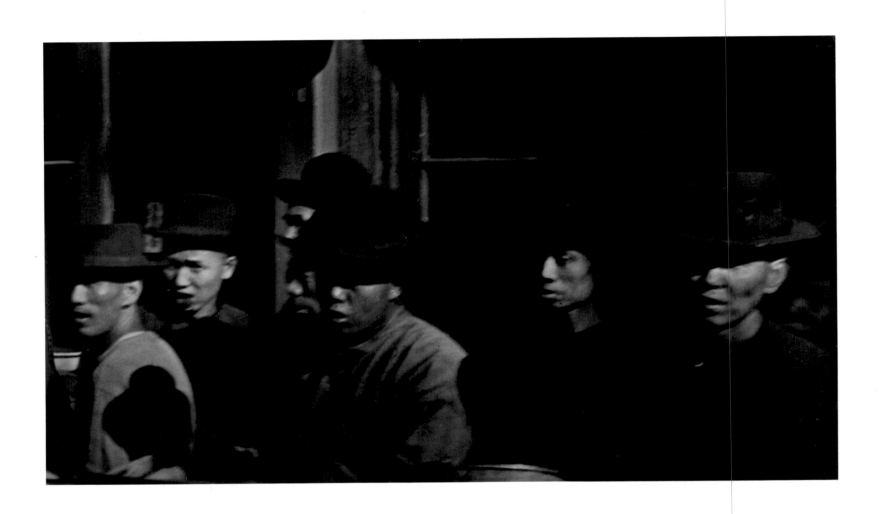

Arnold Genthe. *Chinatown, San Francisco*. 1896–1906

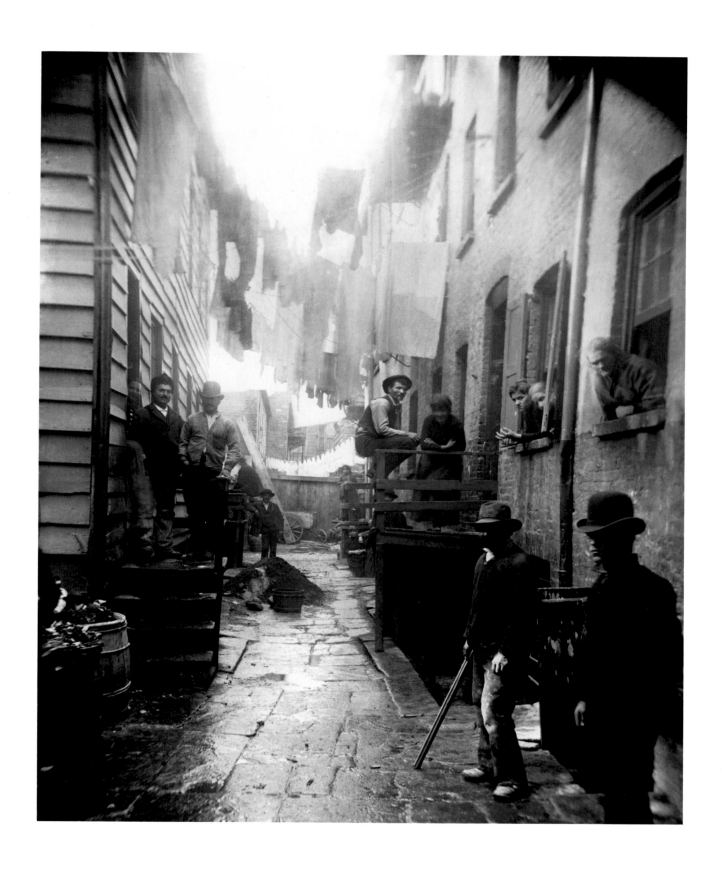

Jacob Riis. *Bandits' Roost, 59 ½ Mulberry Street.* c. 1888

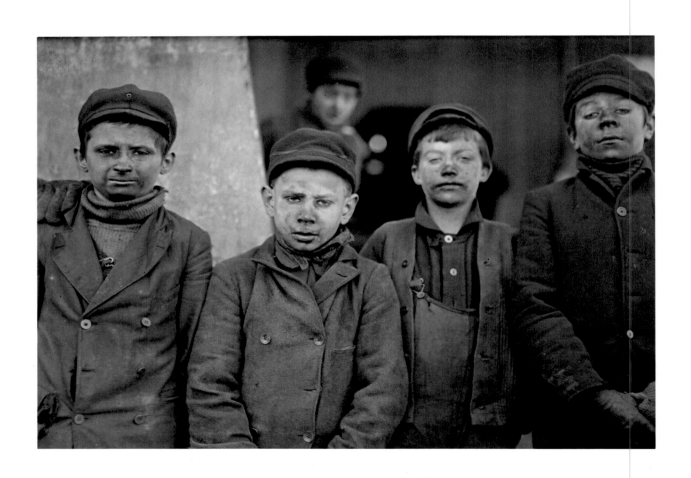

Lewis W. Hine. *Coalbreakers, Pennsylvania.* 1910–11

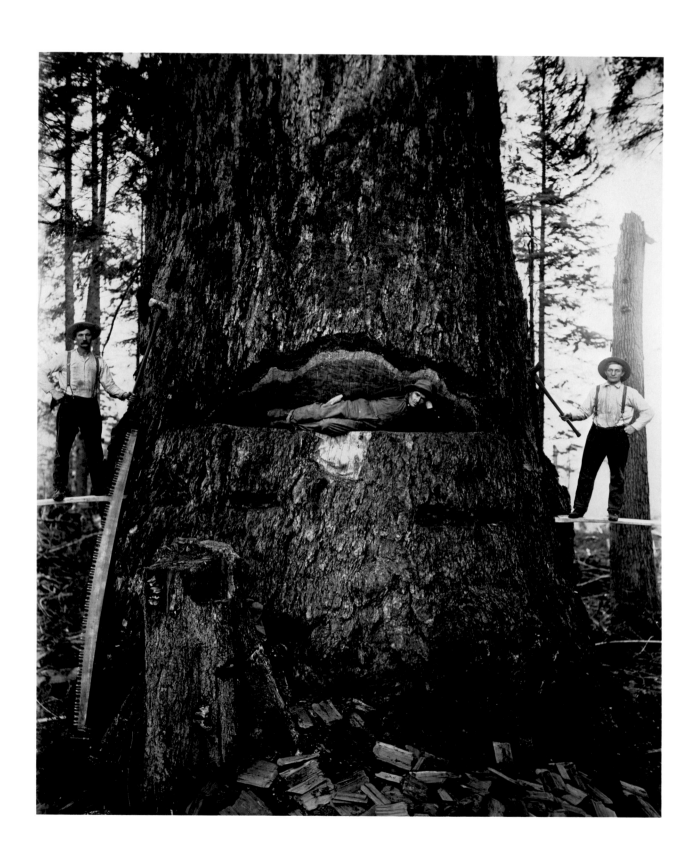

Darius Kinsey. *Felling a Fir Tree, 51 Feet in Circumference.* 1906

Willard Worden. *Market Street, San Francisco*. April 18, 1906

Charles Norman Sladen. Page from a personal album titled "July 1913," made at Great Chebeague Island, Maine. 1913

Photographer Unknown.
Seventh Avenue, 42nd and 43rd Streets, New York City. View, Facing North, Along West Side of Seventh Avenue, Showing Sidewalk Conditions. 1914

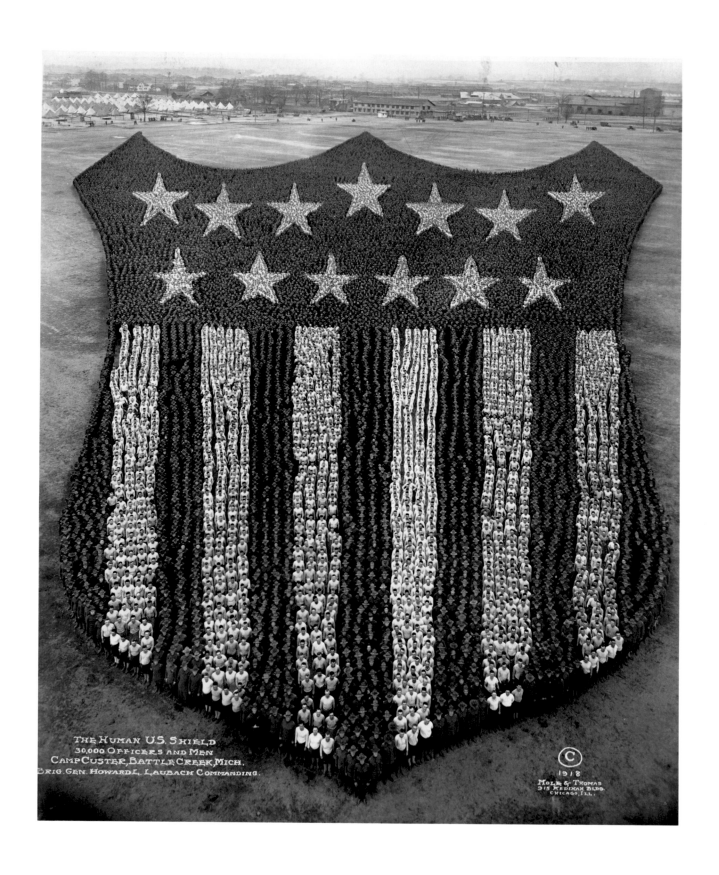

Arthur S. Mole and John D. Thomas. *The Human U.S. Shield: 30,000 Officers and Men. Camp Custer, Battle Creek, Michigan.* 1918

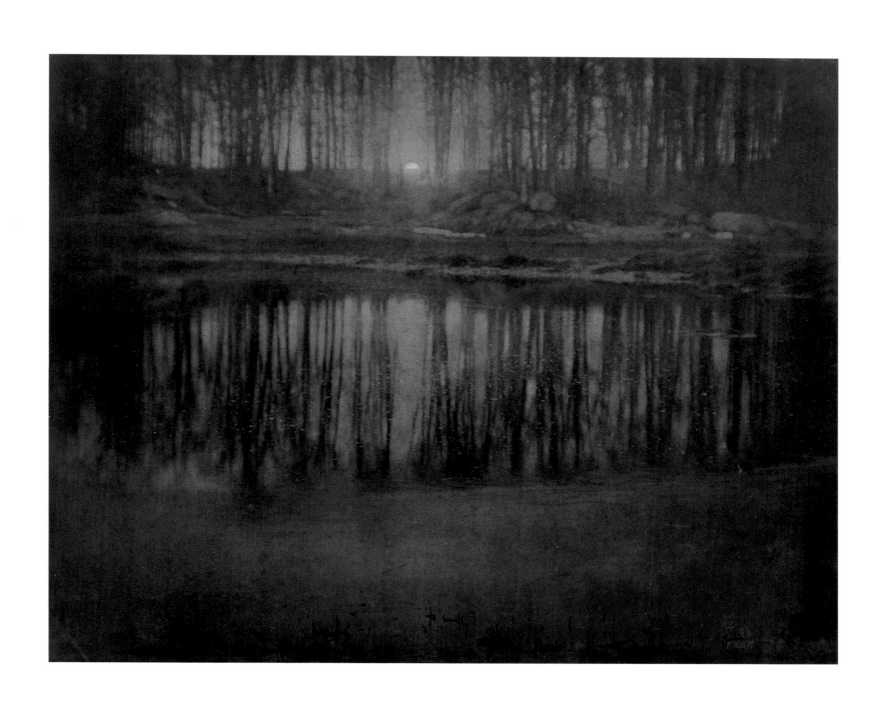

Edward Steichen. *Moonrise — Mamaroneck, New York.* 1904

Edward Steichen. *Self-Portrait, Milwaukee.* 1898

Alfred Stieglitz. *Flatiron Building.* 1903

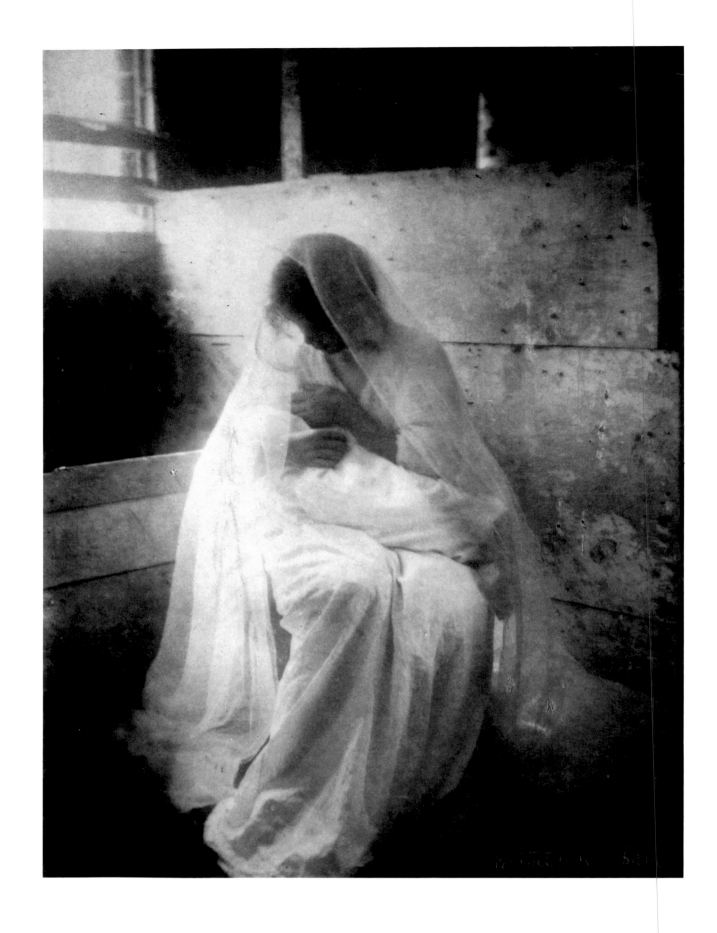

Gertrude Käsebier. *The Manger.* 1899

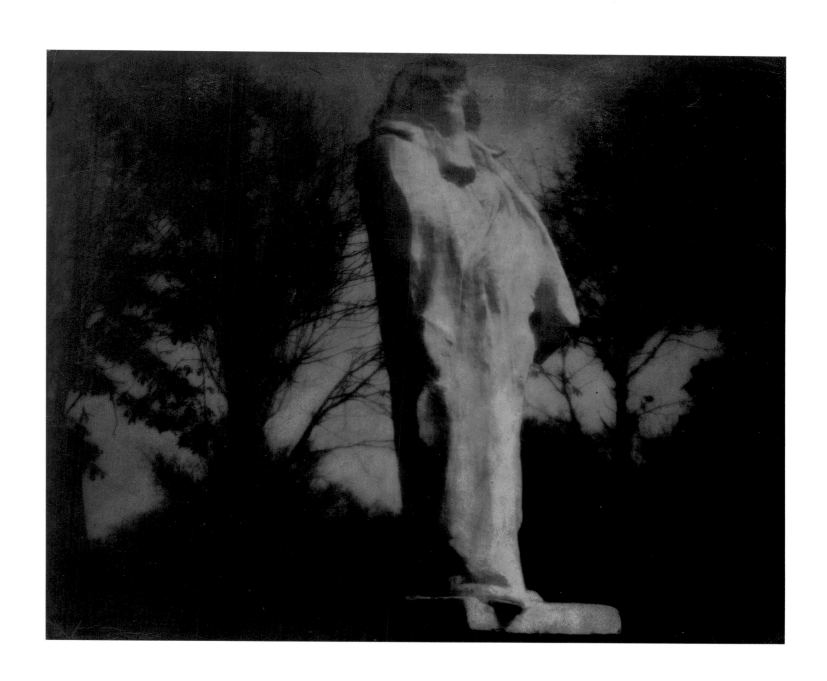

Edward Steichen. *Midnight — Rodin's Balzac.* 1908

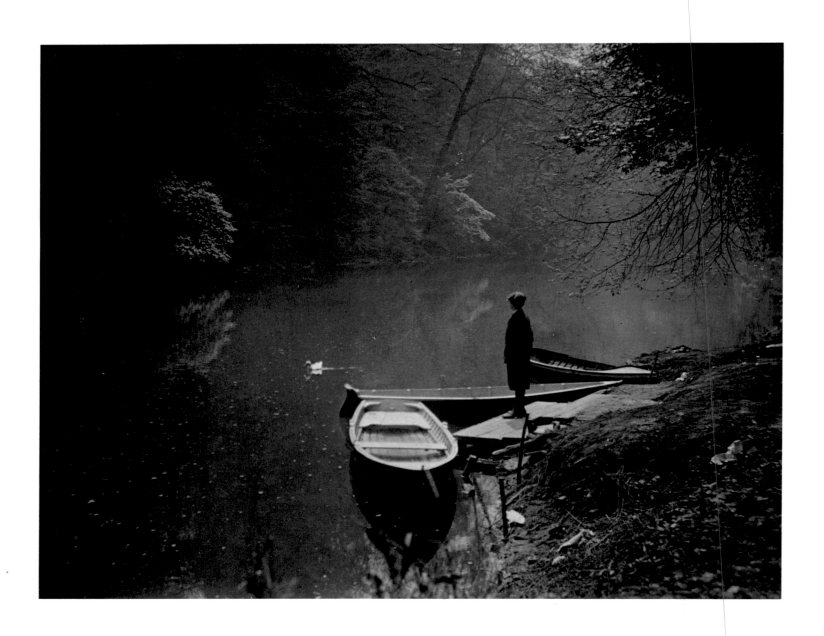

John G. Bullock. Untitled. c. 1910

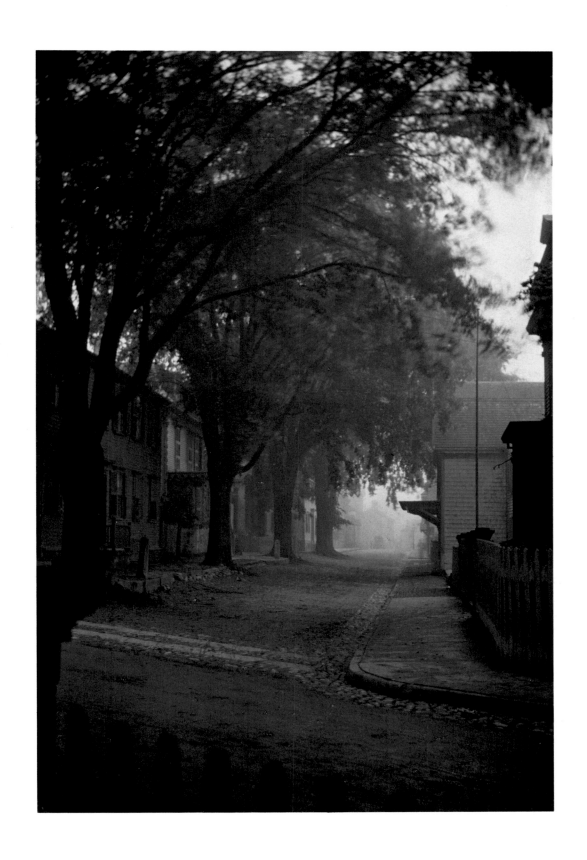

Clarence H. White. *New England Street.* 1907

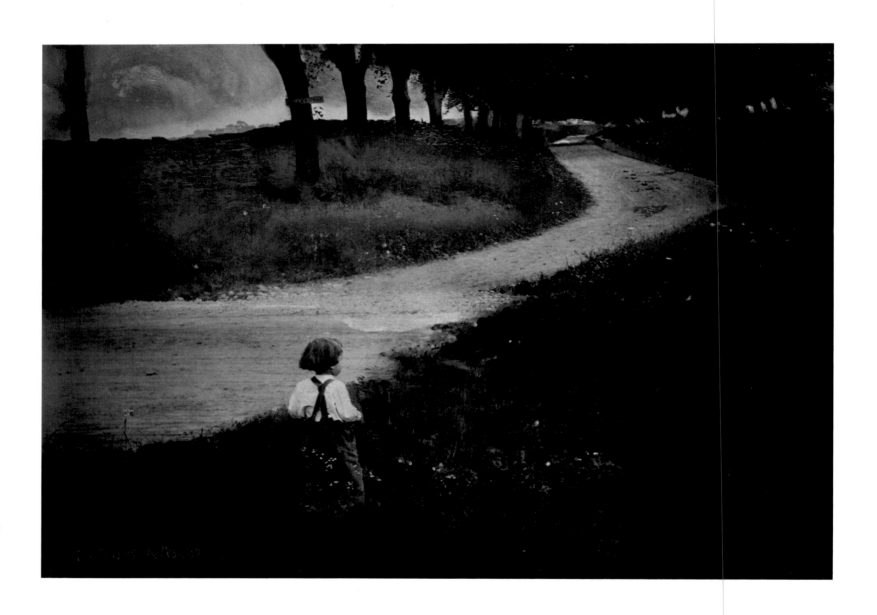

Gertrude Käsebier. *The Road to Rome.* 1903

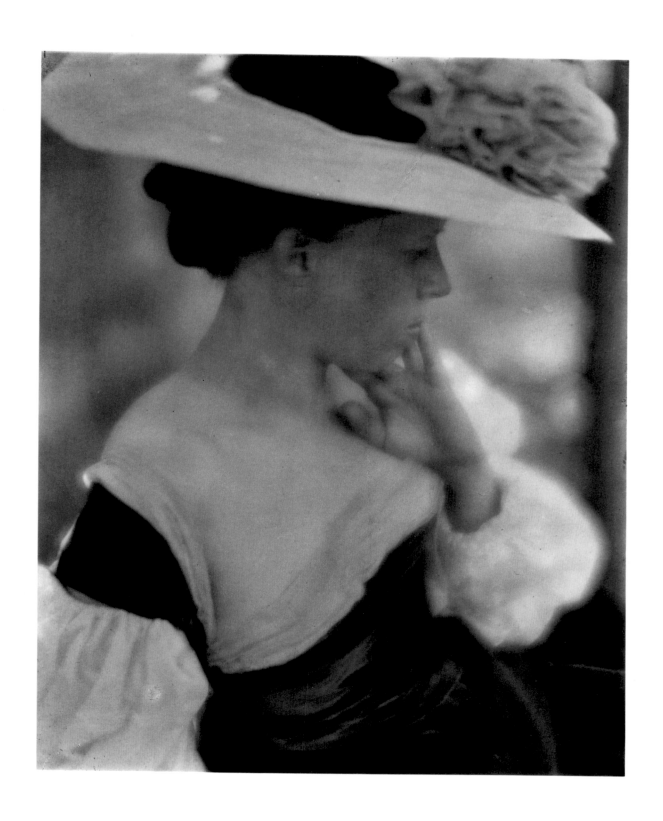

Clarence H. White. *Mrs. Clarence H. White.* 1906

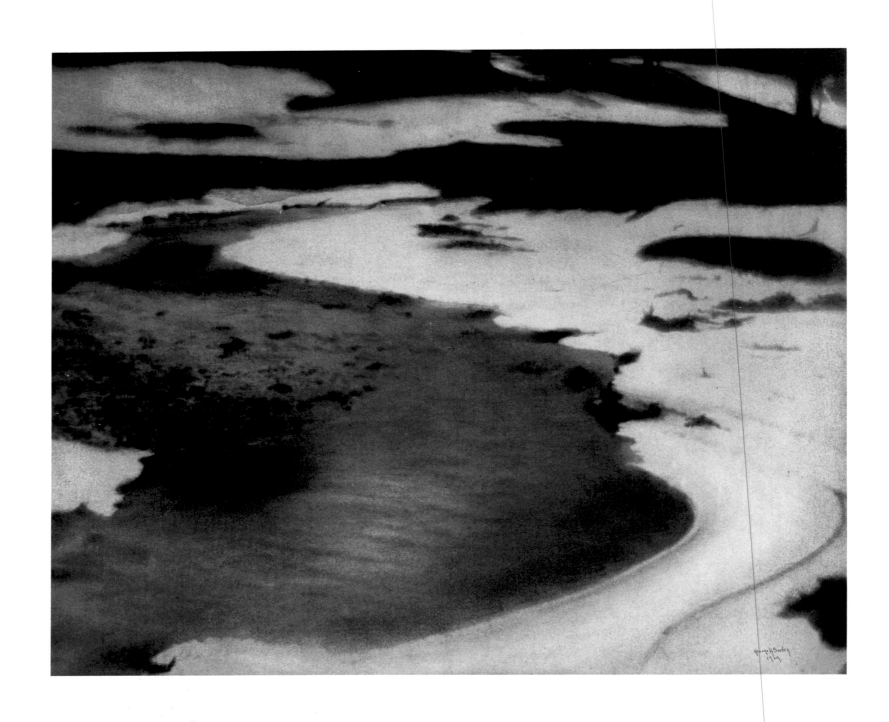

George H. Seeley. *Winter Landscape.* 1909

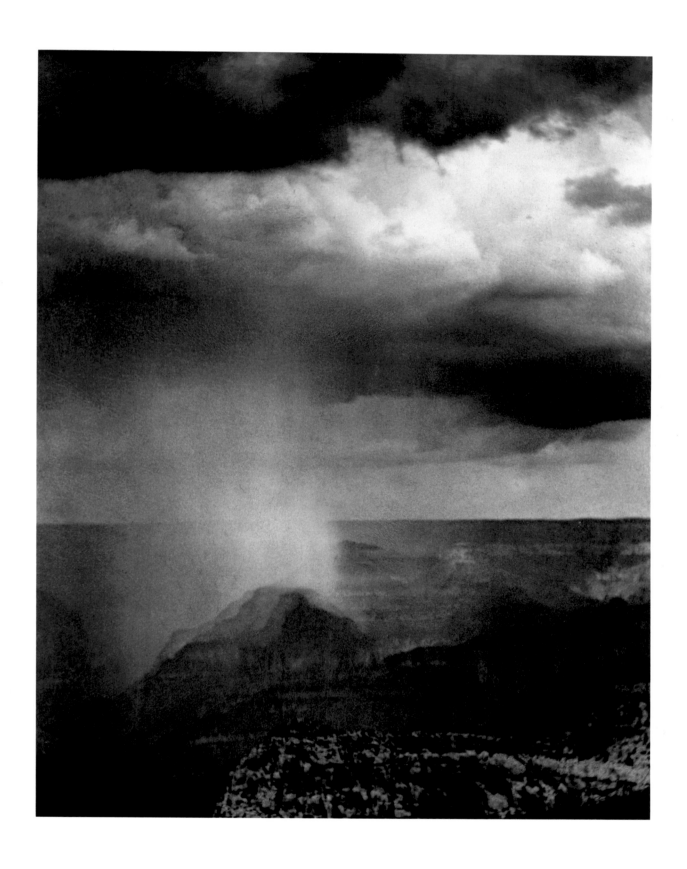

Alvin Langdon Coburn. *Grand Canyon.* 1911

Alfred Stieglitz. *The Mauretania.* 1910

Clarence H. White. *The Skeleton of the Ship, Bath, Maine.* 1917

Laura Gilpin. *Ghost Rock.* 1919

Doris Ulmann. Untitled. c. 1930

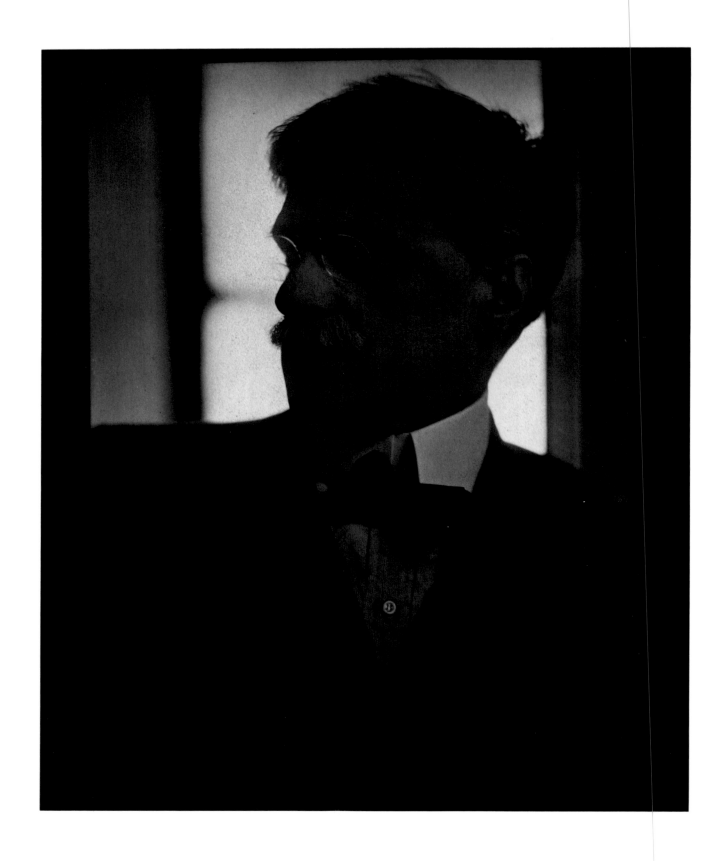

Edward Steichen. *Alfred Stieglitz*. 1909–10

Alfred Stieglitz. *Picasso-Braque Exhibition at "291."* 1915

Paul Strand. Untitled. 1915

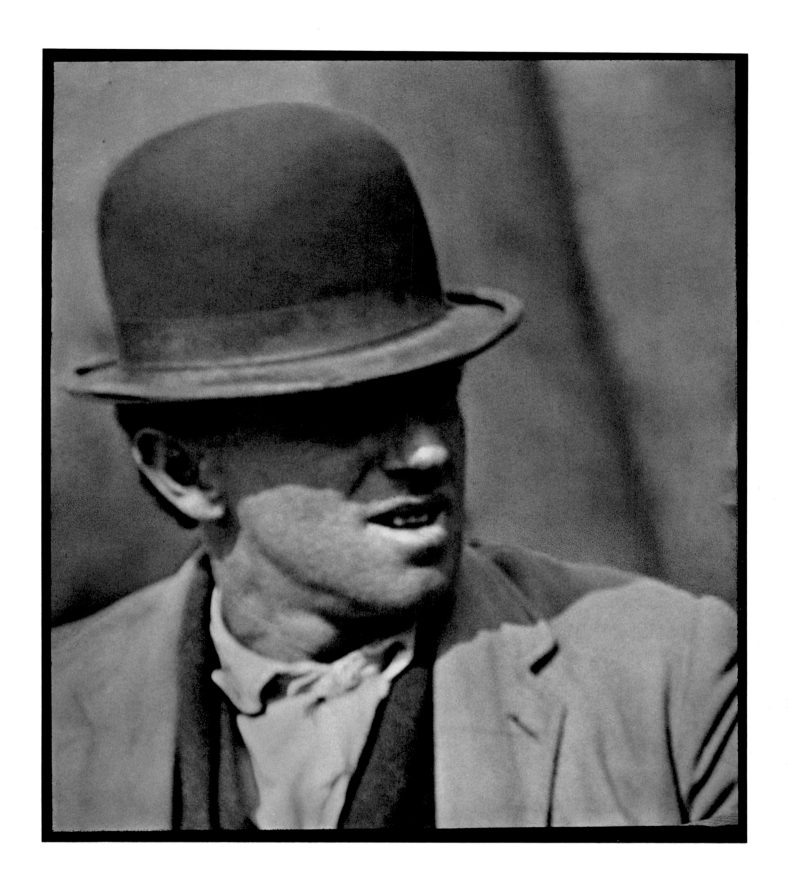

Paul Strand. Untitled. c. 1915

Charles Sheeler. *White Barn, Bucks County, Pennsylvania.* 1914–17

Charles Sheeler. *Stair Well.* 1914–17

Paul Strand. *Leaves II.* 1929

Edward Steichen. *Pillars of the Parthenon.* 1921

Alfred Stieglitz. *Hands and Thimble—Georgia O'Keeffe.* 1920

Edward Weston. *Torso of Neil.* 1925

Tina Modotti. *Roses, Mexico.* 1924

Edward Weston. *Nahui Olín*. 1924

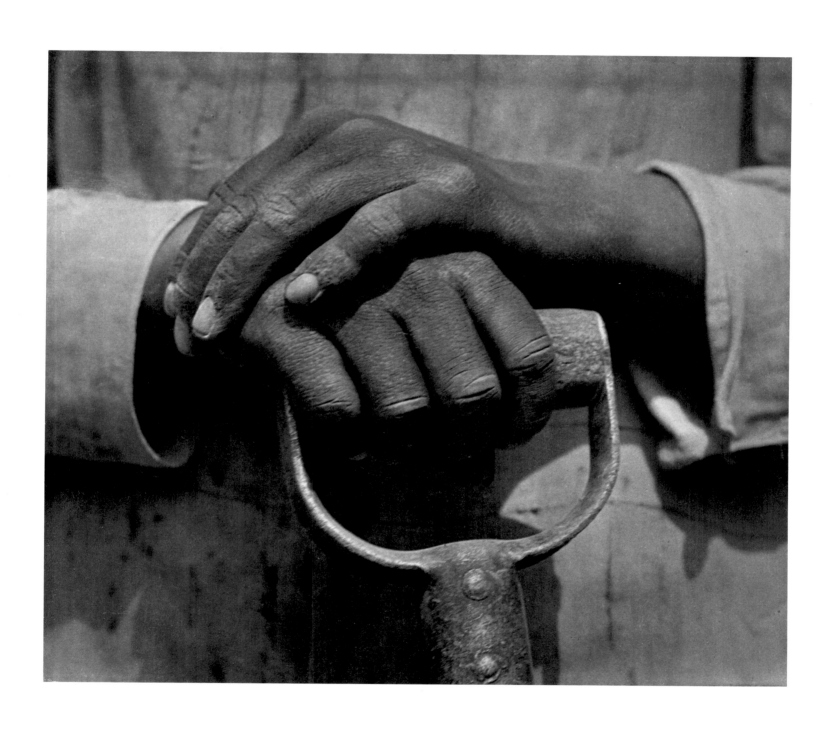

Tina Modotti. *Worker's Hands.* 1926

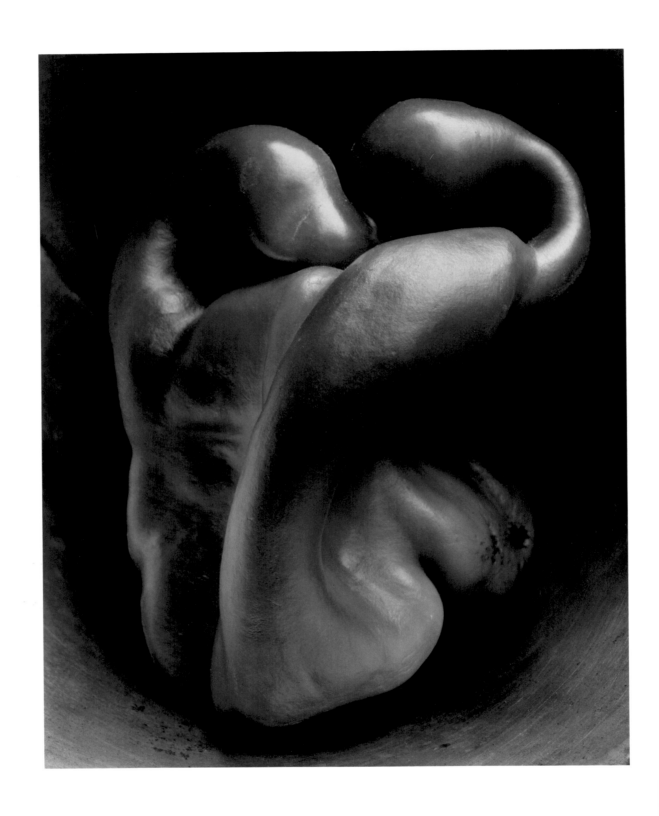

Edward Weston. *Pepper No. 30.* 1930

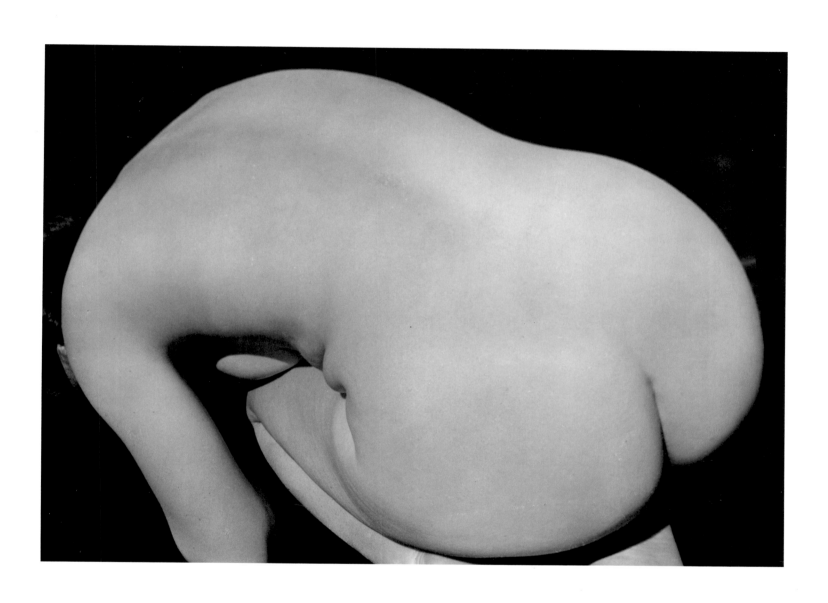

Imogen Cunningham. *Nude*. 1932

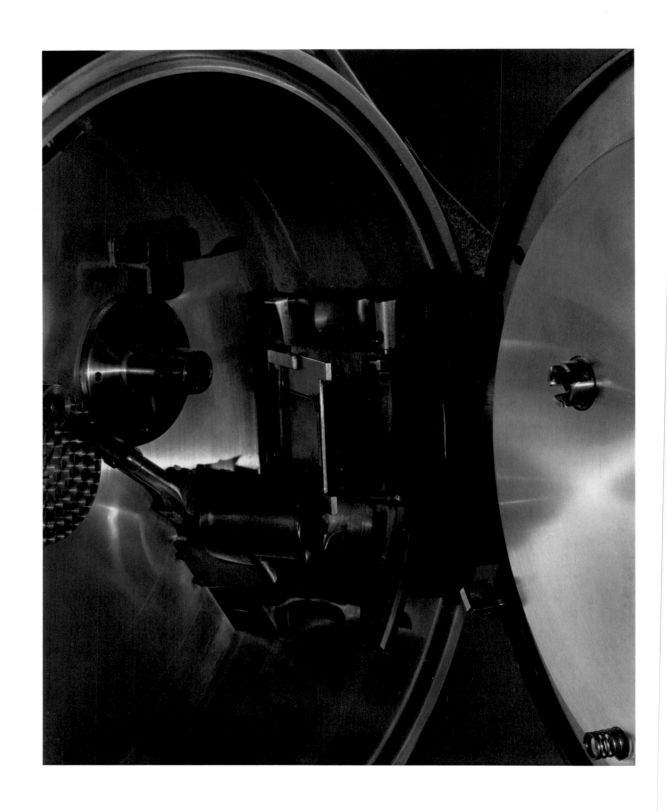

Paul Strand. *Akeley Motion Picture Camera*. 1923

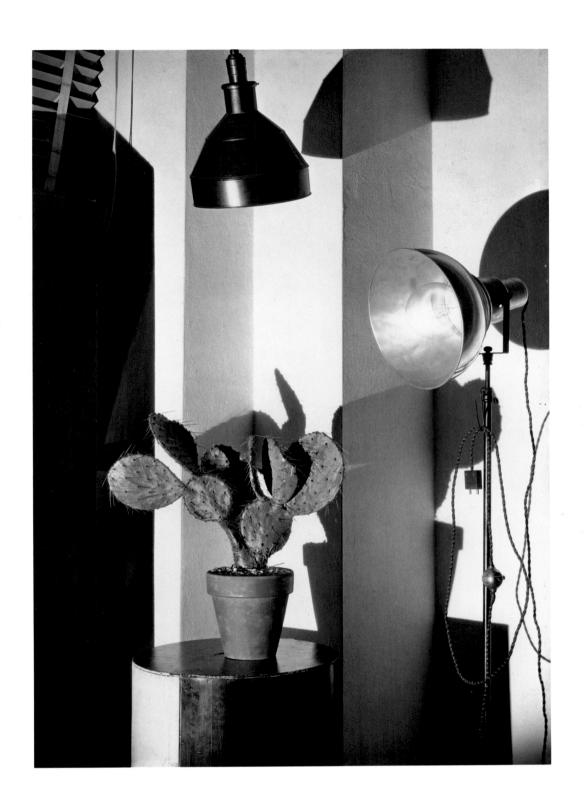

Charles Sheeler. *Cactus and Photographer's Lamp, New York.* 1931

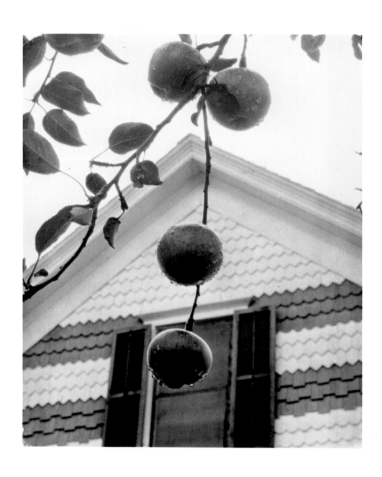

Alfred Stieglitz. *Apples and Gable, Lake George.* 1922

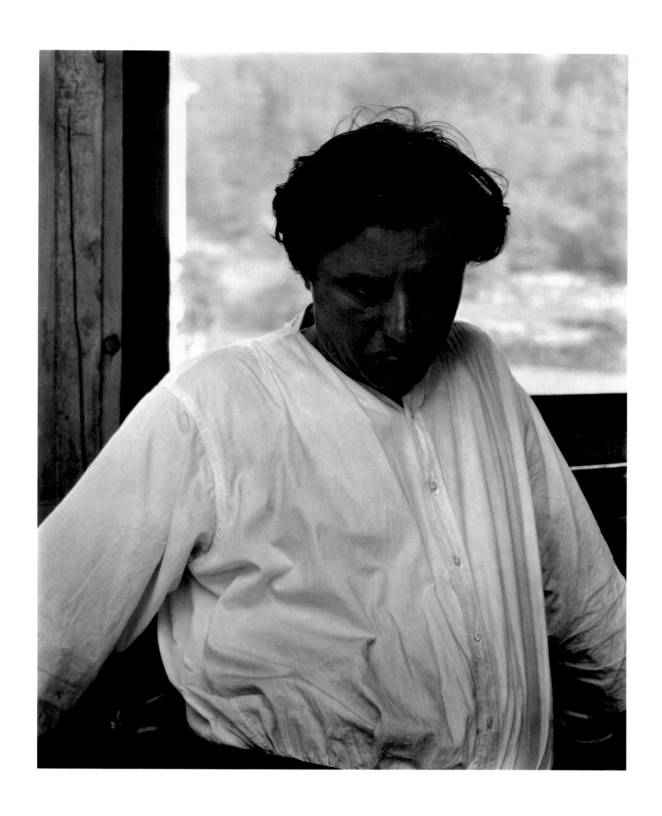

Paul Strand. *Gaston Lachaise*. 1927–28

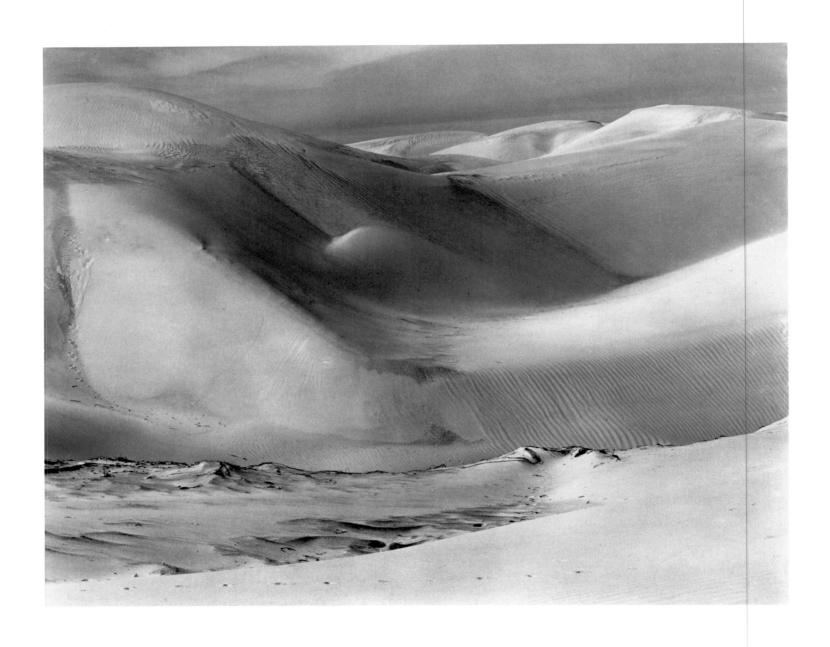

Edward Weston. *Dunes, Oceano.* 1936

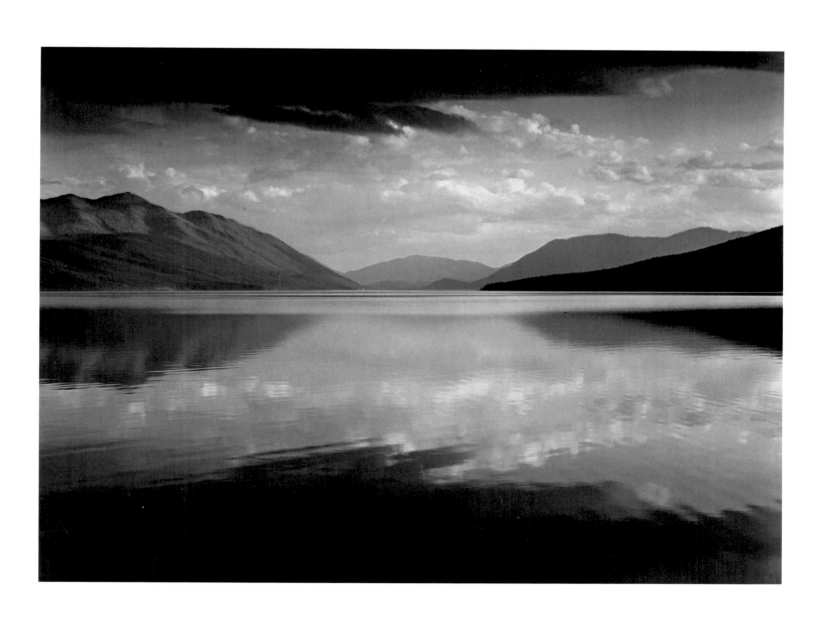

Ansel Adams. *Lake MacDonald, Glacier National Park.* 1942

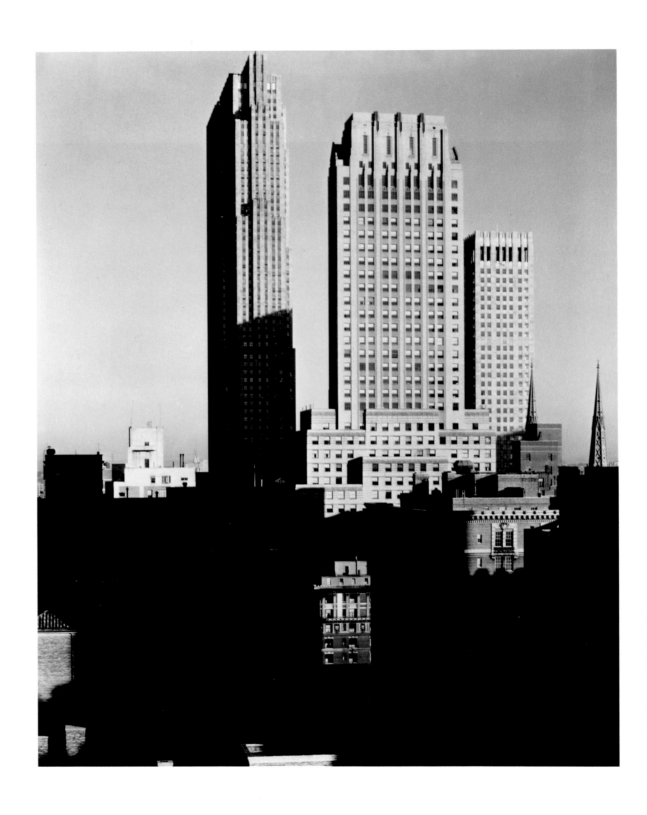

Alfred Stieglitz. *From the Shelton, West.* 1935

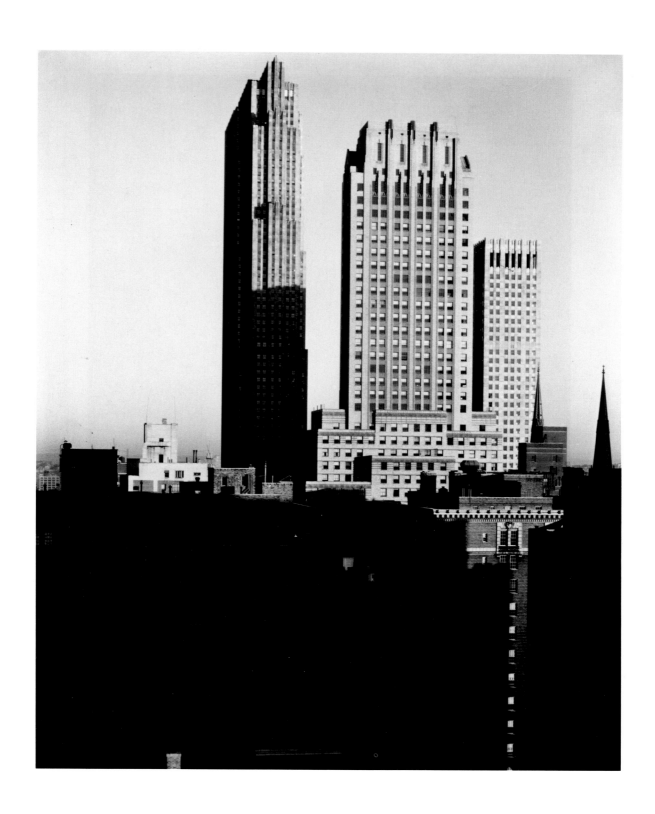

Alfred Stieglitz. *From the Shelton, West.* 1935

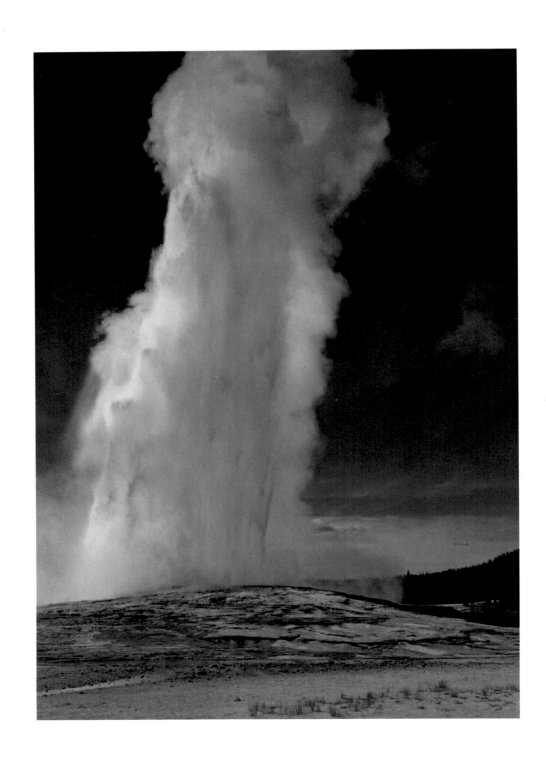

Ansel Adams. *Old Faithful Geyser, Yellowstone National Park.* 1942

Ansel Adams. *Old Faithful Geyser, Yellowstone National Park.* 1942

Paul Outerbridge. *Ide Collar.* 1922

Grancel Fitz. *Cellophane.* 1928–29

Nickolas Muray. *Babe Ruth (George Herman Ruth).* c. 1927

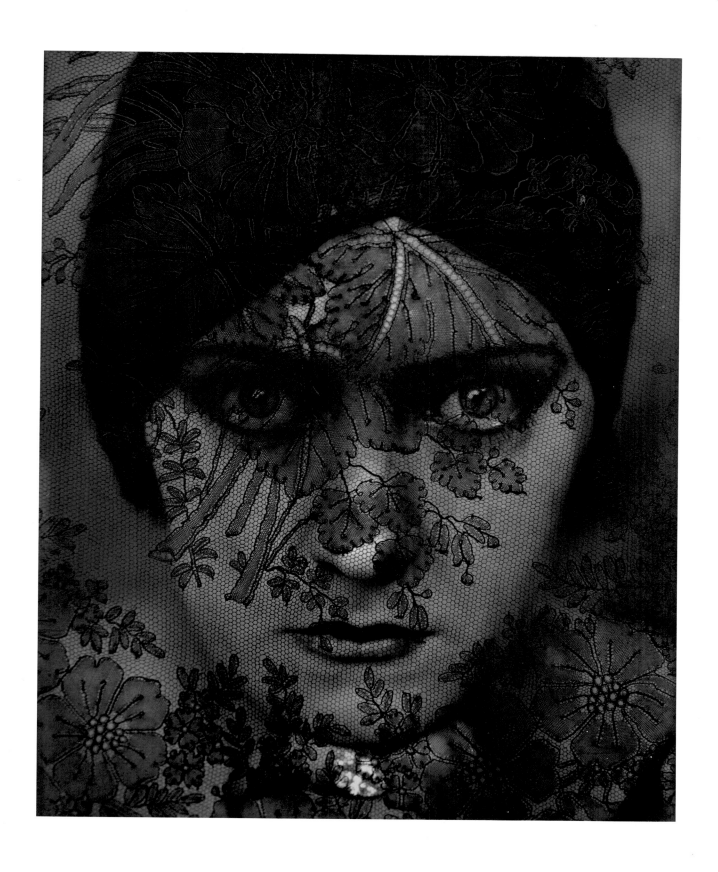

Edward Steichen. *Gloria Swanson*. 1924

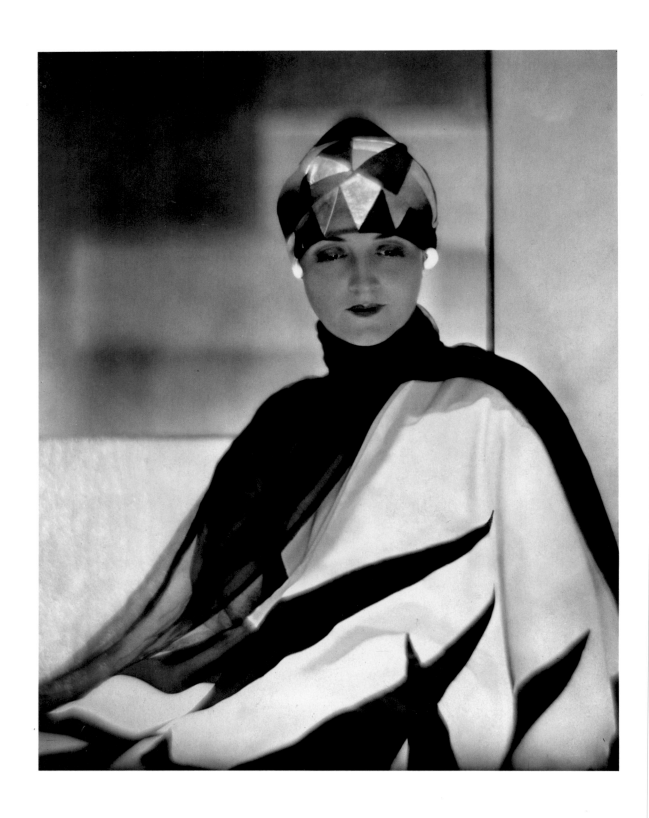

Baron Adolf De Meyer. *Green and Silver Leaves.* 1925

Photographer Unknown. *Film Still for "The Common Law."* 1931

James Van Der Zee. *Baptism Celebration to Maria Warma Mercado*. April 23, 1927

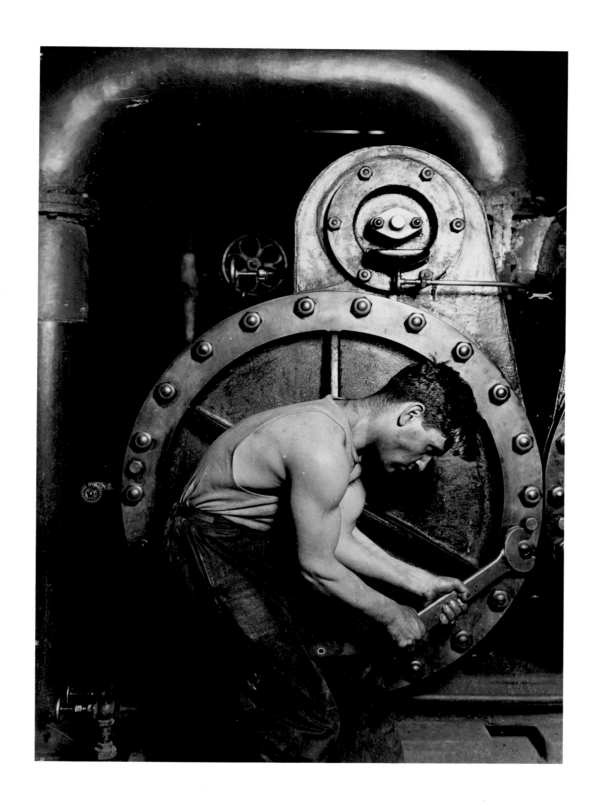

Lewis W. Hine. *Steamfitter.* 1920

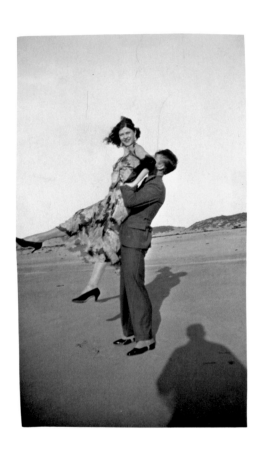

Photographer Unknown. *Coronado Beach, California*. c. 1930

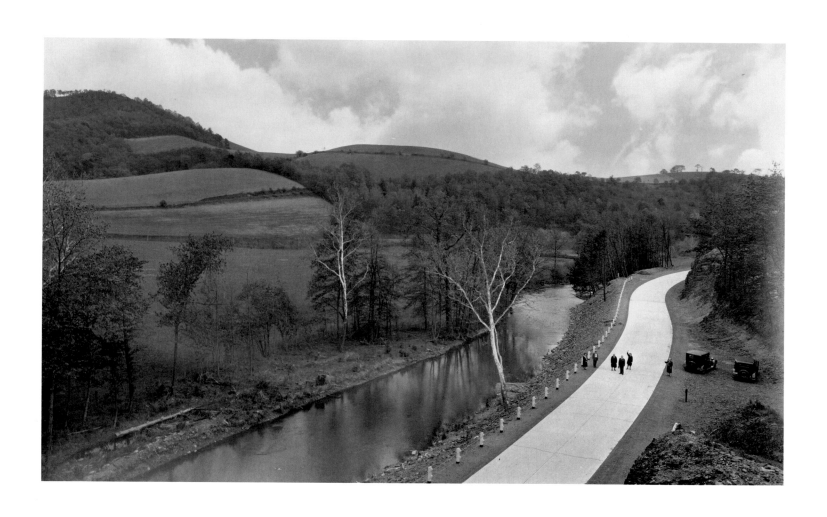

James Bartlett Rich. *Stopping Off for Lunch, Route 143, The Ontelaunee Creek, Near Kempton, Berks County, Pennsylvania.* 1931 **131**

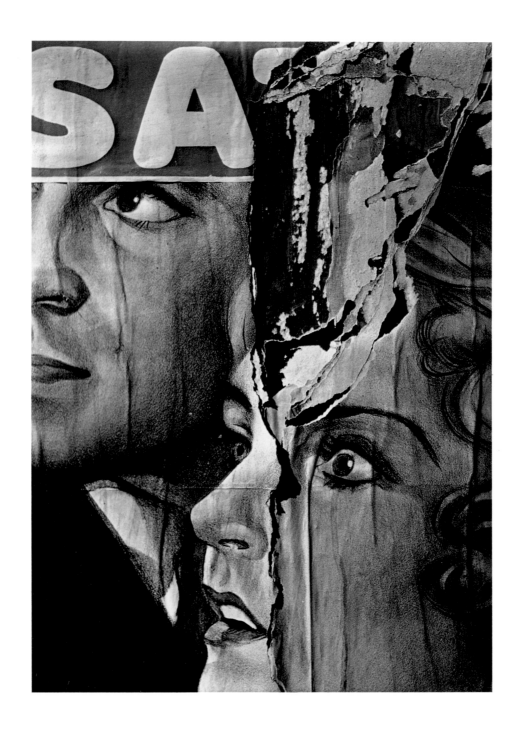

Walker Evans. *Torn Movie Poster.* 1930

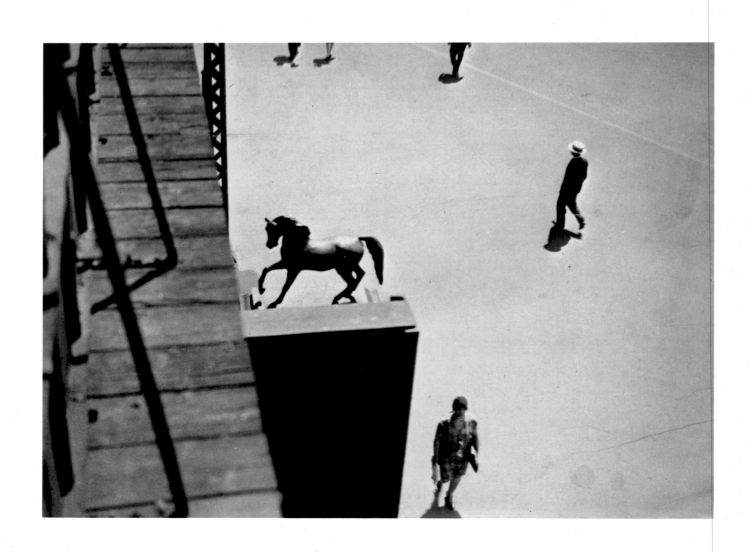

Berenice Abbott. *El at Columbus Avenue and Broadway.* 1929

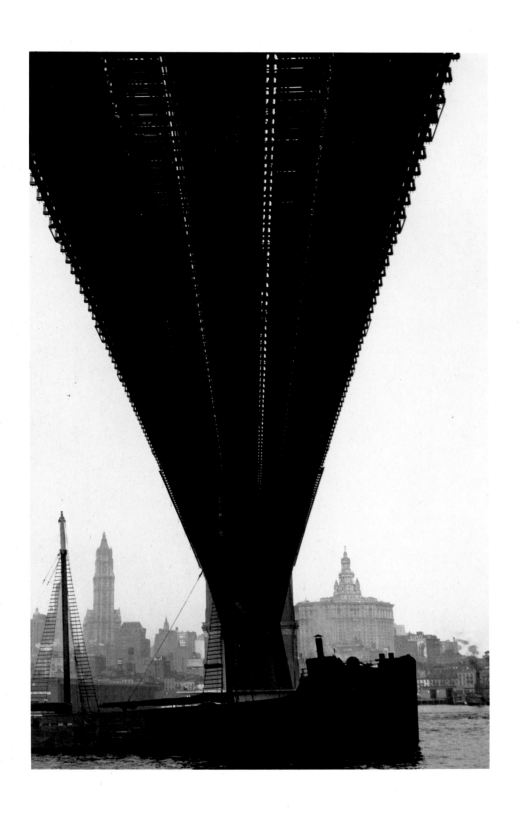

Walker Evans. *Brooklyn Bridge*. 1929

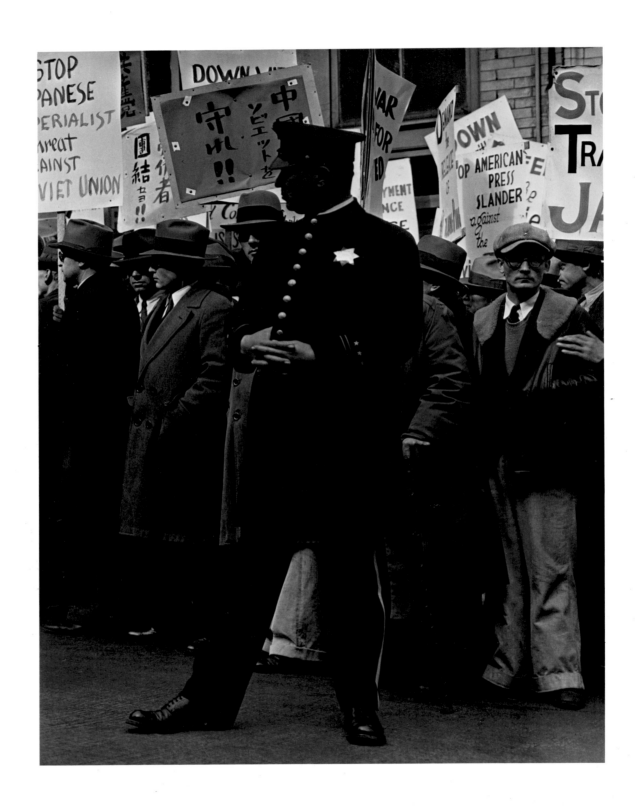

Dorothea Lange. *Street Demonstration, San Francisco.* 1933

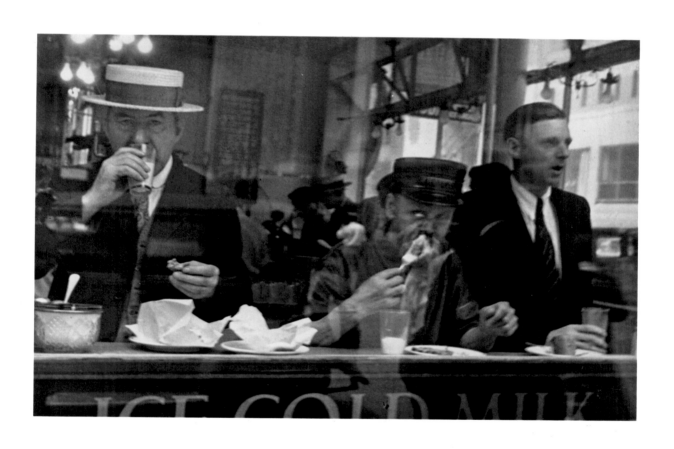

Walker Evans. *City Lunch Counter.* 1929

Walker Evans. *Maine Pump.* 1933

Ralph Steiner. *American Rural Baroque.* 1930

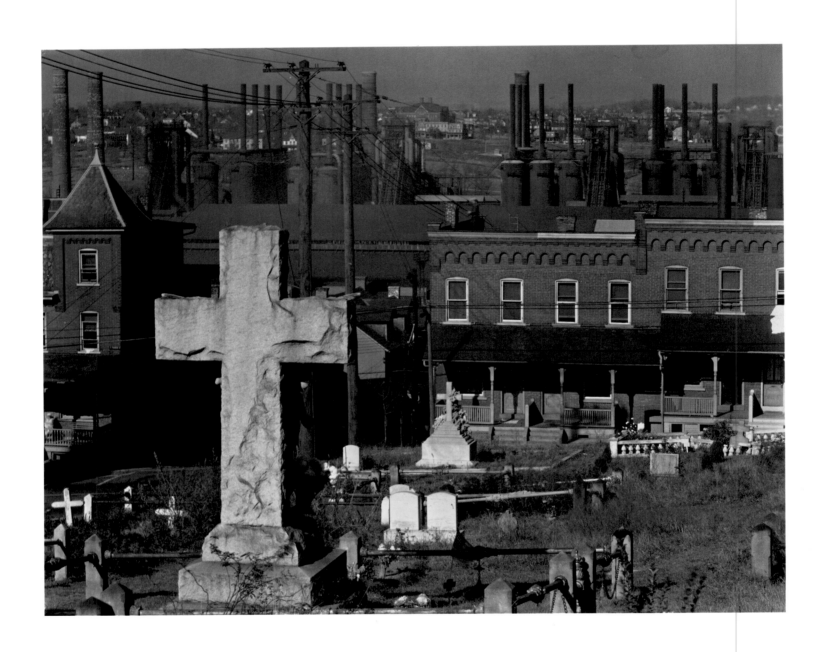

Walker Evans. *Graveyard, Houses, and Steel Mill, Bethlehem, Pennsylvania.* 1935

Ralph Steiner. *Sign, Saratoga Springs.* 1929

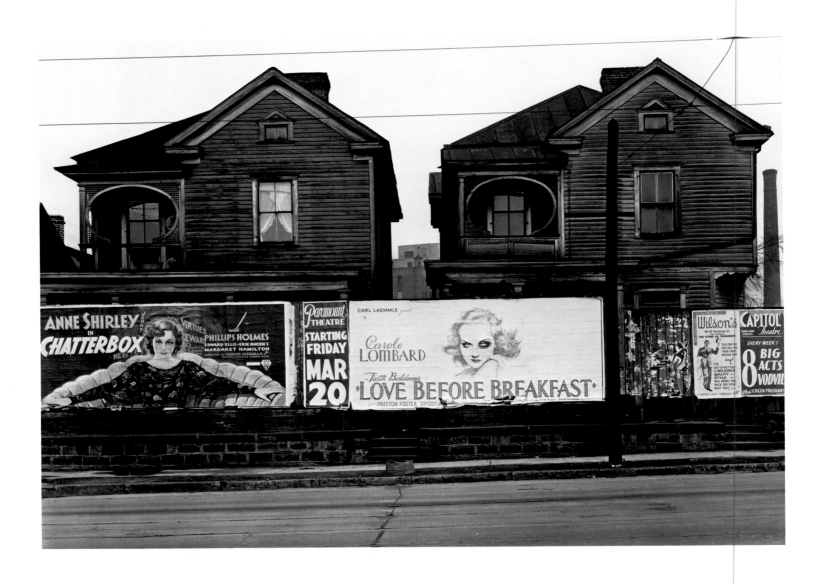

Walker Evans. *Houses and Billboards in Atlanta.* 1936

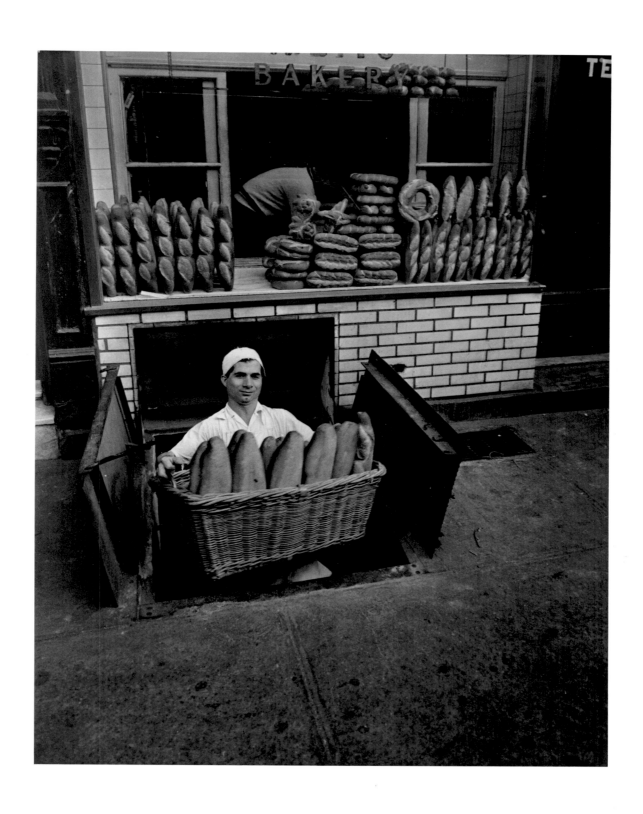

Berenice Abbott. *Zito's Bakery, Bleecker Street, New York.* 1937

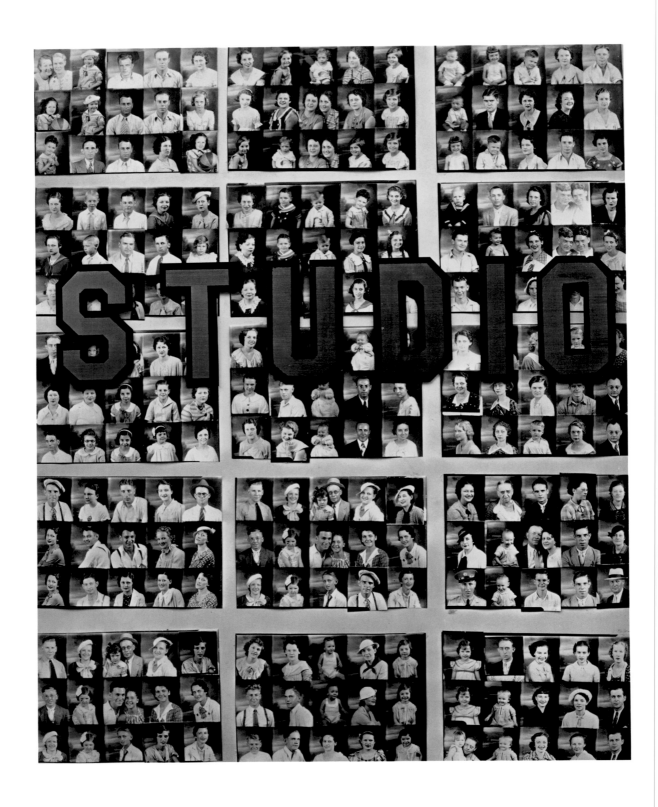

Walker Evans. *Penny Picture Display, Savannah, Georgia.* 1936

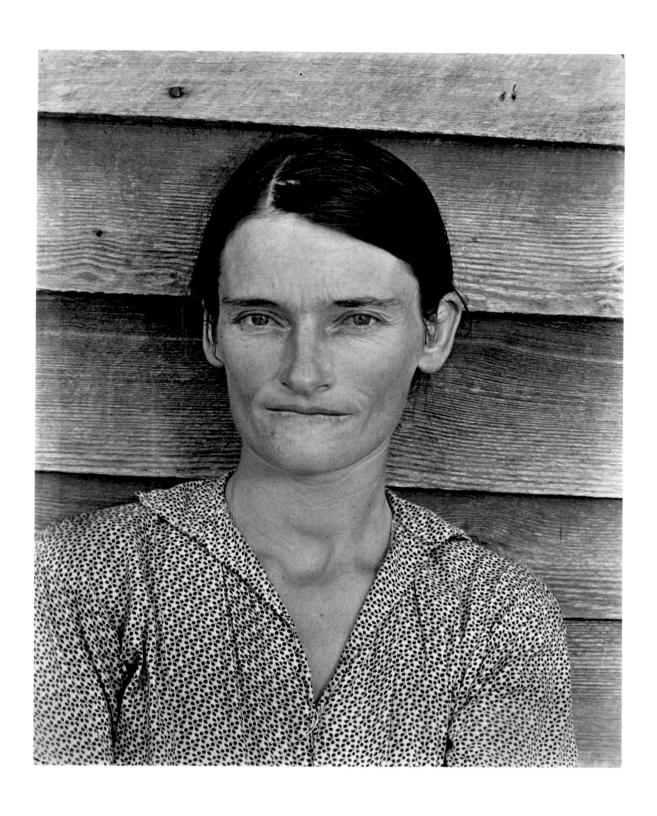

Walker Evans. *Alabama Cotton Tenant Farmer Wife*. 1936

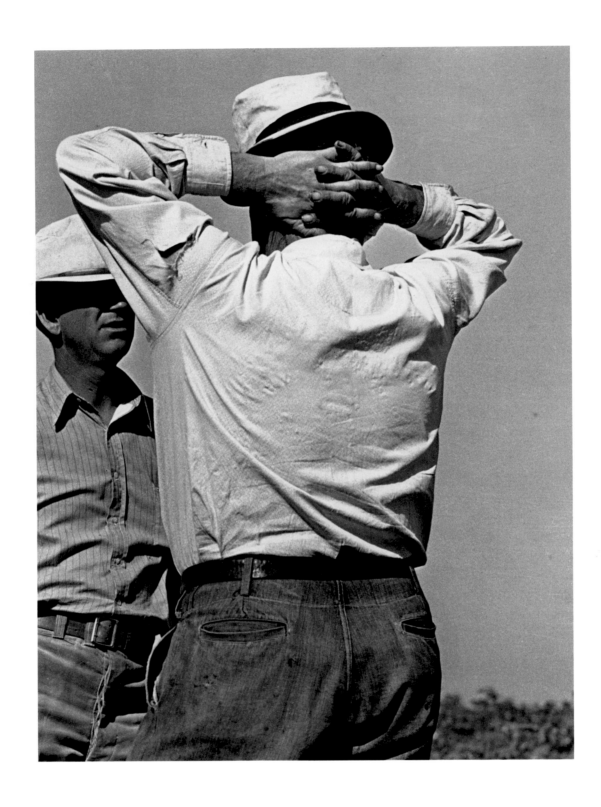

Dorothea Lange. *Back.* 1938

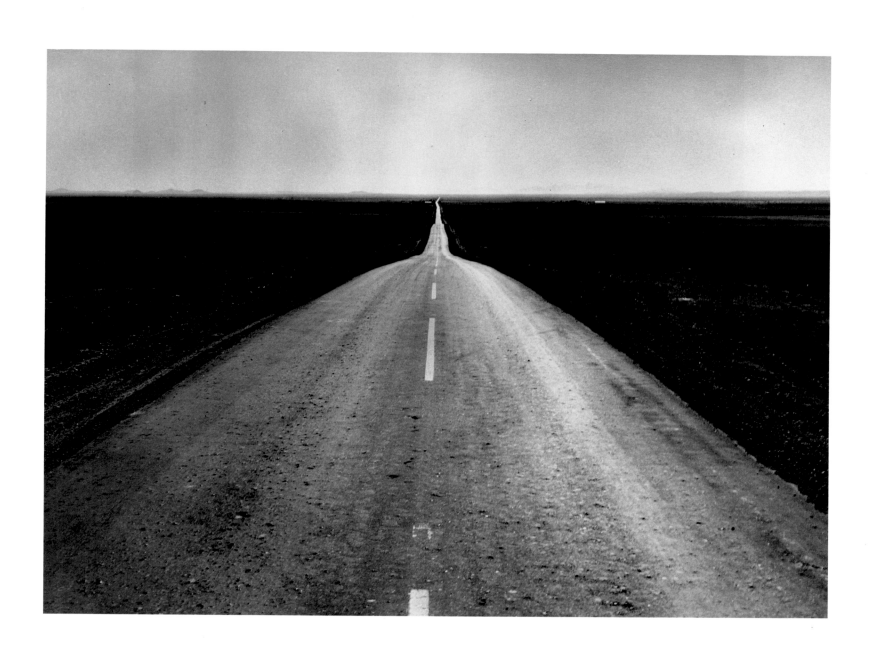

Dorothea Lange. *The Road West, New Mexico.* 1938

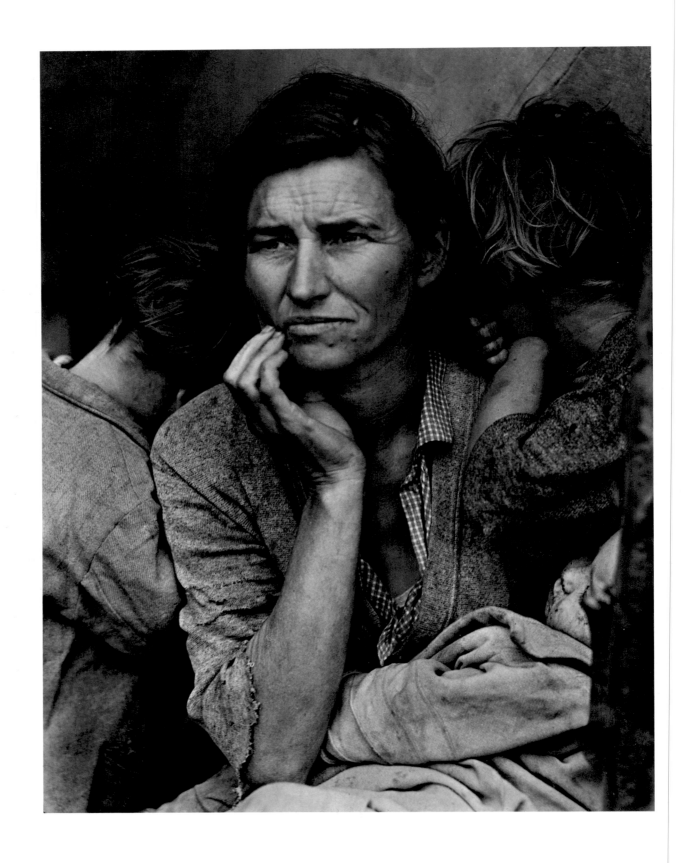

Dorothea Lange. *Migrant Mother, Nipomo, California.* 1936

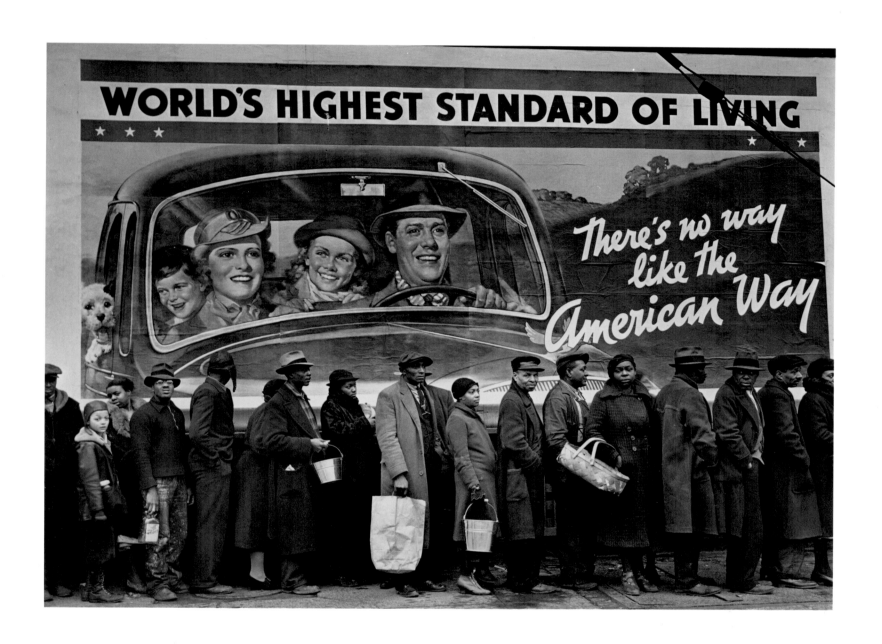

Margaret Bourke-White. *At the Time of the Louisville Flood.* 1937

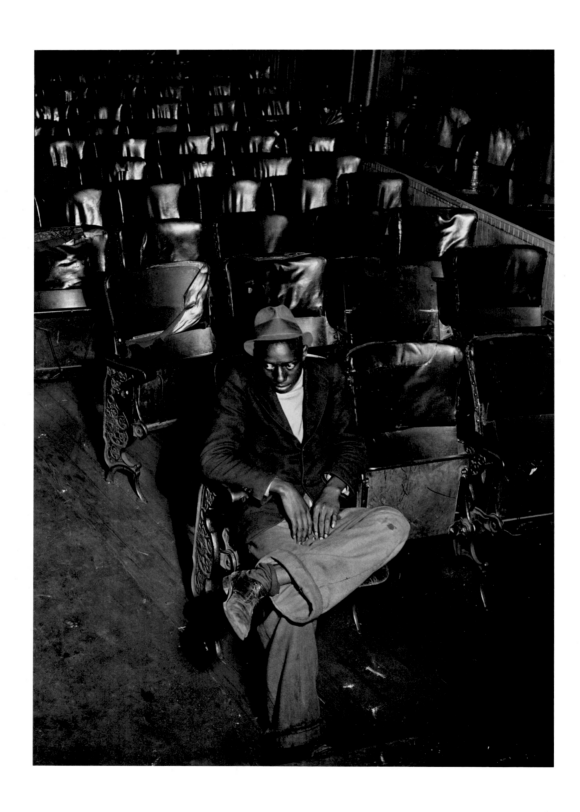

Louise Dahl-Wolfe. *Nashville.* 1932

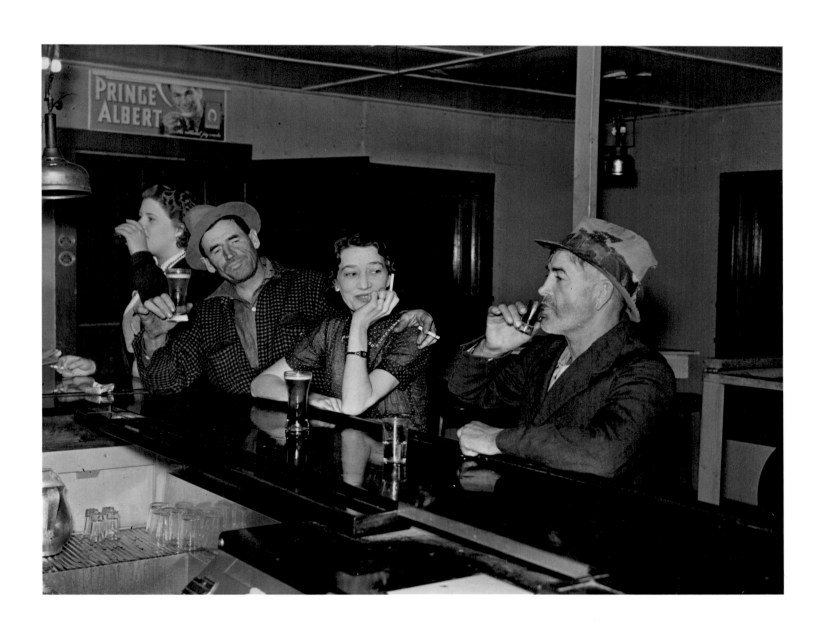

Russell Lee. *Lumberjacks — Saturday Night, Minnesota.* 1937

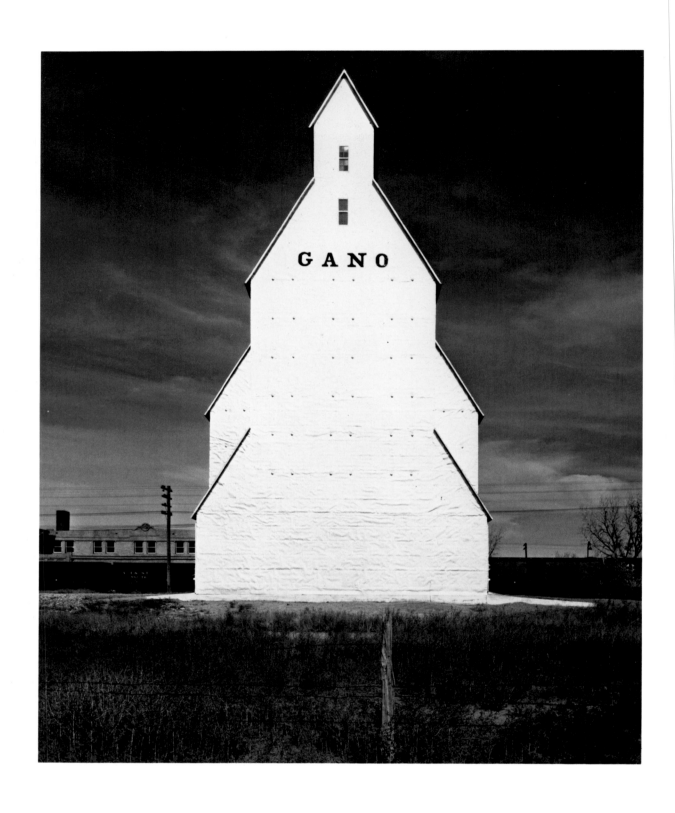

Wright Morris. *Gano Grain Elevator, Western Kansas.* 1939

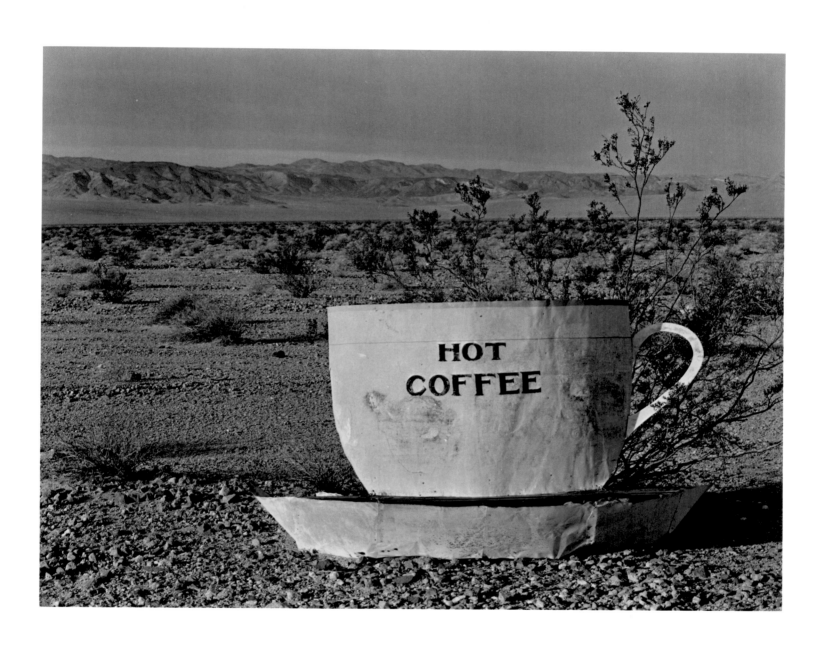

Edward Weston. *Hot Coffee, Mojave Desert.* 1937

Rudy Burckhardt. Facing pages from a unique album titled "An Afternoon in Astoria." 1940

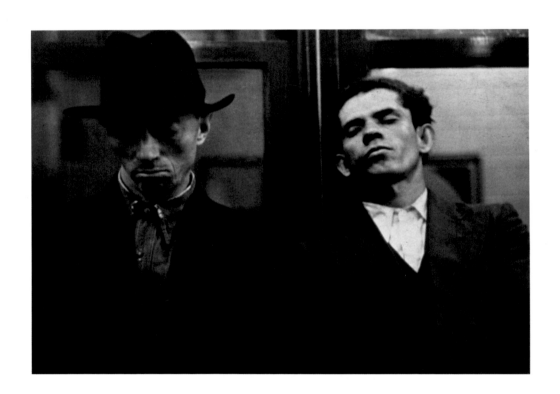

Walker Evans. *Subway Portrait*. 1938–41

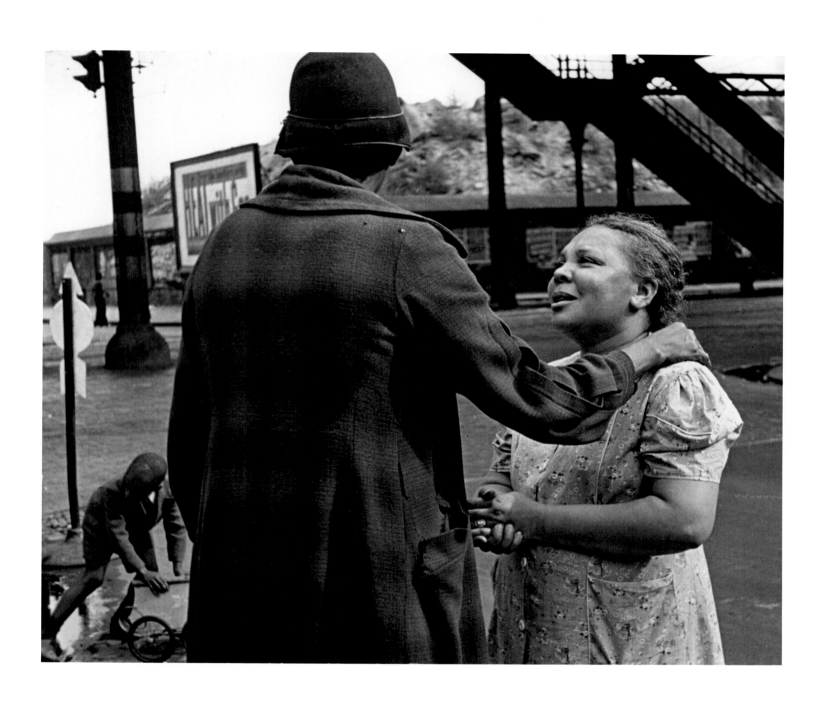

Helen Levitt. *New York.* 1939

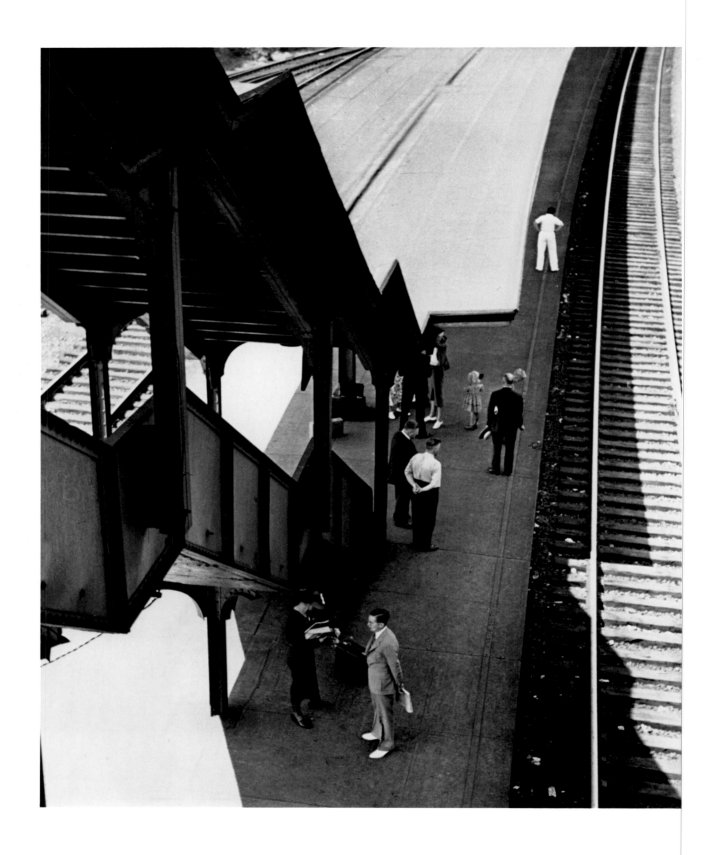

André Kertész. *Railroad Station, Poughkeepsie, New York.* 1937

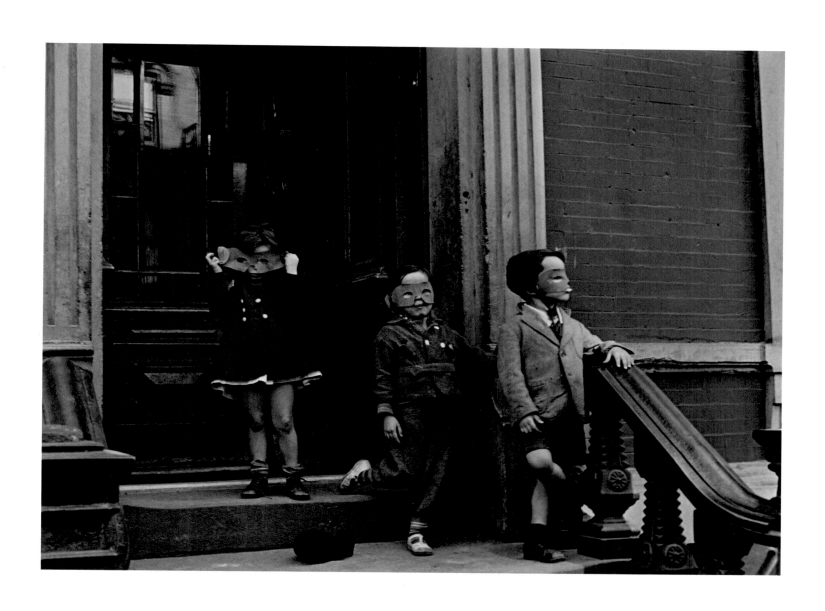

Helen Levitt. *New York.* 1939

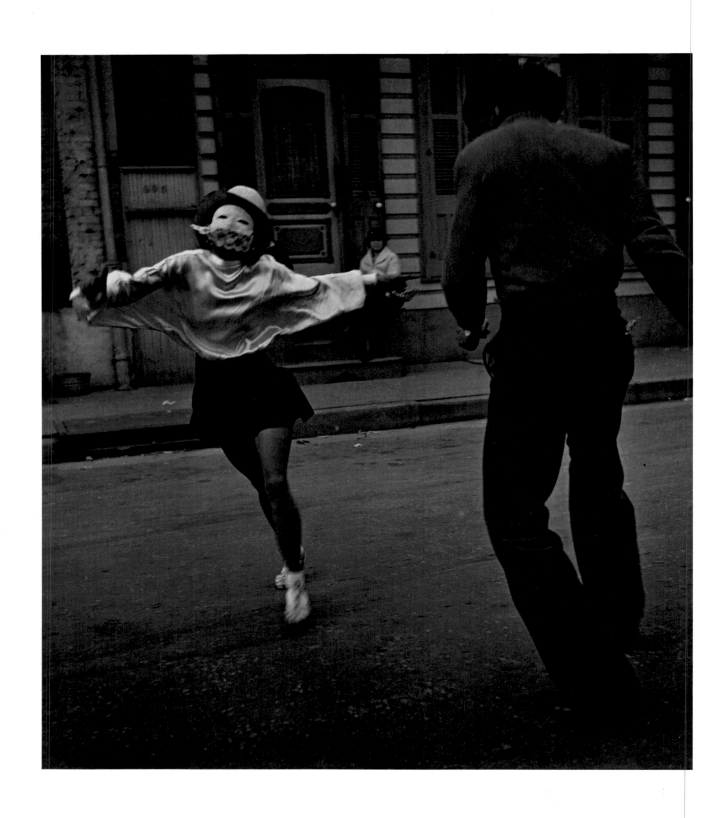

John Gutmann. *Jitterbug, New Orleans.* 1937

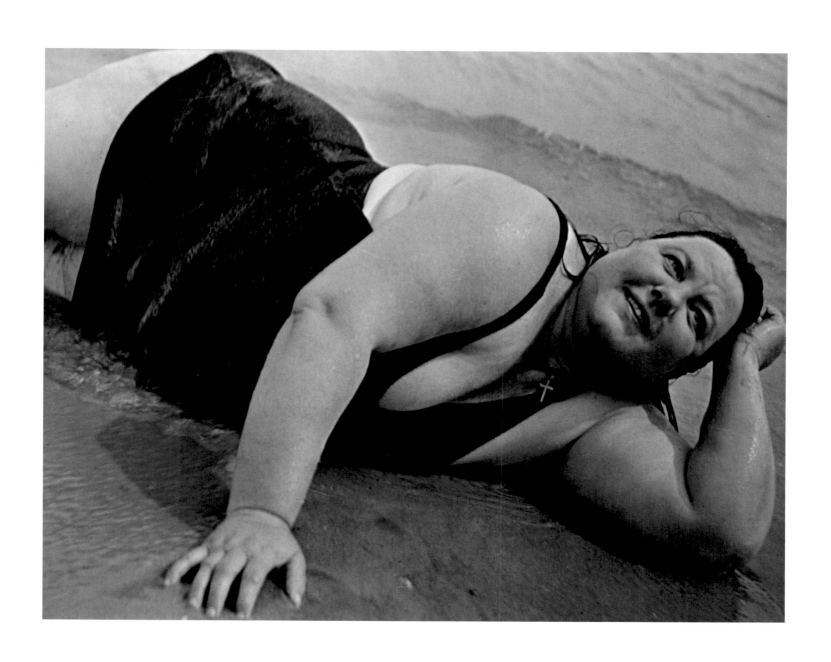

Lisette Model. *Coney Island.* 1941

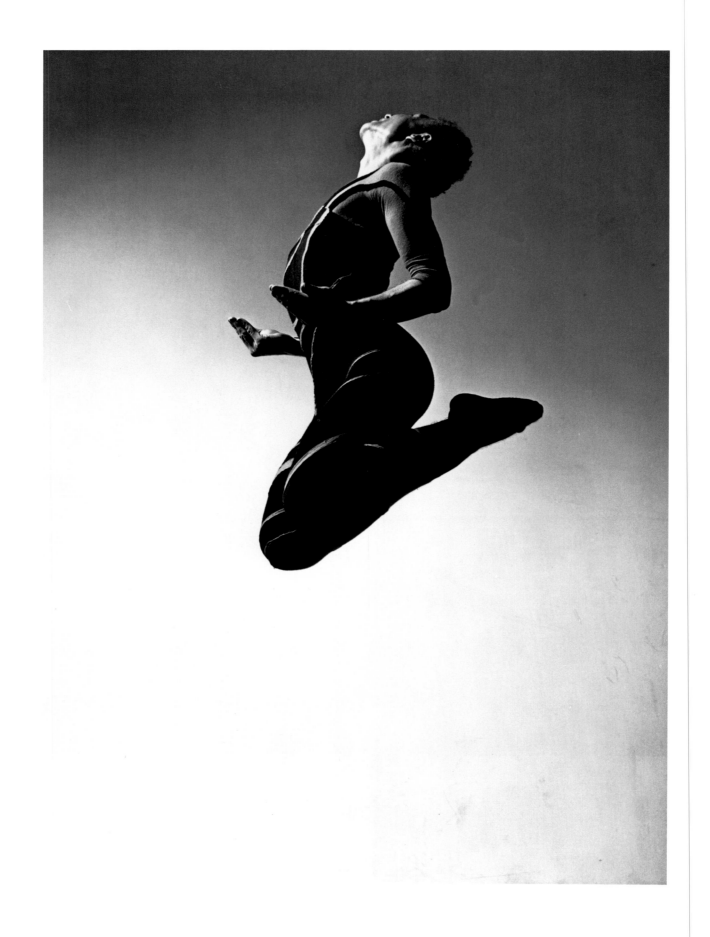

Barbara Morgan. *Merce Cunningham — Totem Ancestor*. 1942

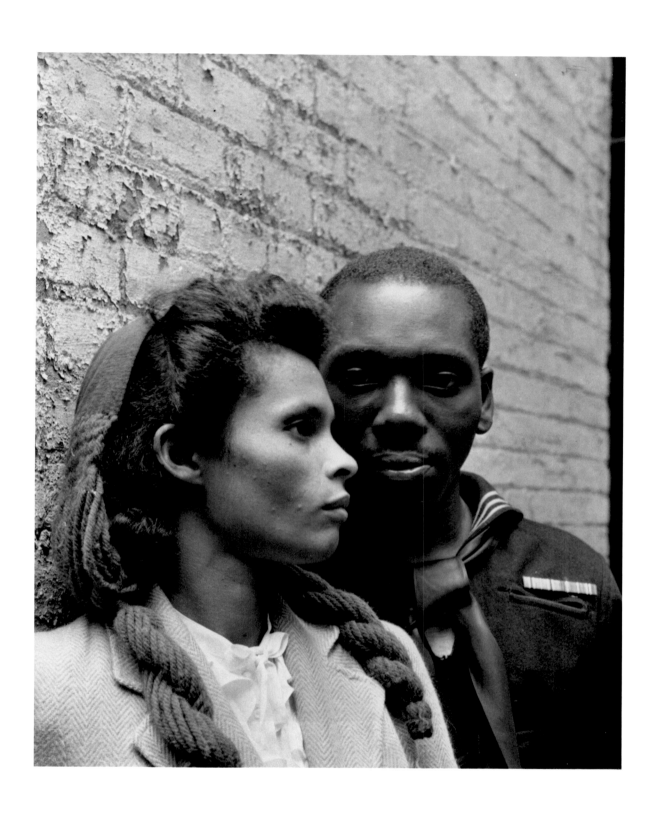

Arnold Newman. *Jacob and Gwen Lawrence.* 1944

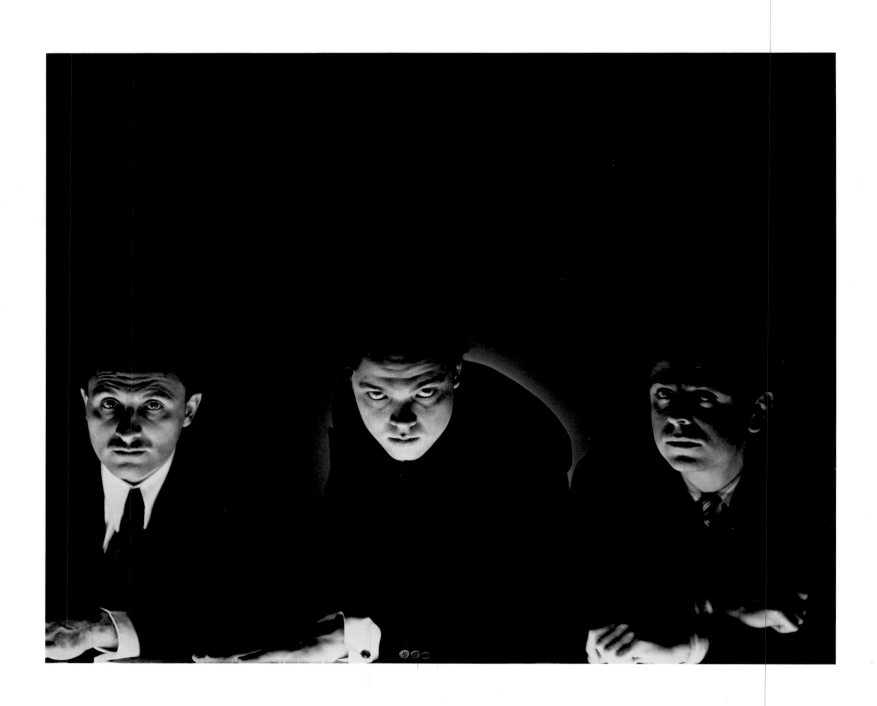

George Platt Lynes. *Marc Blitzstein, Orson Welles, and Lehman Engle.* 1937

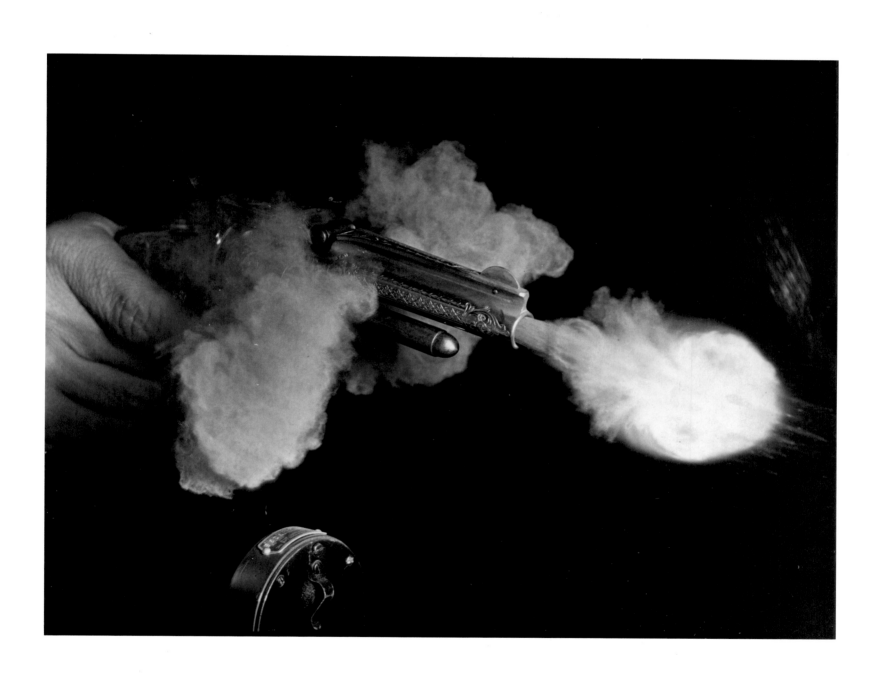

Harold Edgerton with Kenneth Germeshausen. *Dangerous Weapon.* 1936

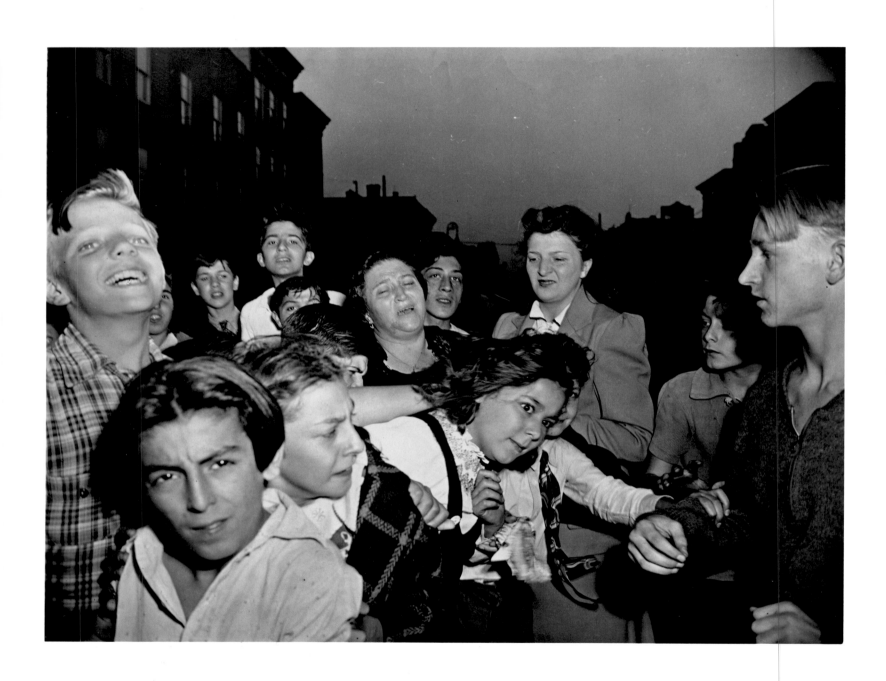

Weegee (Arthur Fellig). *Brooklyn School Children See Gambler Murdered in Street.* 1941

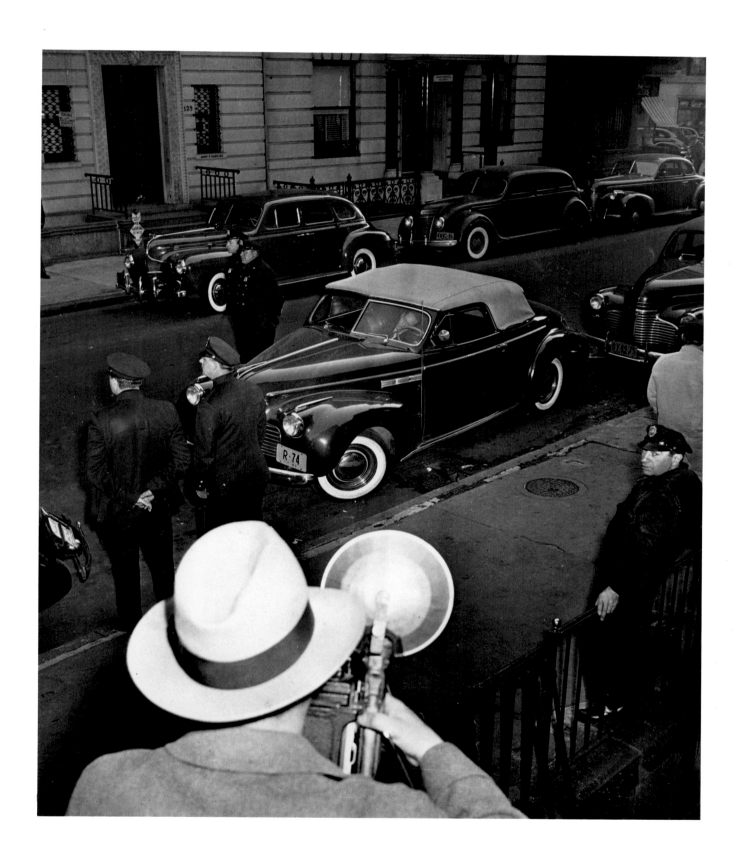

Weegee (Arthur Fellig). *Harry Maxwell Shot in Car.* 1936

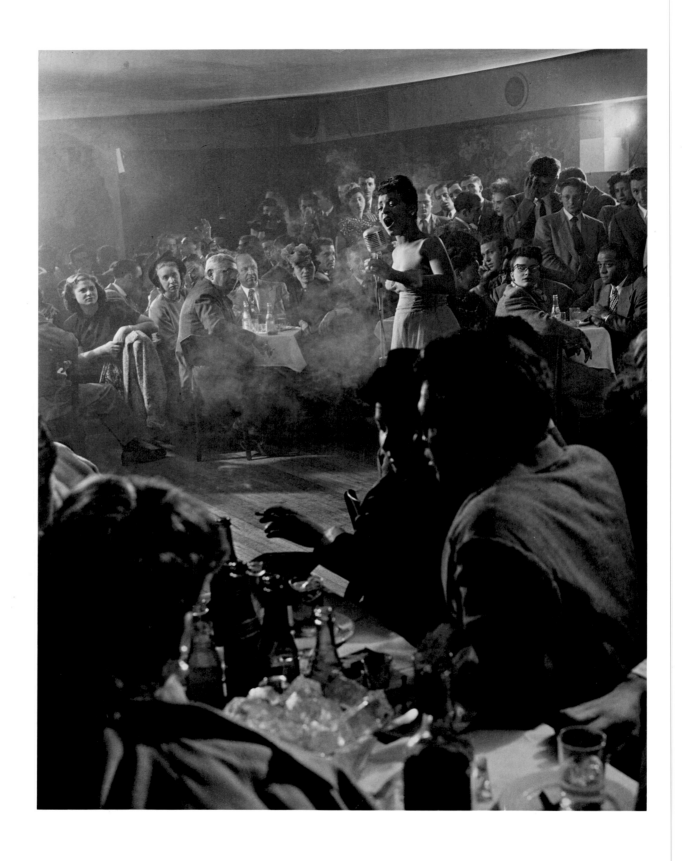

Gjon Mili. *Cafe Society, New York.* 1943–47

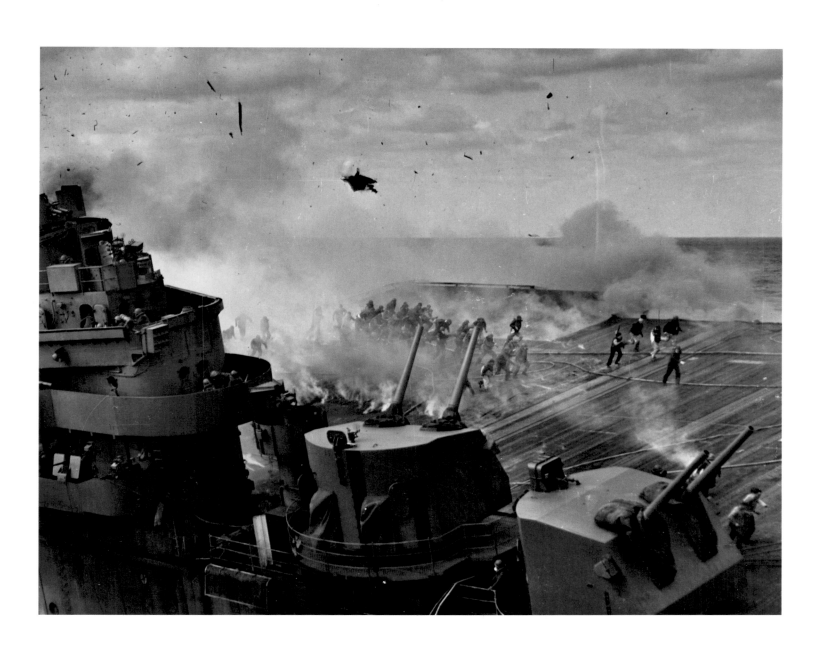

U.S. Navy. *Explosion Following Hit on the USS Franklin by Japanese Dive Bomber*. March 19, 1945

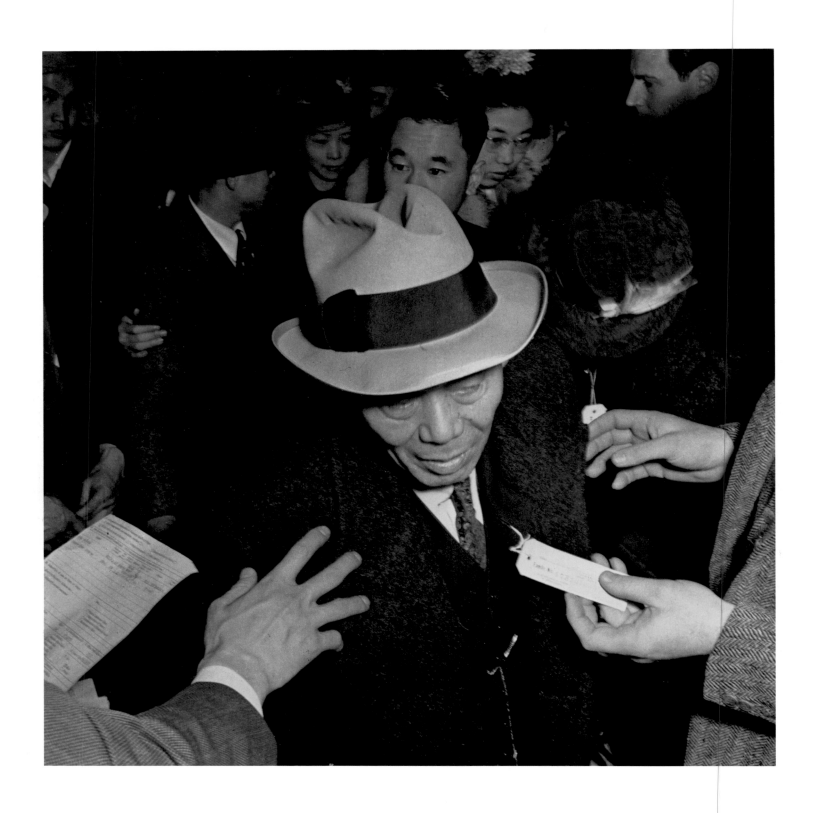

Dorothea Lange. *San Francisco*. c. 1942

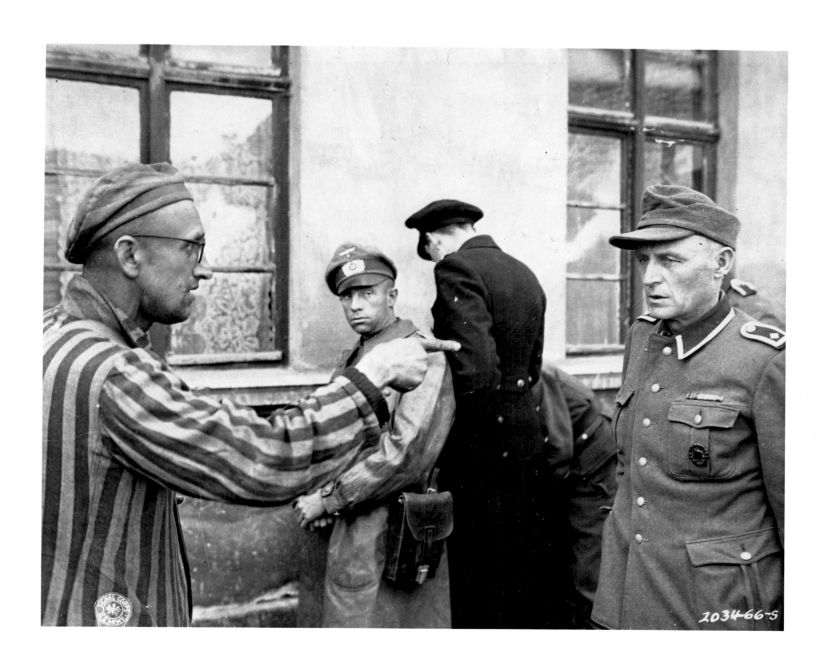

U.S. Army Signal Corps. *Russian Slave Laborer Points Out Former Nazi Guard Who Brutally Beat Prisoners.* April 14, 1945

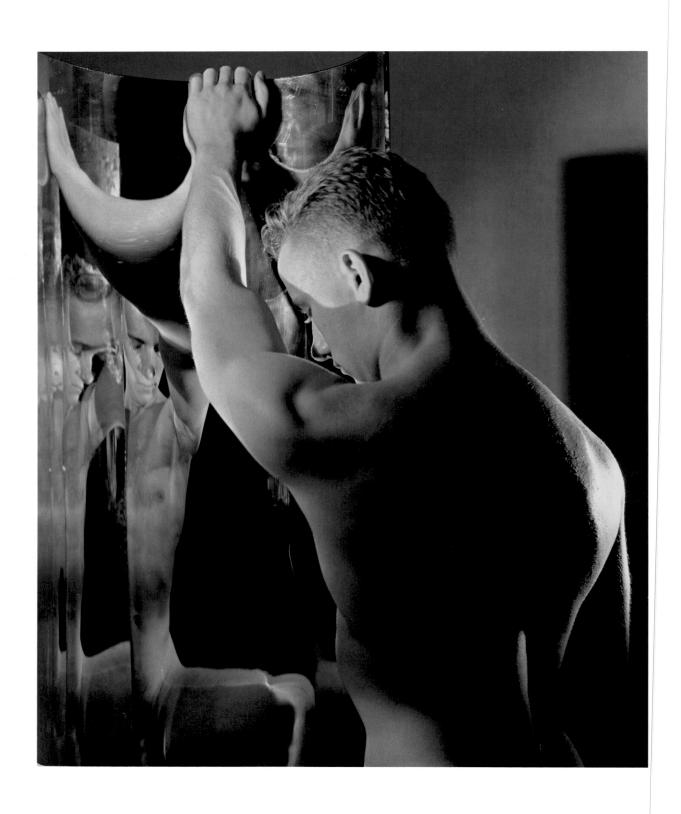

George Platt Lynes. *Self-Analysis.* c. 1940

U.S. Army Signal Corps. *Russian Slave Laborer Points Out Former Nazi Guard Who Brutally Beat Prisoners.* April 14, 1945

Harry Callahan. *Chicago.* c. 1950

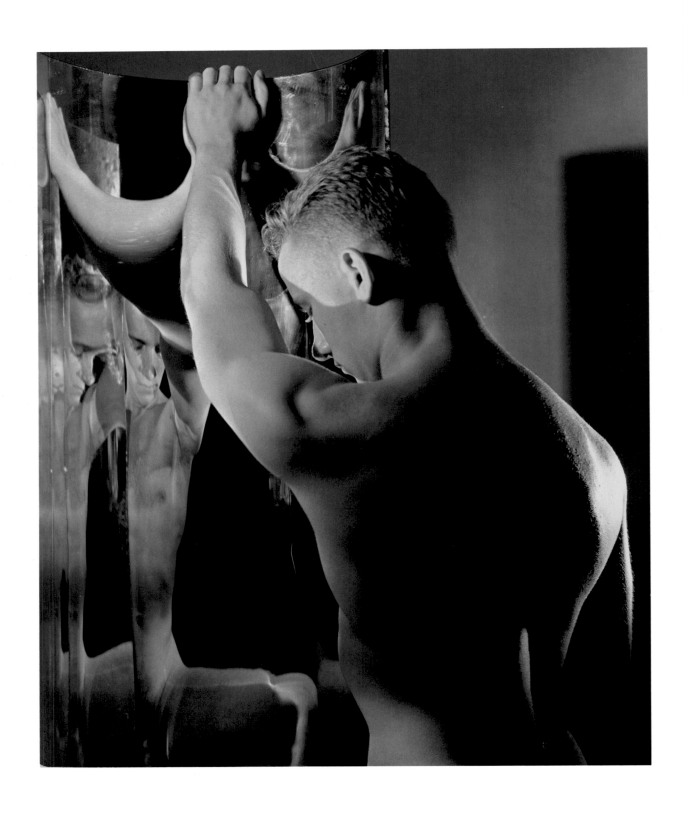

George Platt Lynes. *Self-Analysis*. c. 1940

Clarence John Laughlin. *The Eye That Never Sleeps.* 1946

Frederick Sommer. *Moon Culminations.* 1951

Frederick Sommer. *Max Ernst*. 1946

Aaron Siskind. *Gloucester.* 1944

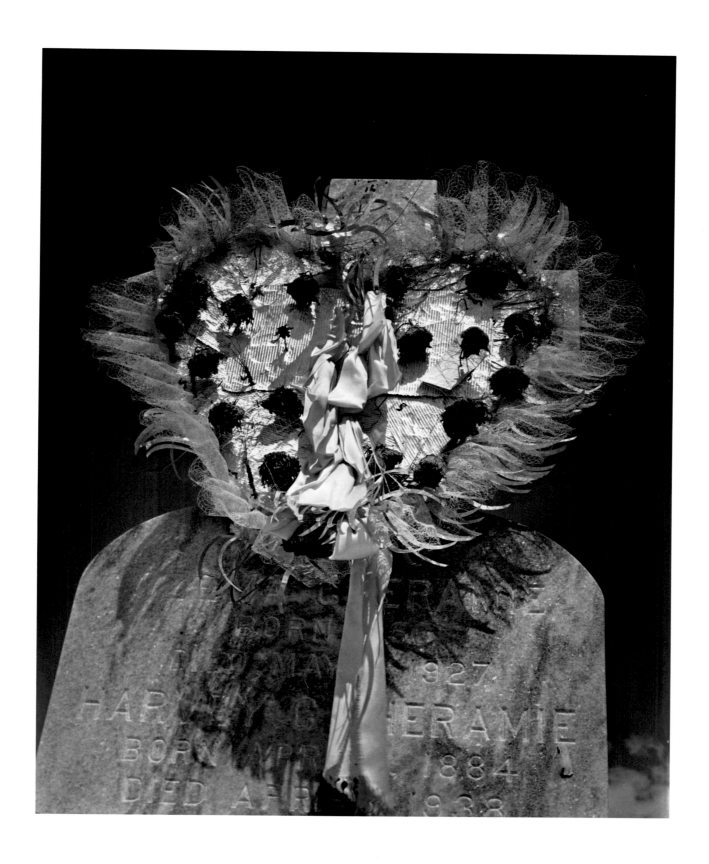

Clarence John Laughlin. *The Insect-Headed Tombstone*. 1953

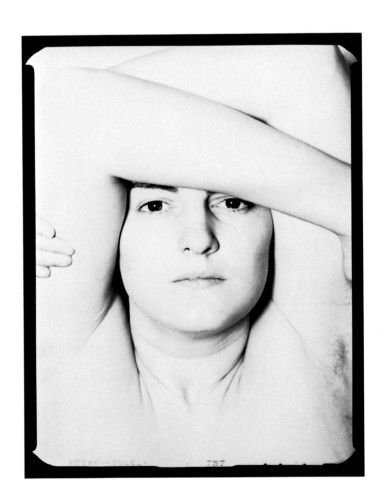

Harry Callahan. *Eleanor*. c. 1947

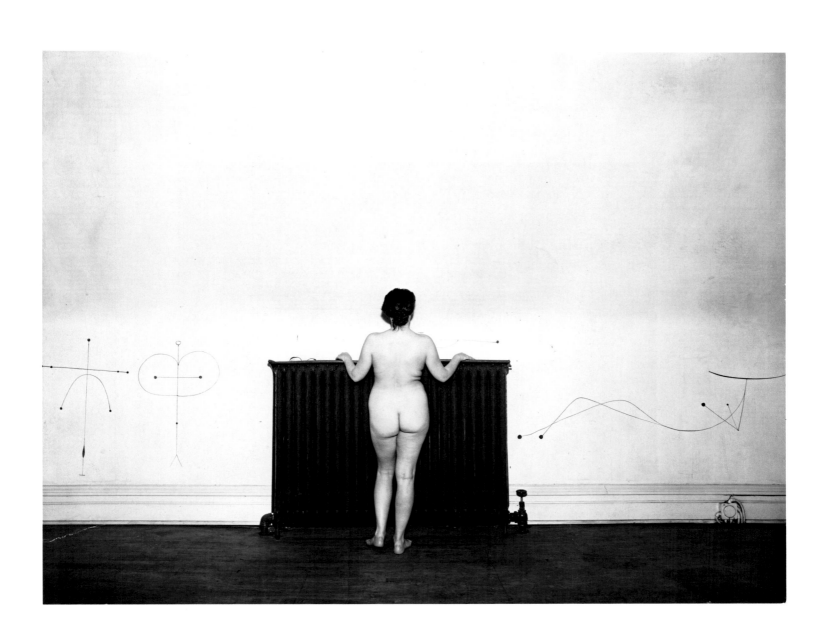

Harry Callahan. *Eleanor, Chicago.* 1949

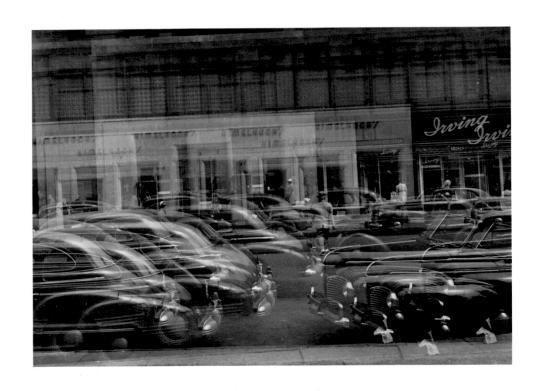

Harry Callahan. *Detroit.* 1943

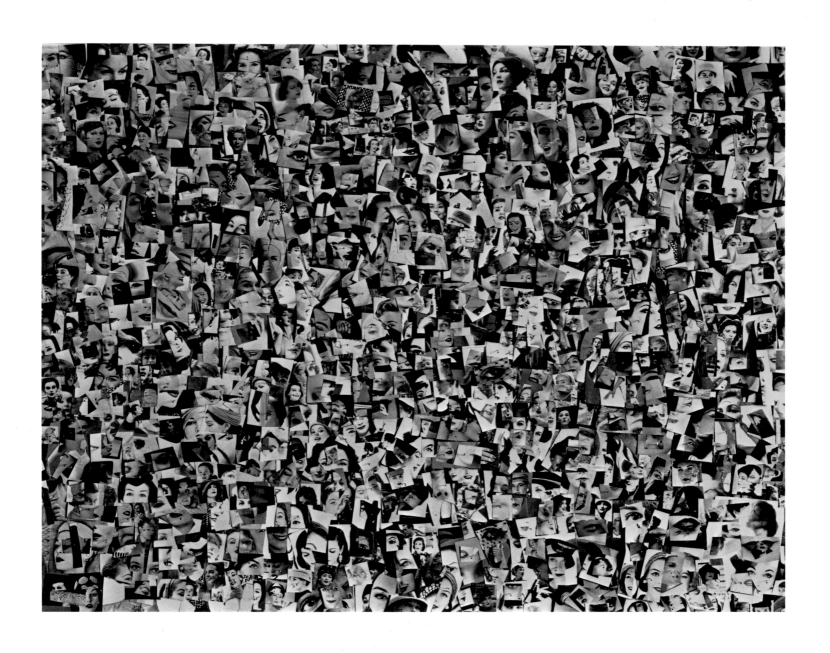

Harry Callahan. *Collages*. c. 1956

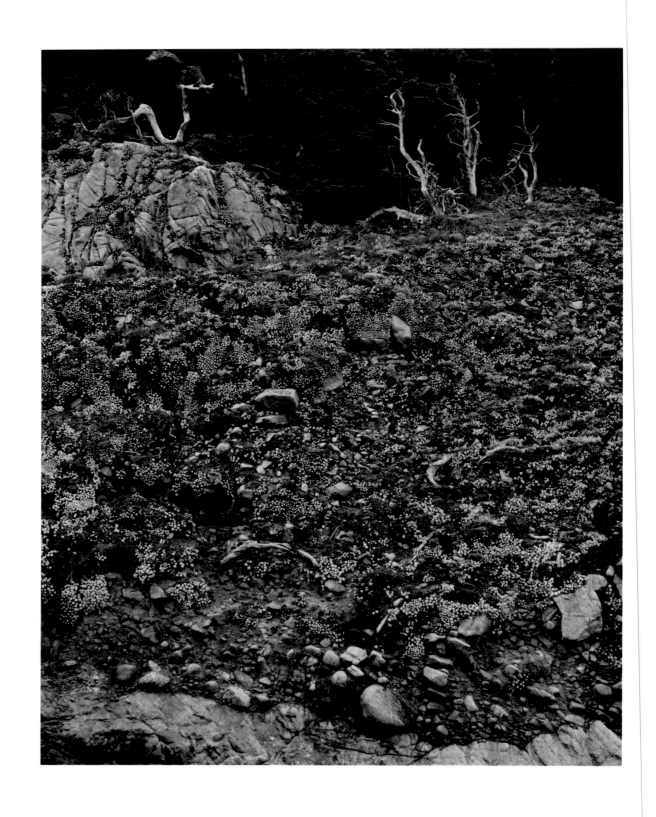

Edward Weston. *North Shore, Point Lobos, California.* 1946

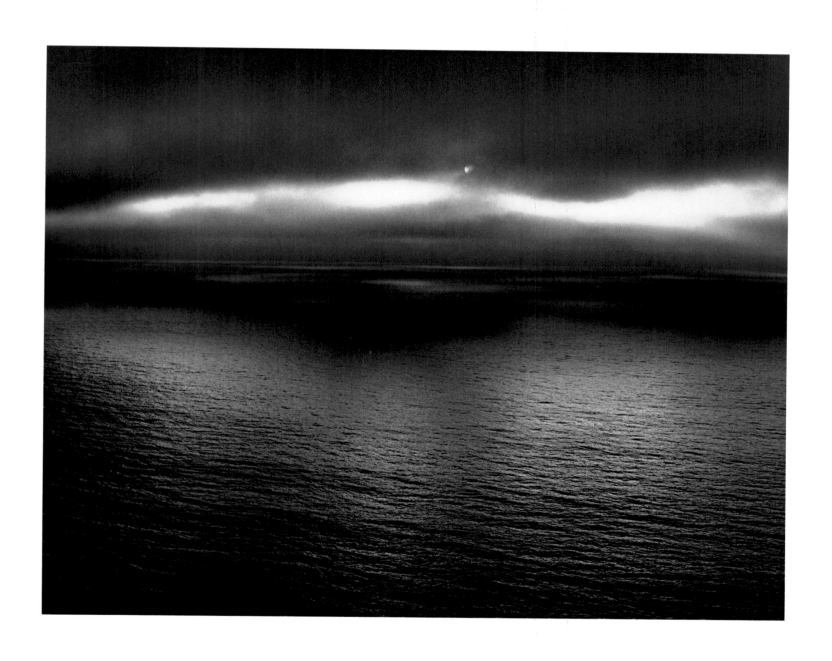

Minor White. *Pacific.* 1947

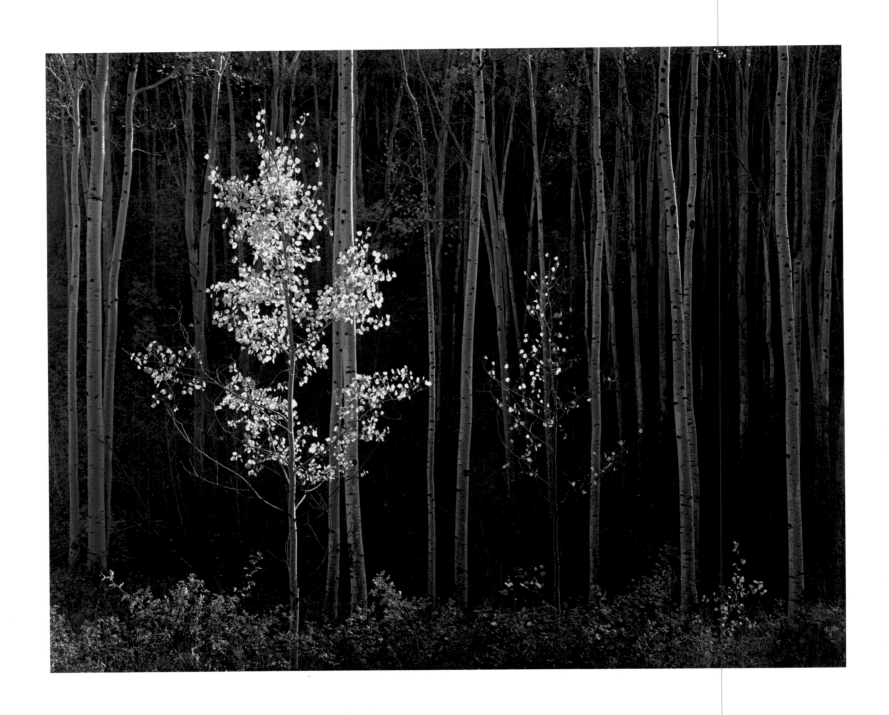

Ansel Adams. *Aspens, Northern New Mexico.* 1958

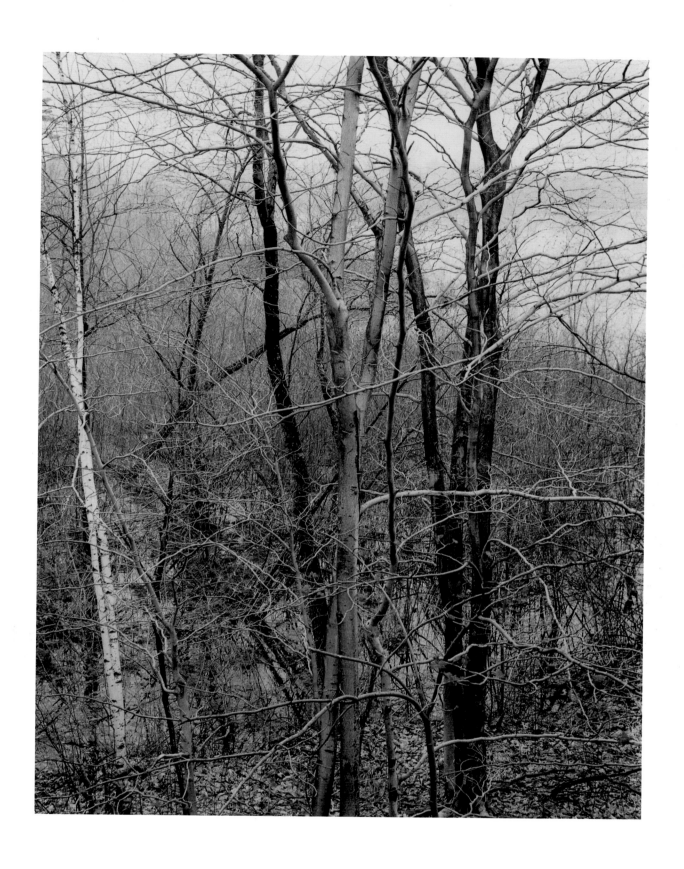

Eliot Porter. *Trees and Pond, Near Sherborn, Massachusetts.* 1957

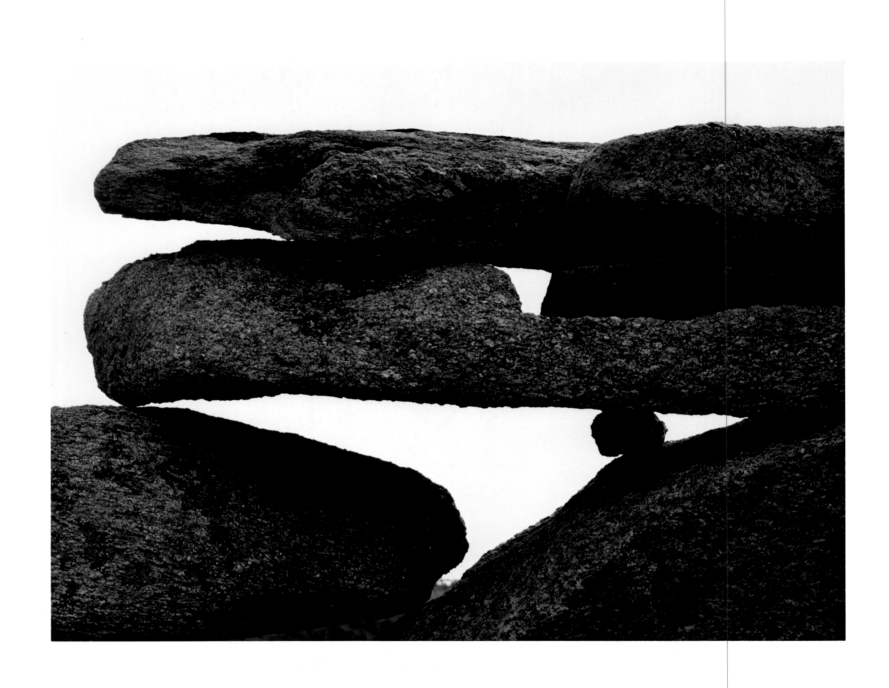

Aaron Siskind. *Martha's Vineyard.* 1954

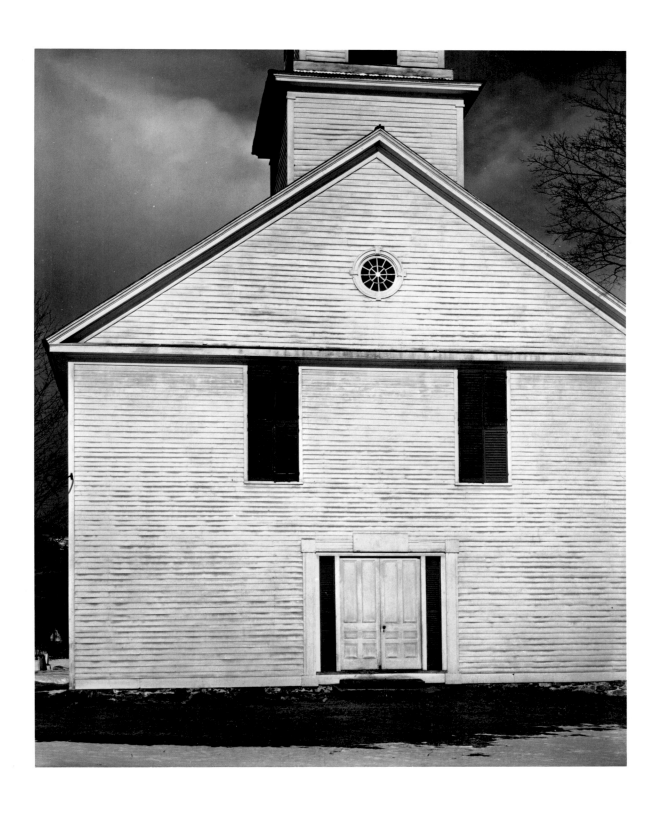

Paul Strand. *Church.* 1944

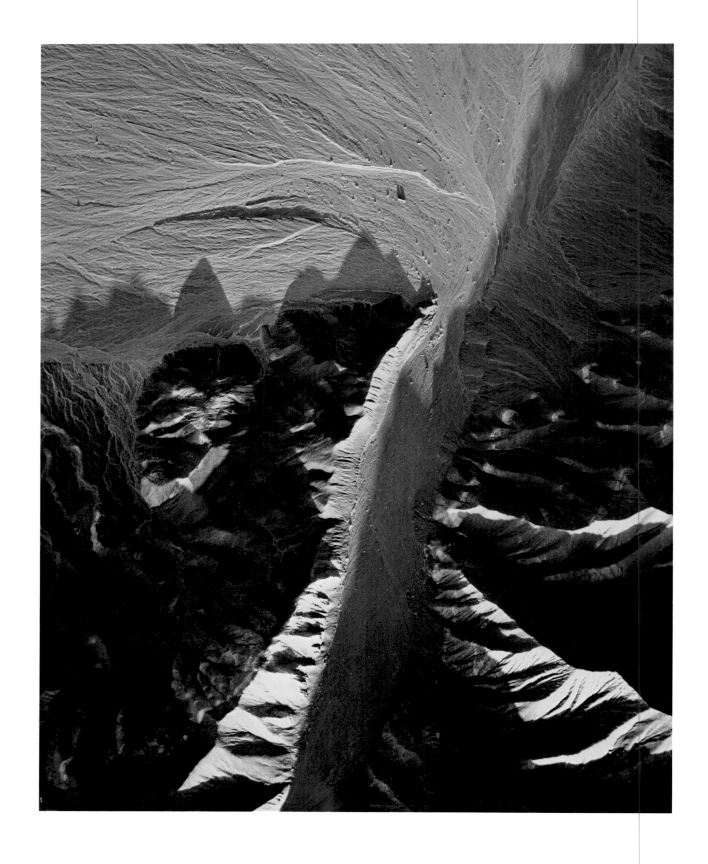

William A. Garnett. *Dry Wash with Alluvium, Death Valley, California.* 1957

Aaron Siskind. *Chicago.* 1949

John Szarkowski. *Column Capital, Guaranty Building, Buffalo.* 1952

Irving Penn. *George Jean Nathan and H. L. Mencken.* 1947

Irving Penn. *Still Life with Watermelon.* 1947

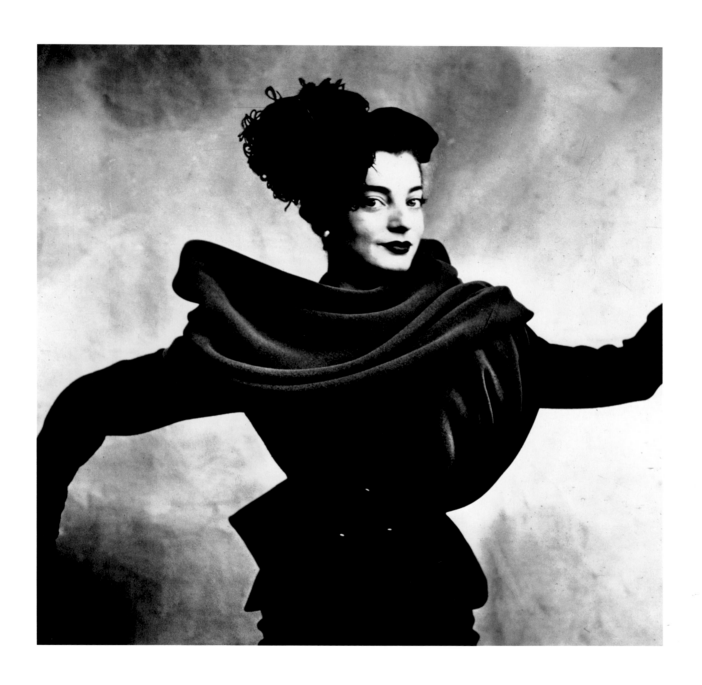

Irving Penn. *Régine* (Balenciaga Suit). 1950

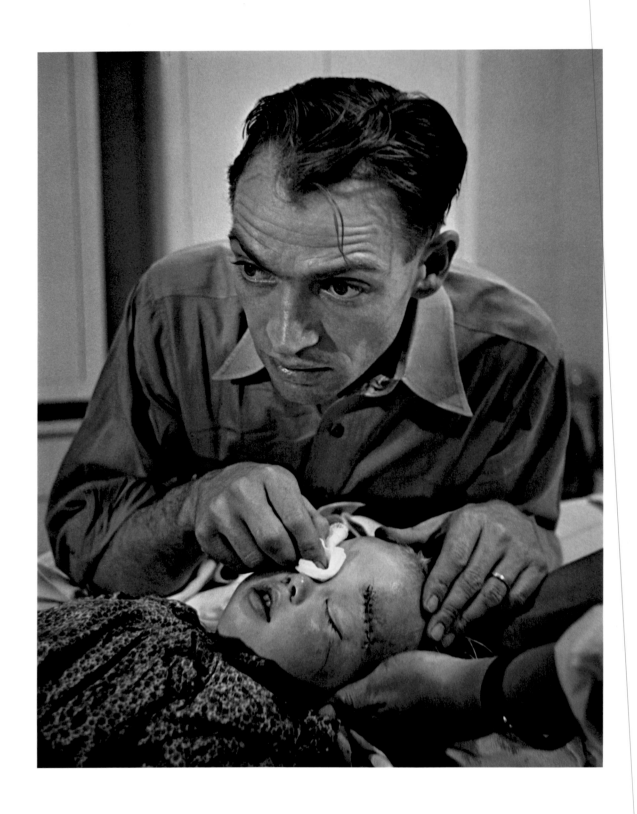

W. Eugene Smith. Untitled, from "Country Doctor." 1948

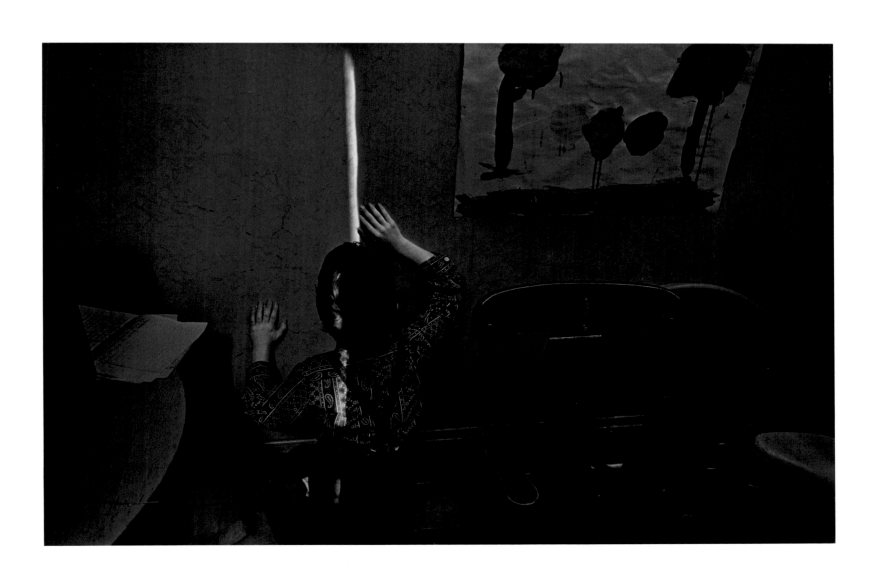

Charles Harbutt. *Blind Boy.* 1961

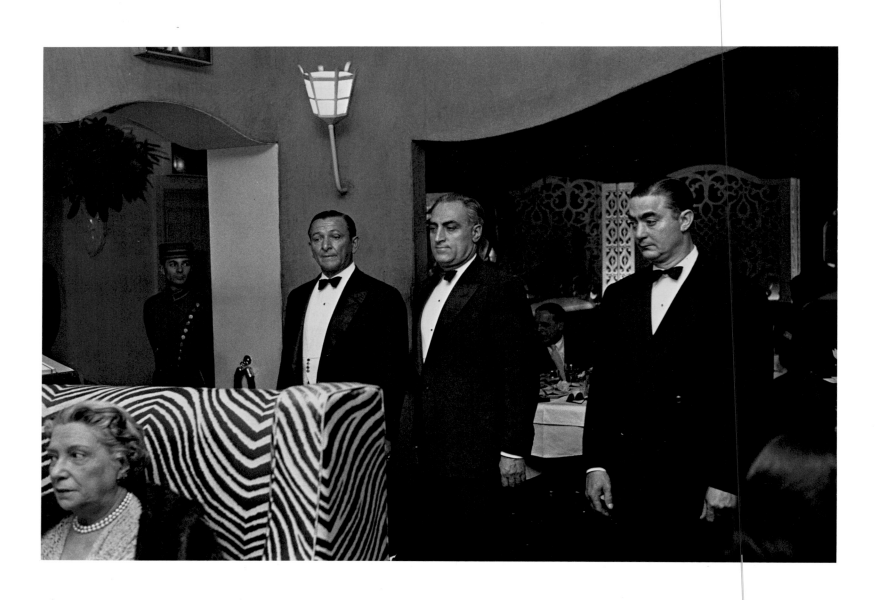

Dan Weiner. *El Morocco, New York.* 1955

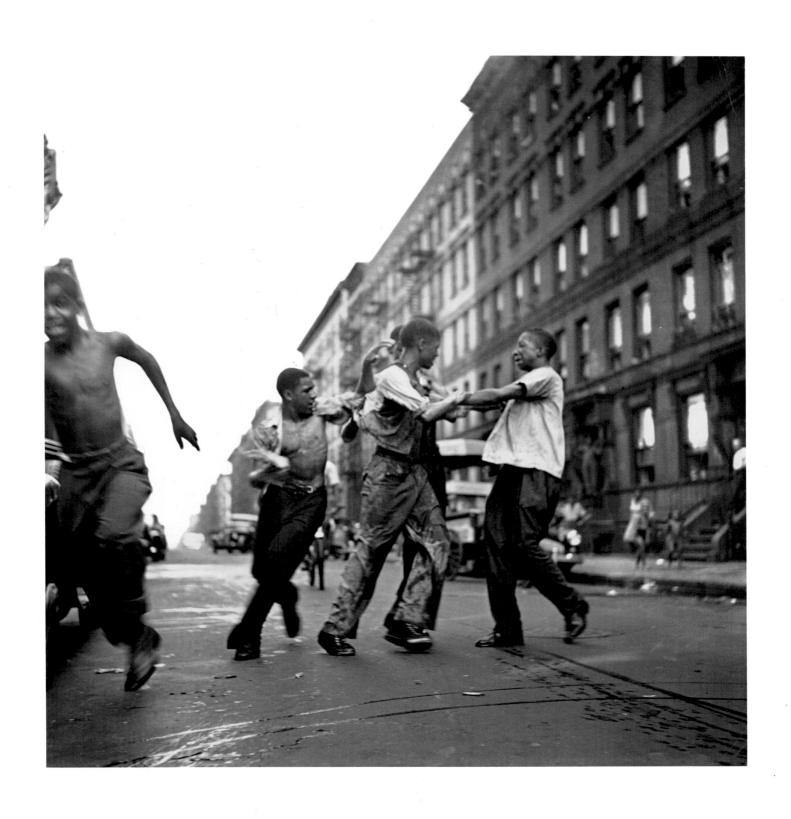

Gordon Parks. *Harlem Gang Wars.* 1948

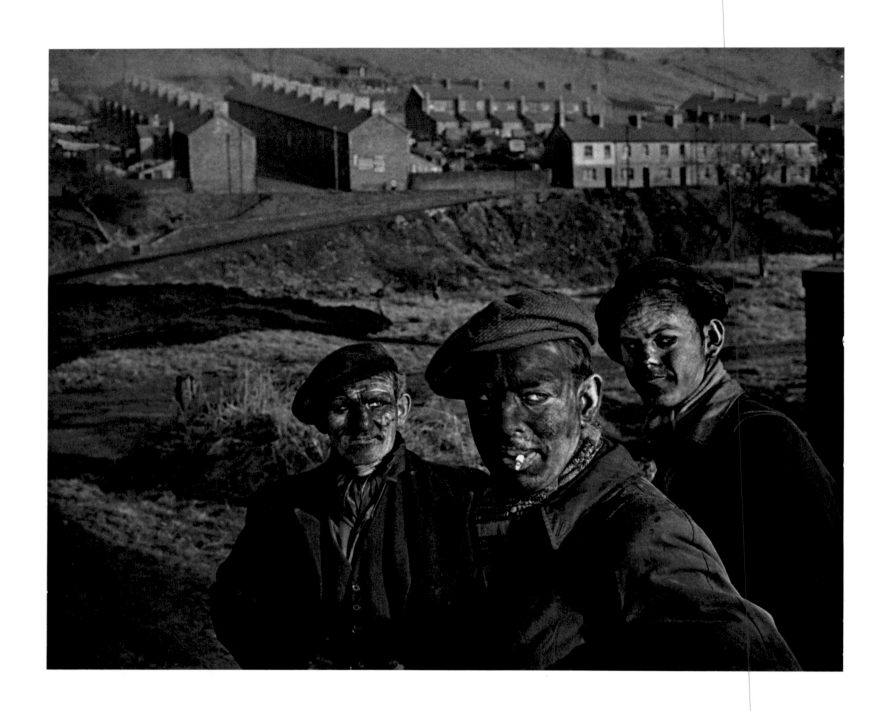

W. Eugene Smith. *Welsh Miners.* 1950

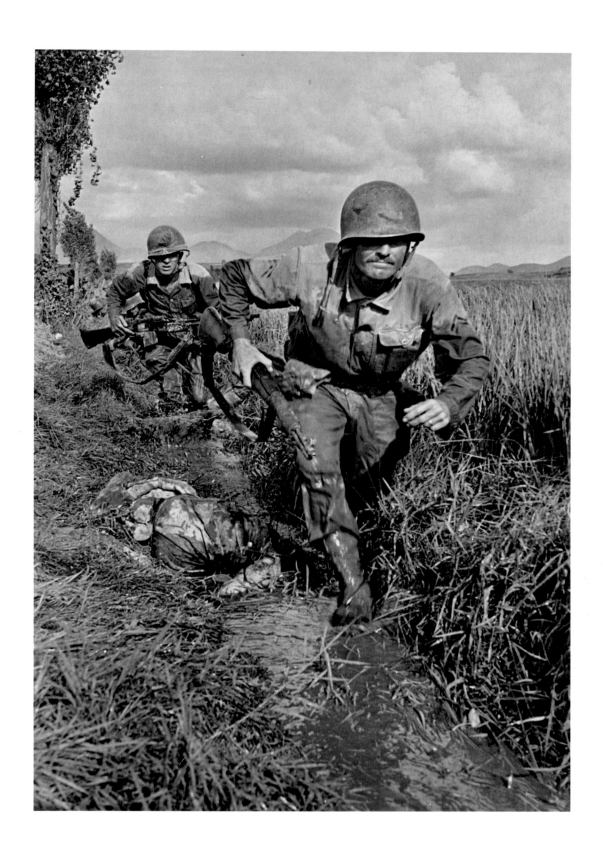

David Douglas Duncan. *Korea.* 1950

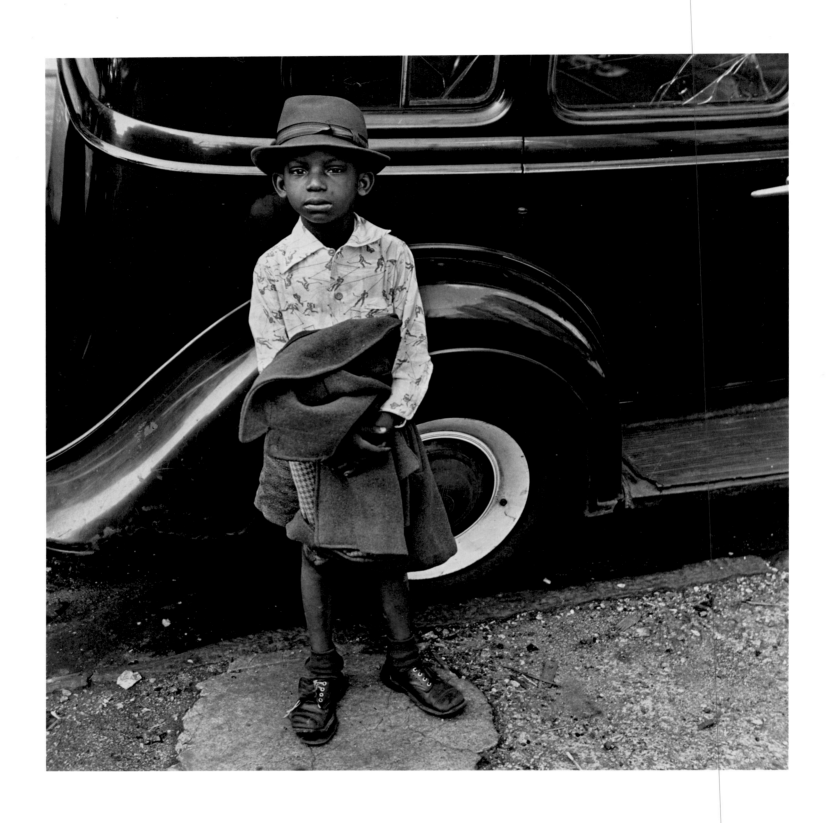

Jerome Liebling. *Boy and Car, New York City.* 1948

Louis Faurer. *George Barrows in Robert Frank's Loft.* 1947

Robert Frank. *Street Line, New York.* 1951

Harry Callahan. *Chicago.* 1950

Robert Rauschenberg. Untitled. 1949

Walter Chappell. *Number 10.* 1958

Paul Caponigro. Untitled. 1957

Minor White. *Peeled Paint.* 1959

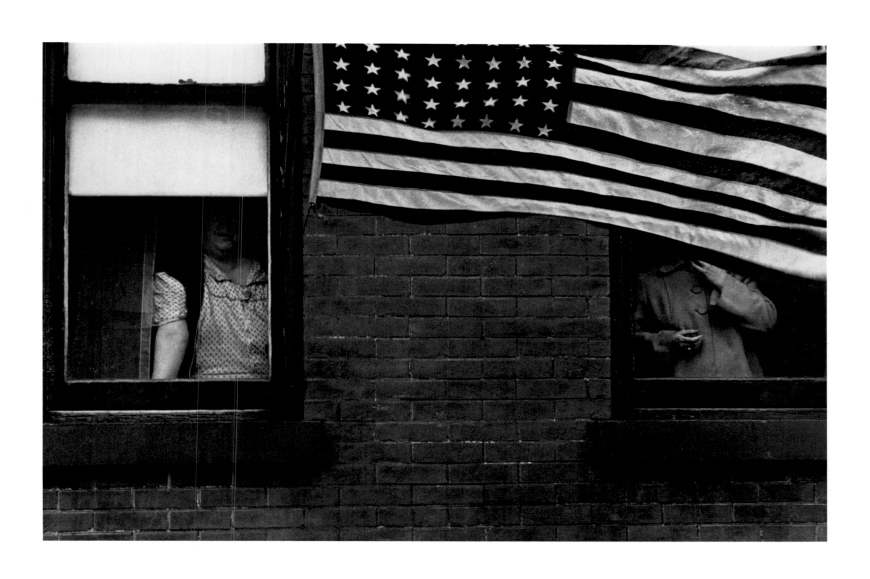

Robert Frank. *Parade, Hoboken, New Jersey.* 1955

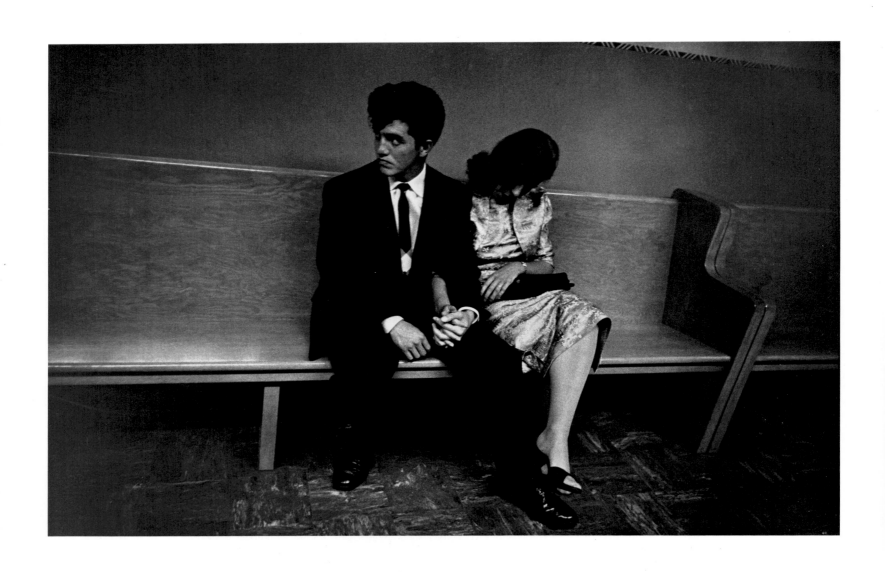

Robert Frank. *Reno, Nevada.* 1956

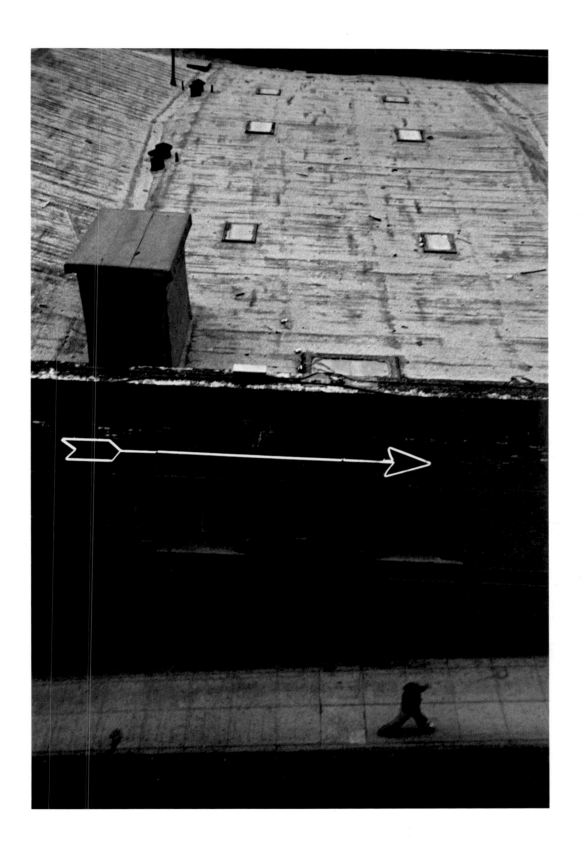

Robert Frank. *Los Angeles.* 1955–56

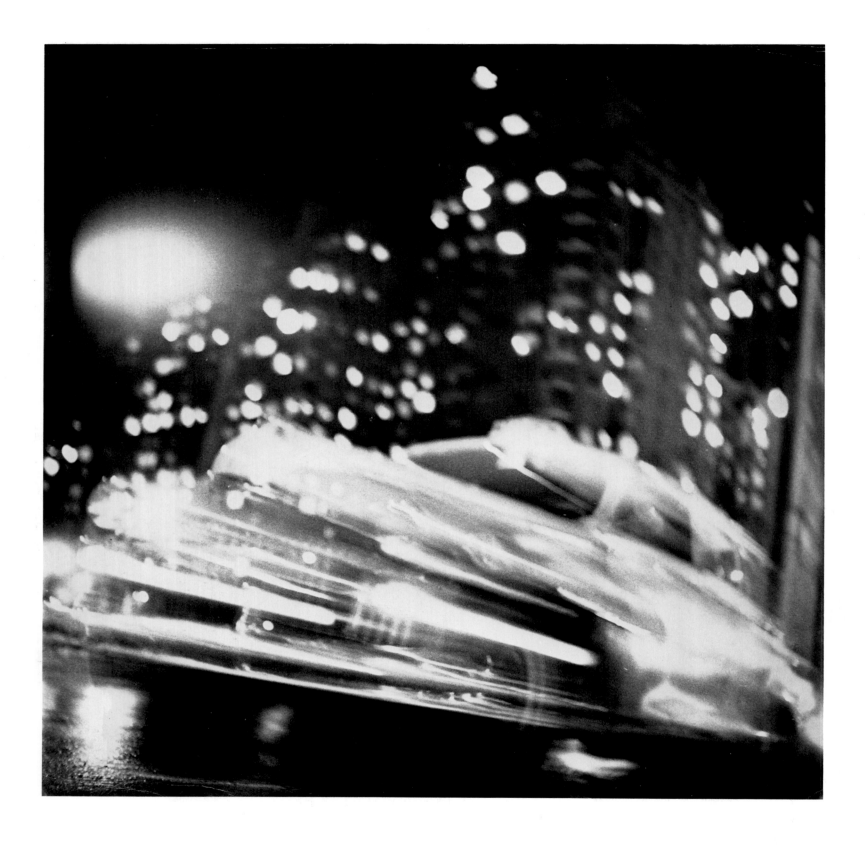

Ted Croner. Untitled. 1947–49

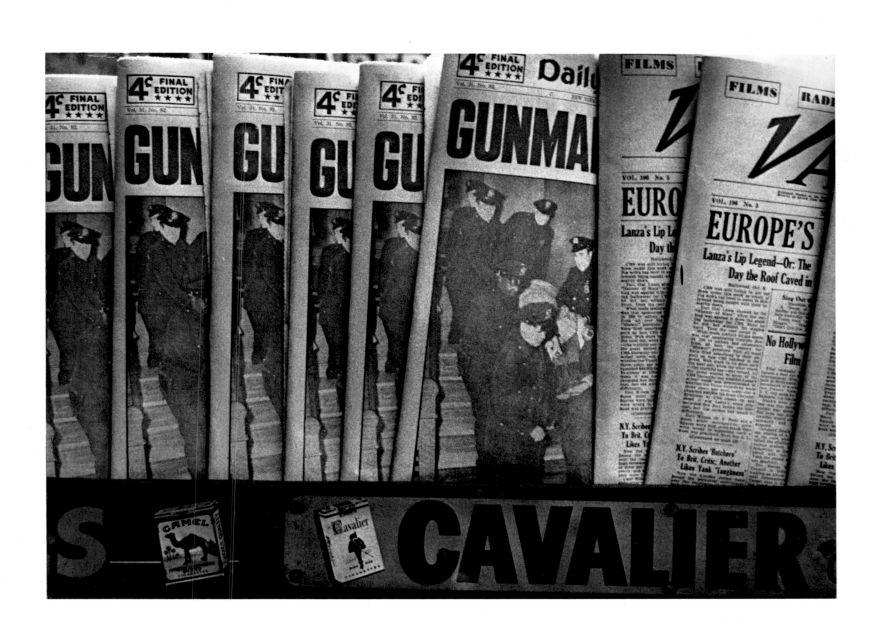

William Klein. *Gun, Gun, Gun, New York.* 1955

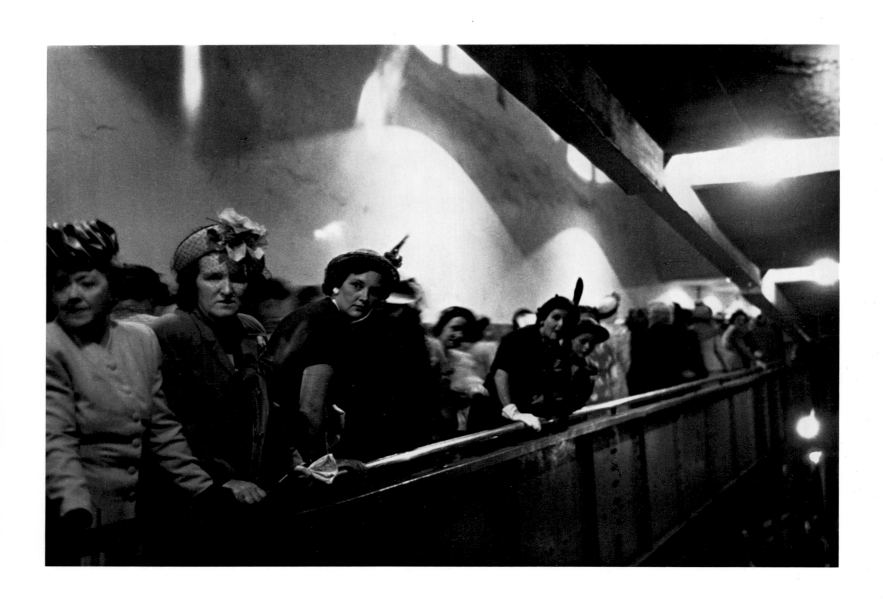

Dan Weiner. *Shoppers Glimpse a Movie Star at Grand Central Station, New York.* 1953

Louis Faurer. Untitled. 1950

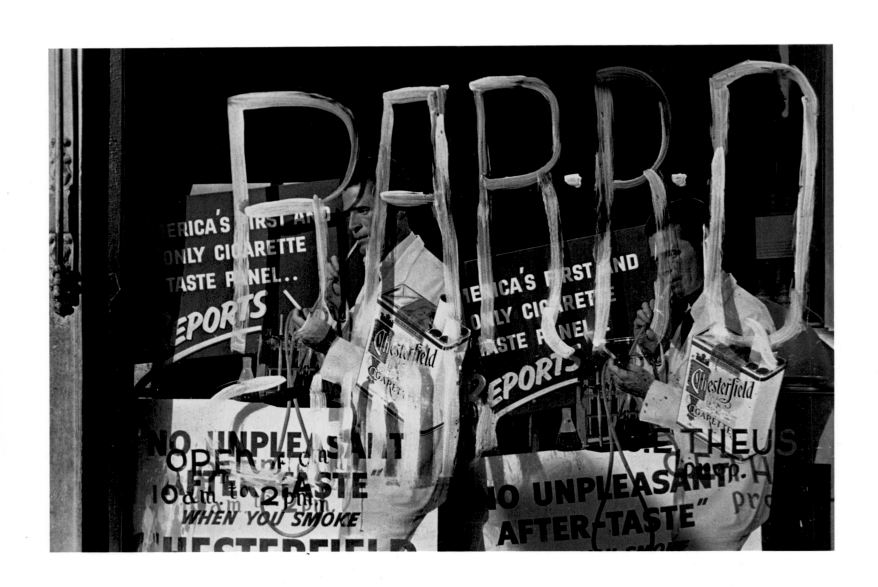

Philip Elliott. *Bar-B-Q.* 1952 or earlier

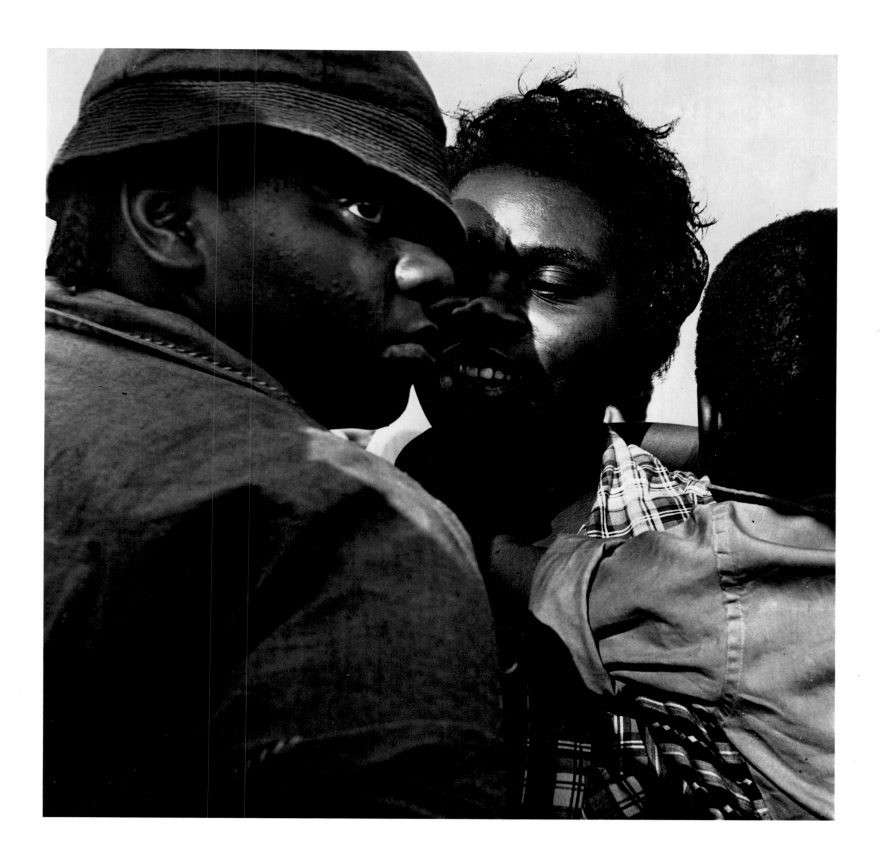

Leon Levinstein. *Coney Island.* 1953 or earlier

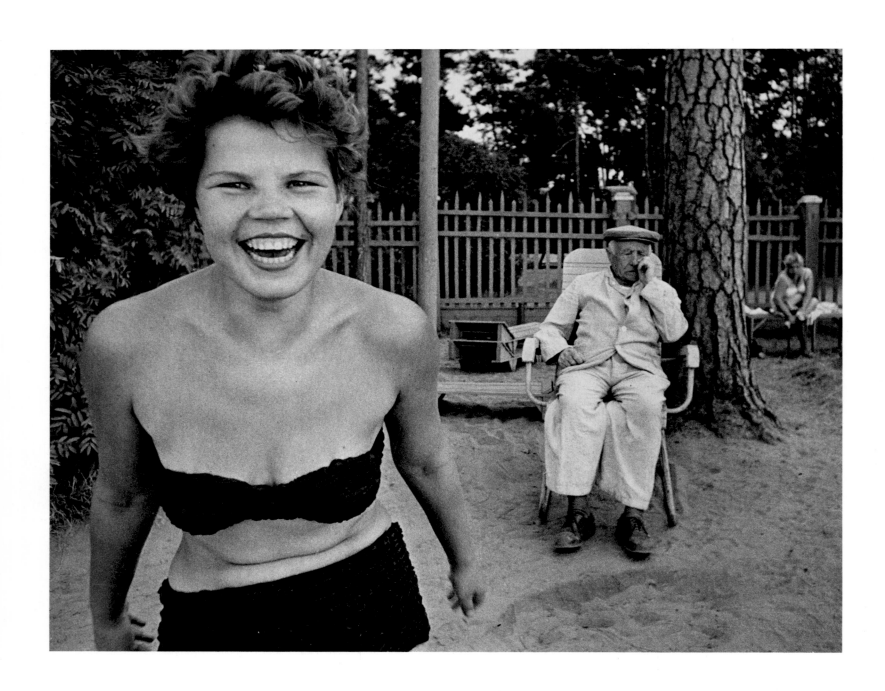

William Klein. *Moscow Beach*. 1959

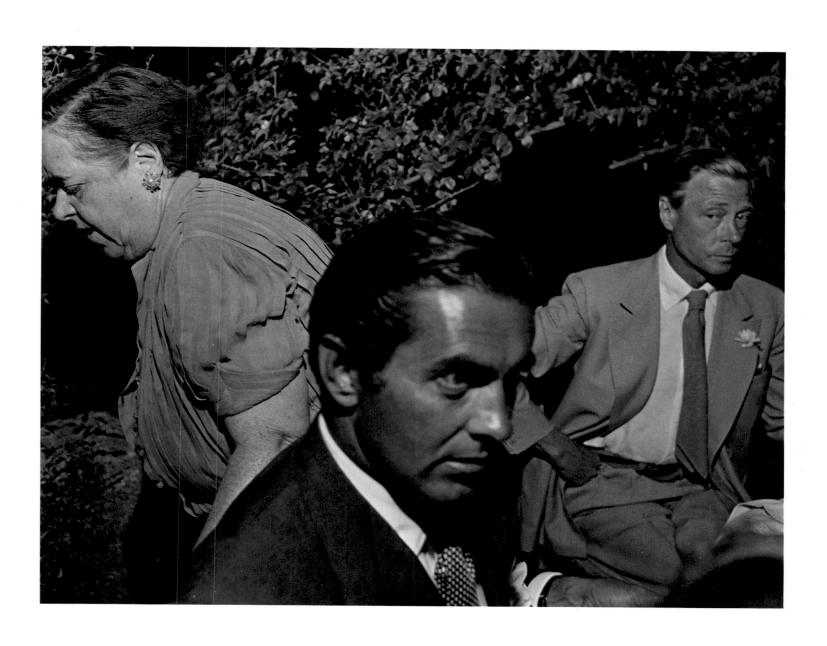

John Swope. *Cap d'Antibes, France.* 1948

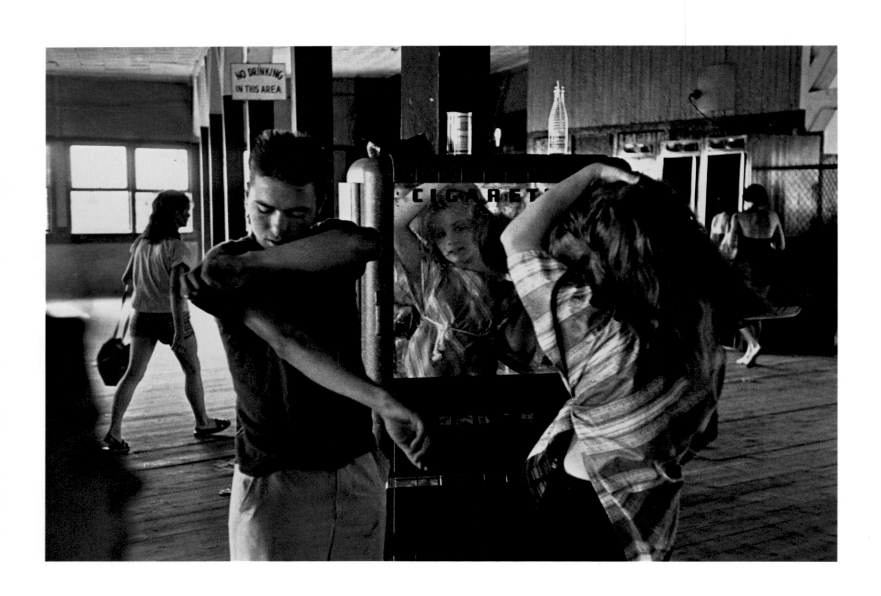

226 Bruce Davidson. Untitled, from the series Teenagers. 1959

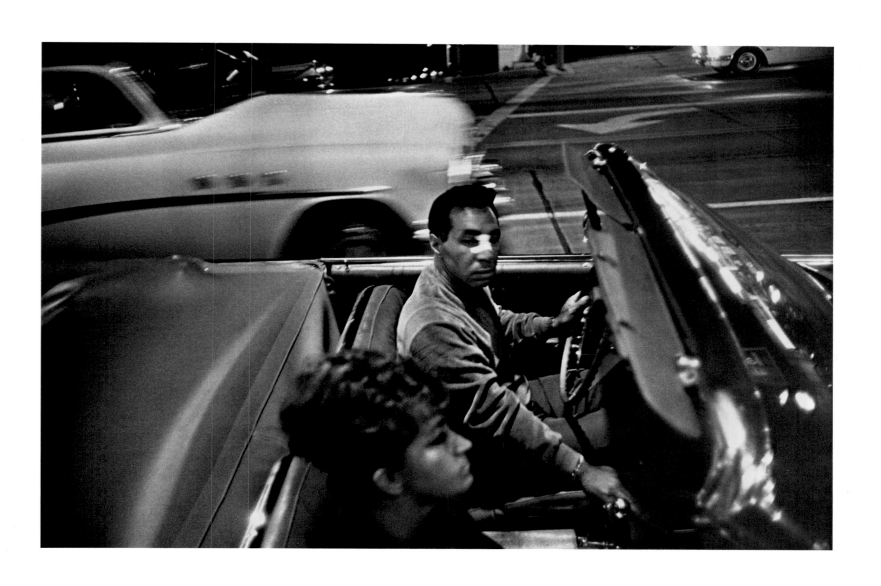

Garry Winogrand. *Los Angeles*. 1964

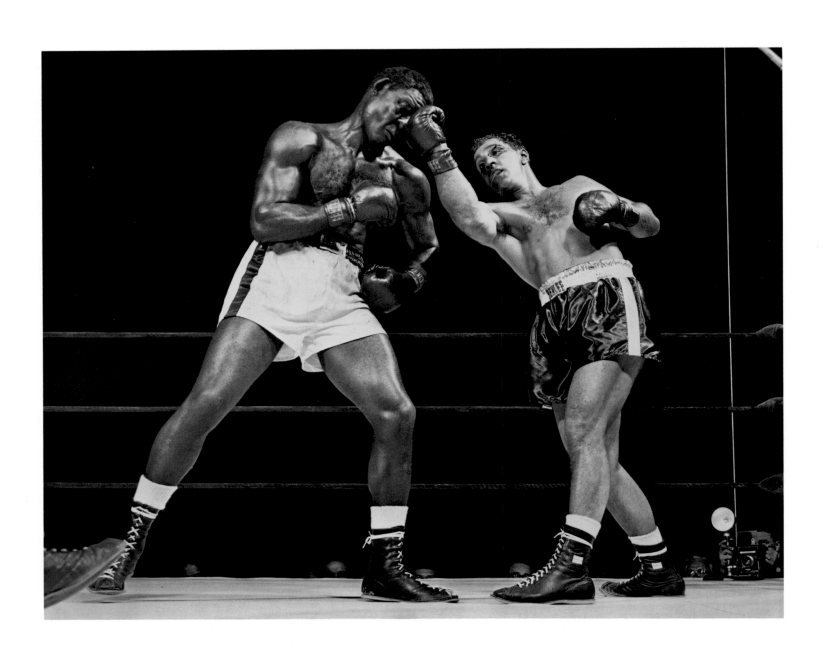

Charles Hoff. *Rocky Marciano and Ezzard Charles.* 1954

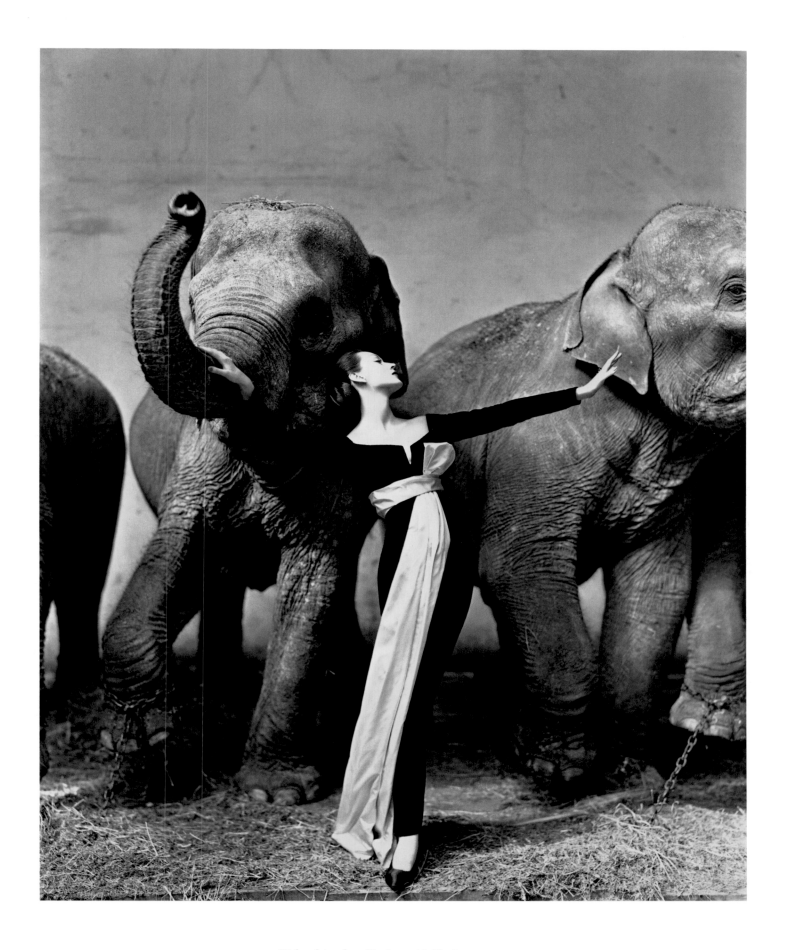

Richard Avedon. *Dovima with Elephants.* 1955

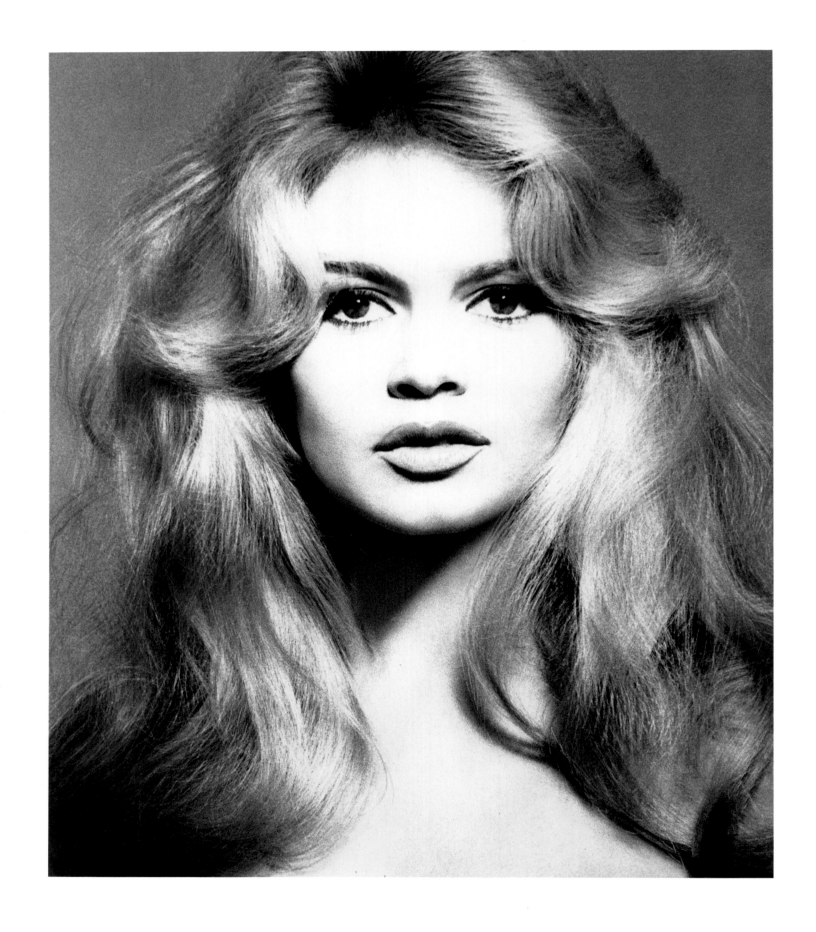

Richard Avedon. *Brigitte Bardot.* 1959

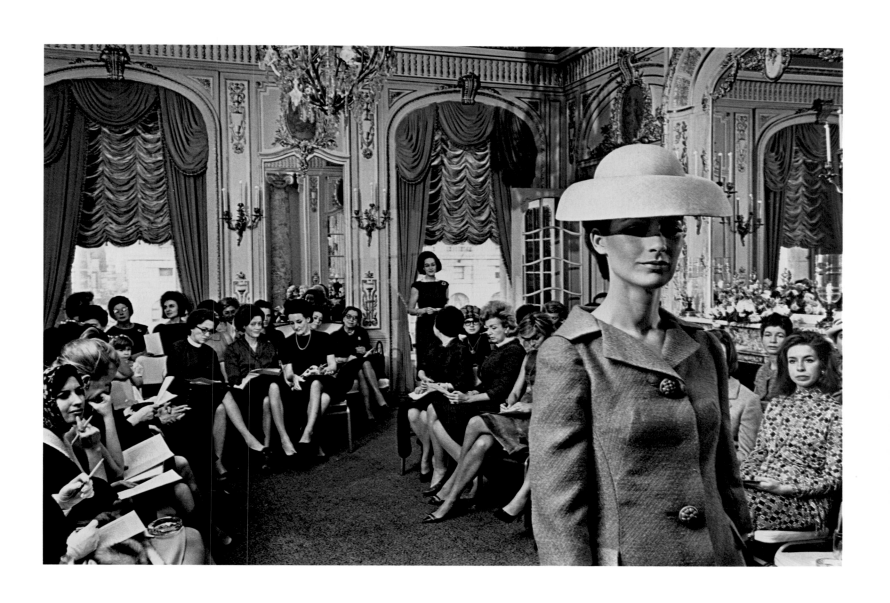

Elliott Erwitt. *New York.* 1964

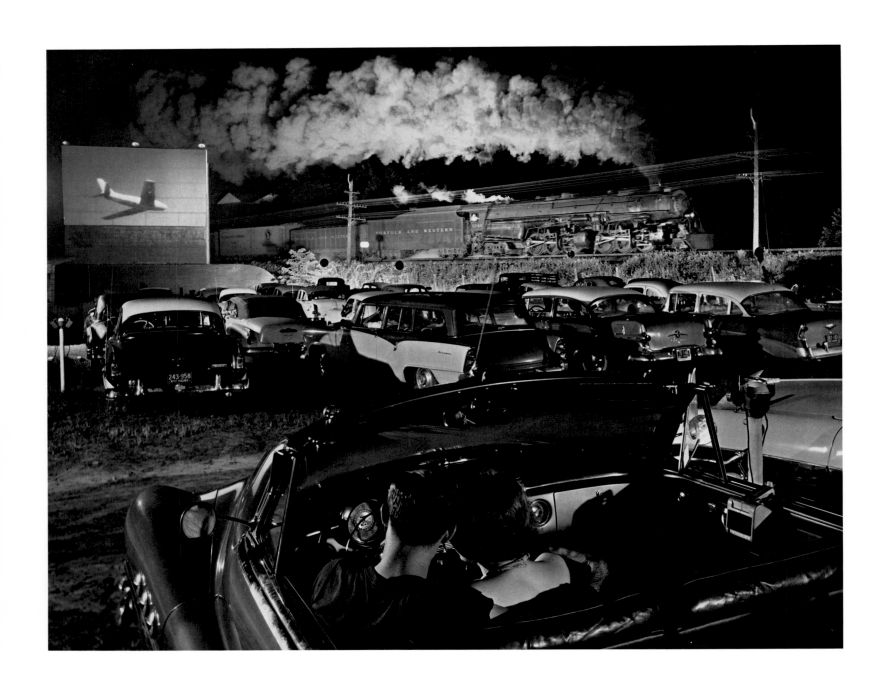

O. Winston Link. *Hot Shot East Bound at Iager, West Virginia.* 1956

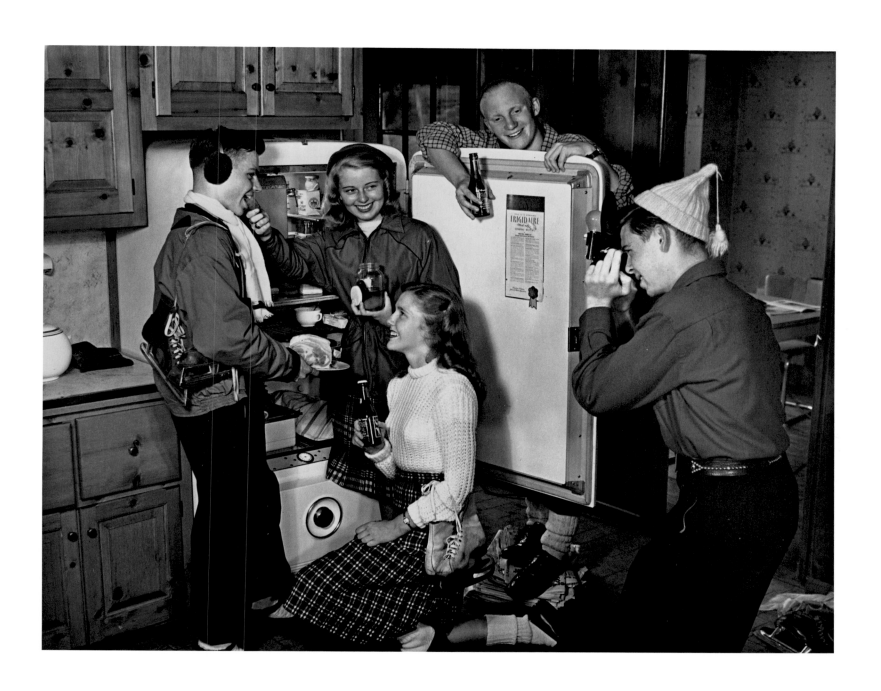

Ralph Bartholomew. *Kodak Advertisement.* c. 1950

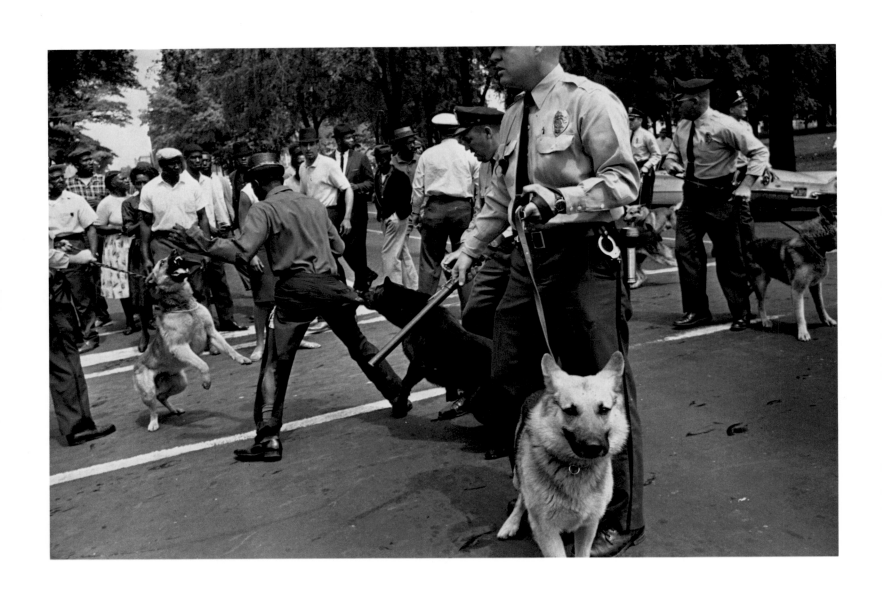

Charles Moore. *Birmingham, Alabama.* 1963

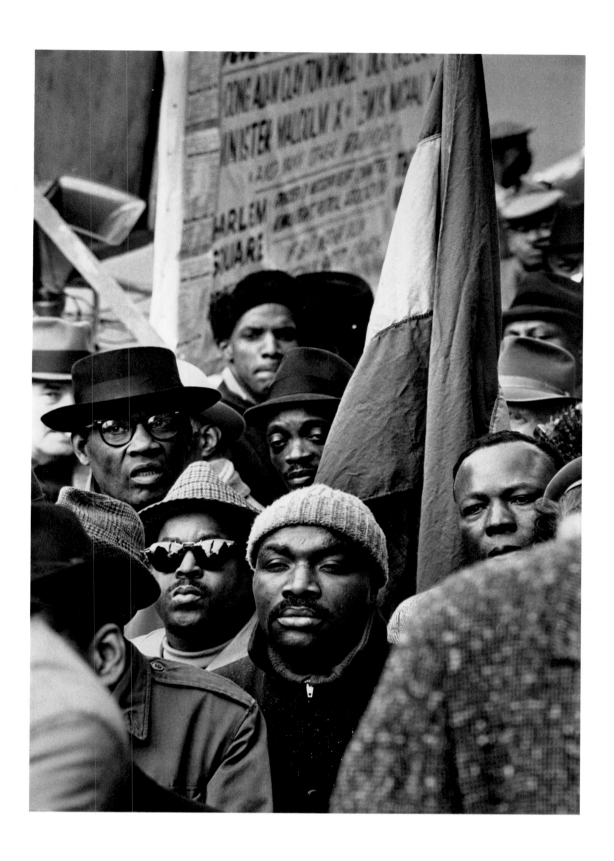

Gordon Parks. *Harlem Rally.* 1963

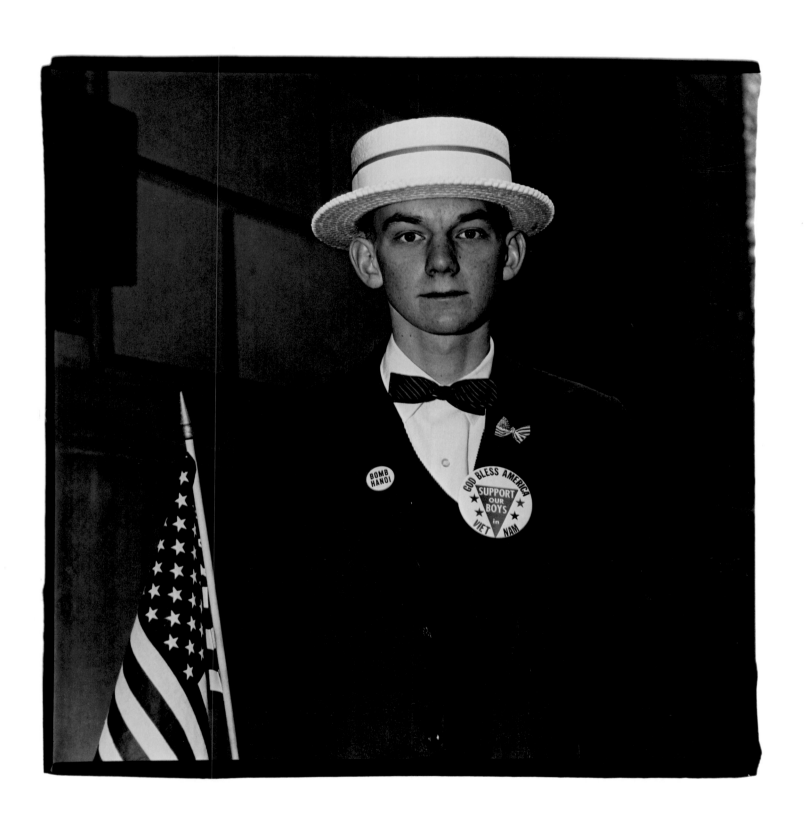

Diane Arbus. *Boy with a Straw Hat Waiting to March in a Pro-War Parade, New York City.* 1967

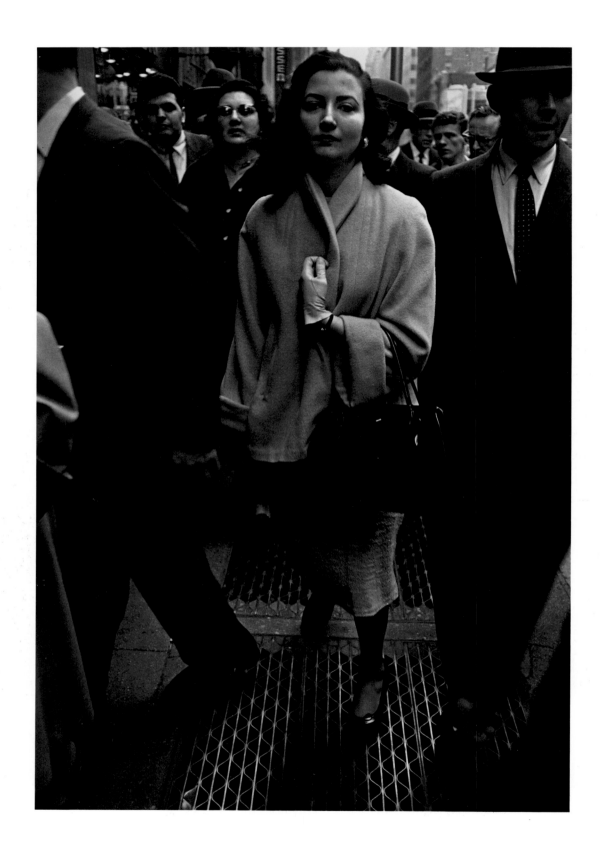

Simpson Kalisher. Untitled. 1961

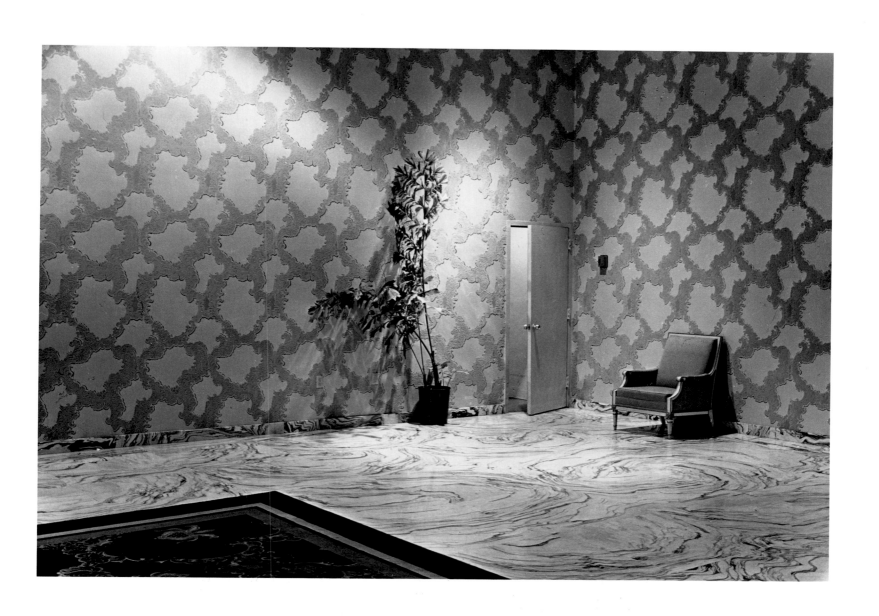

Elliott Erwitt. *Fontainebleau Hotel, Miami Beach.* 1962

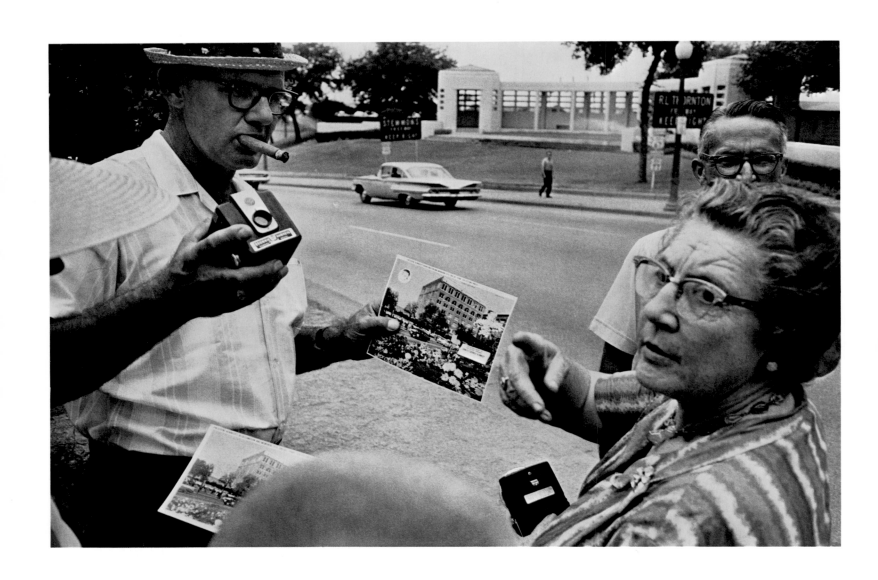

Garry Winogrand. *Dallas.* 1964

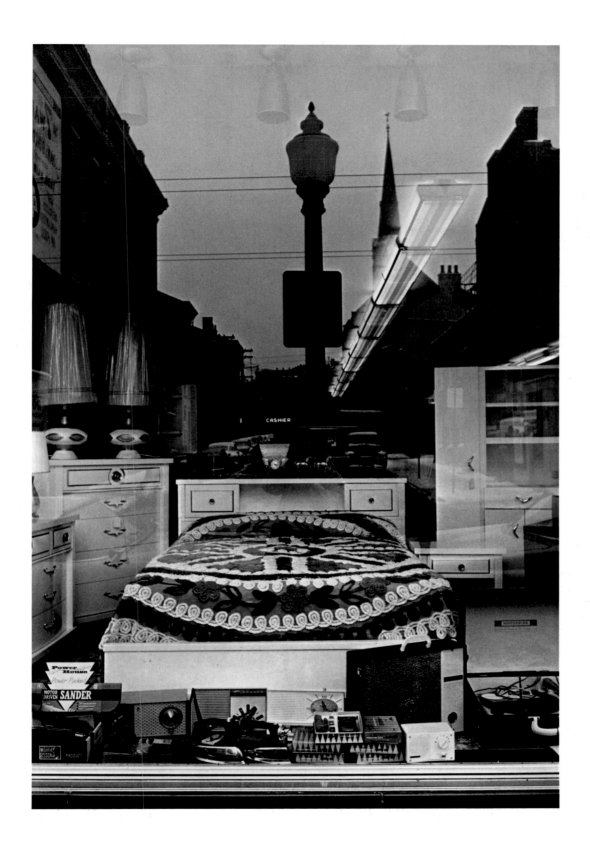

Lee Friedlander. *Cincinnati.* 1963

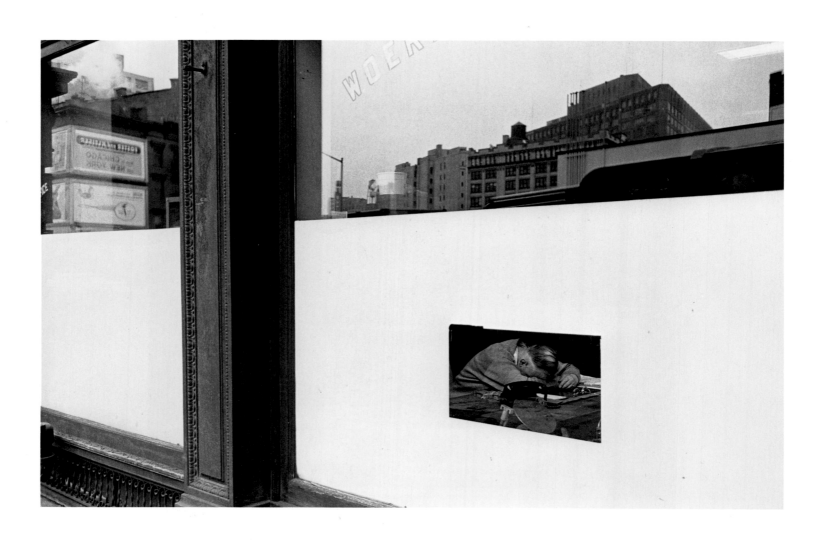

Lee Friedlander. *New York City.* 1964

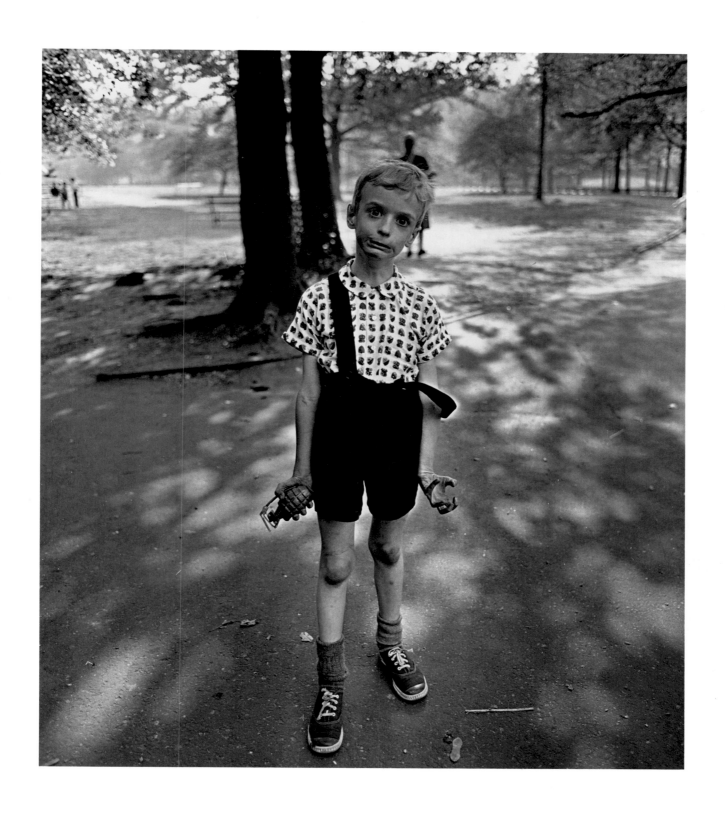

Diane Arbus. *Child with Toy Hand Grenade in Central Park, New York City.* 1962

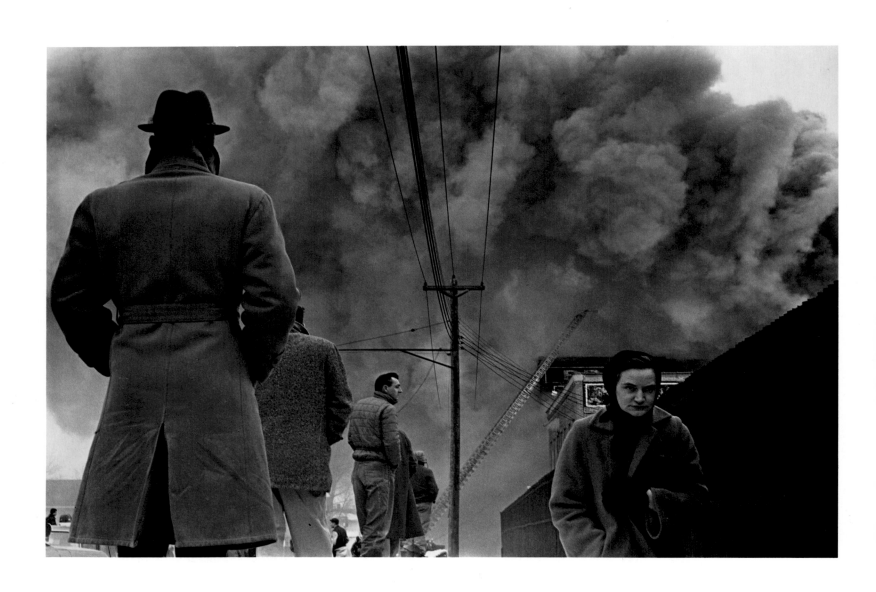

Irwin Klein. *Minneapolis Fire*. 1962

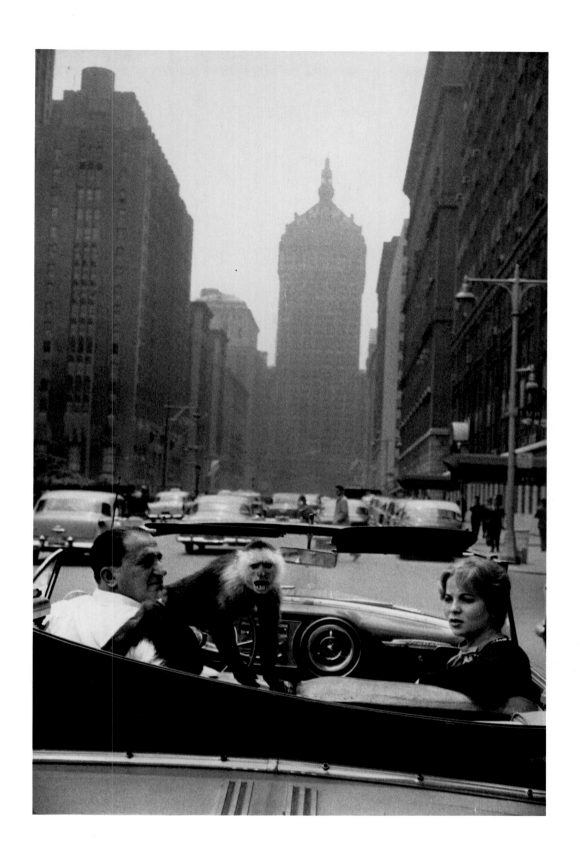

Garry Winogrand. *Park Avenue, New York.* 1959

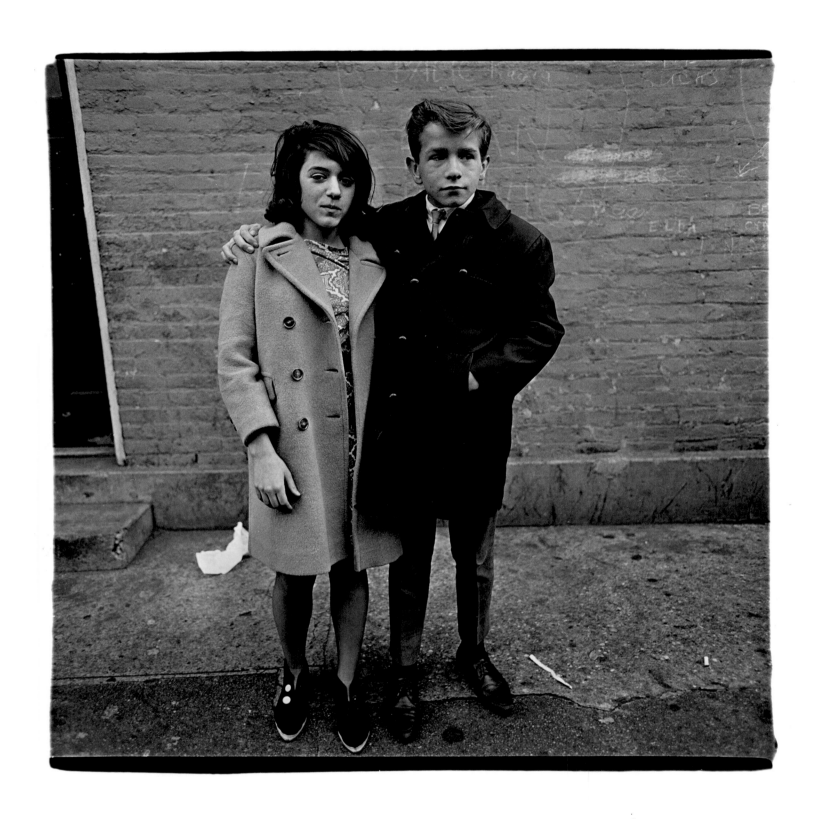

Diane Arbus. *Teenage Couple on Hudson Street, New York City.* 1963

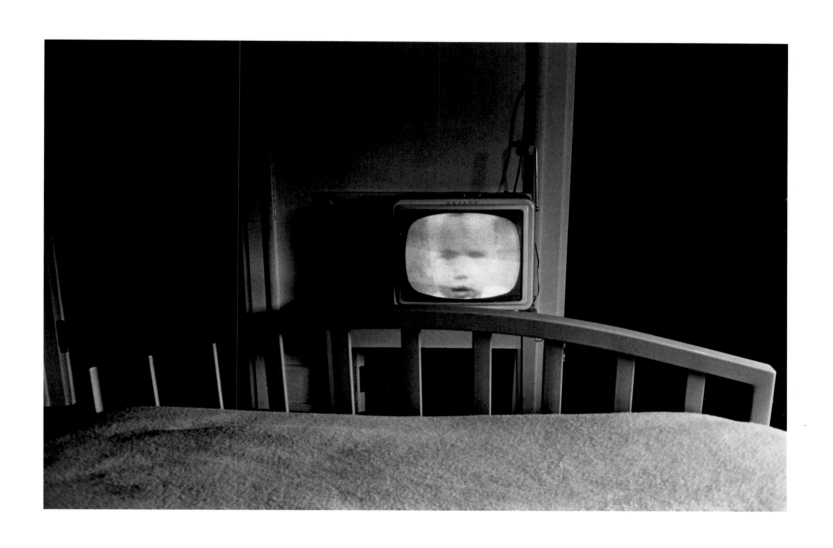

Lee Friedlander. *Galax, Virginia.* 1962

List of Plates

The plates are listed alphabetically by photographer and chronologically under each photographer's name. Works whose authors are unidentified appear at the end of the list. For photographers who were born outside the United States, the country of birth and the date of arrival in the United States are noted after the name. In the dimensions, height precedes width. All works are in the collection of The Museum of Modern Art, New York. The number of the page on which the plate appears is noted at the end of each entry.

Berenice Abbott
1898–1991

El at Columbus Avenue and Broadway. 1929
Gelatin-silver print. 6⅛ x 8⅜" (15.6 x 21.2 cm). Purchase
Page 134

Zito's Bakery, Bleecker Street, New York. 1937
Gelatin-silver print. 9½ x 7⁷⁄₁₆" (24.1 x 18.9 cm). Given anonymously
Page 143

Ansel Adams
1902–1984

Lake MacDonald, Glacier National Park. 1942
Gelatin-silver print. 7¹⁄₁₆ x 9½" (18 x 24.1 cm). Gift of David H. McAlpin
Page 117

Old Faithful Geyser, Yellowstone National Park. 1942
Gelatin-silver print. 9⁵⁄₁₆ x 6½" (23.6 x 16.4 cm). Gift of David H. McAlpin
Page 120

Old Faithful Geyser, Yellowstone National Park. 1942
Gelatin-silver print. 9¹⁄₁₆ x 6⁵⁄₁₆" (23 x 16 cm). Gift of David H. McAlpin
Page 121

Aspens, Northern New Mexico. 1958
Gelatin-silver print. 14³⁄₁₆ x 17⁹⁄₁₆" (36 x 44.6 cm). Gift of Shirley C. Burden
Page 186

Diane Arbus
1923–1971

Child with Toy Hand Grenade in Central Park, New York City. 1962
Gelatin-silver print. 8⁷⁄₁₆ x 7¼" (21.3 x 18.4 cm). Purchase
Page 243

Teenage Couple on Hudson Street, New York City. 1963
Gelatin-silver print. 15³⁄₁₆ x 15⅛" (38.5 x 38.2 cm). Purchase
Page 246

Boy with a Straw Hat Waiting to March in a Pro-War Parade, New York City. 1967
Gelatin-silver print. 15 x 14⅝" (38 x 37 cm). Gift of the photographer
Page 237

Richard Avedon
born 1923

Dovima with Elephants. 1955
Gelatin-silver print. 19¹⁄₁₆ x 15⅛" (48.4 x 38.2 cm). Gift of the photographer
Page 229

Brigitte Bardot. 1959
Gelatin-silver print. 23⅛ x 20" (58.7 x 50.6 cm). Gift of the photographer
Page 230

Ralph Bartholomew
dates unknown

Kodak Advertisement. c.1950
Gelatin-silver print. 15½ x 19½" (39.2 x 49.5 cm). Gift of John C. Waddell
Page 233

Ernest J. Bellocq
1873–1949

Untitled. c. 1912
Gelatin-silver printing-out-paper print, printed by Lee Friedlander, 1966–69. 9⁷⁄₁₆ x 7¾" (24 x 19.6 cm). Mr. and Mrs. John Spencer Fund
Page 71

Henry Hamilton Bennett
1843–1908

Layton Art Gallery, Milwaukee, Wisconsin. c. 1890
Albumen-silver print. 17³⁄₁₆ x 21¾" (43.6 x 55.3 cm). Gift of the H. H. Bennett Studio
Page 65

Panorama from the Overhanging Cliff, Wisconsin Dells. 1897–98
Gelatin-silver printing-out-paper print. 17¹⁄₁₆ x 58½" (43.2 x 148.6 cm). Gift of the H. H. Bennett Studio
Pages 58–59

Margaret Bourke-White
1904–1971

At the Time of the Louisville Flood. 1937
Gelatin-silver print. 9¾ x 13³⁄₁₆" (24.7 x 33.4 cm). Gift of the photographer
Page 149

John G. Bullock
1854–1939

Untitled. c. 1910
Platinum print. 6⅛ x 7¹³⁄₁₆" (15.5 x 19.8 cm). Gift of the Estate of John Emlen Bullock
Page 86

Rudy Burckhardt
born Switzerland 1914, to U.S. 1935

Facing pages from a unique album titled "An Afternoon in Astoria." 1940
Four gelatin-silver prints, each 6½ x 4½" (16.4 x 11.4 cm). Given anonymously
Pages 154 and 155

Harry Callahan
born 1912

Detroit. 1943
Gelatin-silver print. 3½ x 4½" (8.9 x 11.5 cm). Purchase
Page 182

Eleanor. c. 1947
Gelatin-silver print. 4⁹⁄₁₆ x 3⅜" (11.6 x 8.5 cm). Acquired with matching funds from the Joseph G. Mayer Foundation, Inc., and the National Endowment for the Arts
Page 180

Eleanor, Chicago. 1949
Gelatin-silver print. 7½ x 9⁹⁄₁₆" (19.1 x 24.3 cm). Purchase
Page 181

Chicago. c. 1950
Gelatin-silver print. 7⅝ x 9⁹⁄₁₆" (19.4 x 24.3 cm). Purchase
Page 173

Chicago. 1950
Gelatin-silver print. 9³⁄₁₆ x 13¾" (23.3 x 34.8 cm). Purchase
Page 209

Collages. c. 1956
Gelatin-silver print. 7¹¹⁄₁₆ x 10¼" (19.5 x 24.6 cm). Acquired with matching funds from Shirley C. Burden and the National Endowment for the Arts
Page 183

Paul Caponigro
born 1932

Untitled. 1957
Gelatin-silver print. 7⅝ x 9⁹⁄₁₆" (19.3 x 24.3 cm). Purchase
Page 212

Walter Chappell
born 1925

Number 10. 1958
Gelatin-silver print. 10⁷⁄₁₆ x 13¼" (26.4 x 33.5 cm). Gift of the photographer
Page 211

Alvin Langdon Coburn
1882–1966

Grand Canyon. 1911
Platinum print. 16³⁄₁₆ x 12½" (41 x 31.6 cm). David H. McAlpin Fund
Page 91

Ted Croner
born 1922

Untitled. 1947–49
Gelatin-silver print. 15⅞ x 15¾"
(40.3 x 40 cm). The Family of Man
Fund
Page 218

Imogen Cunningham
1883–1976

Nude. 1932
Gelatin-silver print. 6⅝ x 9⁷⁄₁₆"
(16.8 x 23.9 cm). Gift of Albert M.
Bender
Page 111

Charles H. Currier
1851–1938

*Kitchen in the Vicinity of Boston,
Massachusetts.* c. 1900
Gelatin-silver print. 7¾ x 9⅞" (19.6 x
25 cm). Gift of Ernst Halberstadt
Page 70

Edward S. Curtis
1868–1954

Watching the Dancers—Hopi.
1906
From *The North American Indian.*
Photogravure. 15⅛ x 11⁵⁄₁₆" (38.4 x
28.7 cm). Gift of Jean-Anthony
du Lac
Page 60

Louise Dahl-Wolfe
born 1895

Nashville. 1932
Gelatin-silver print. 12⅞ x 9⅛"
(32.7 x 23.1 cm). Gift of the
photographer
Page 150

Bruce Davidson
born 1933

*Untitled, from the series
Teenagers.* 1959
Gelatin-silver print. 6¾ x 10" (17.1 x
25.4 cm). Purchase
Page 226

Roy DeCarava
born 1919

Untitled. 1955
Gelatin-silver print. 8⅛ x 13½"
(20.6 x 34.3 cm). John Parkinson III
Fund
Page 205

Self-Portrait. 1956
Gelatin-silver print. 10⅛ x 13¹¹⁄₁₆"
(25.7 x 34.7 cm). Purchase
Page 206

Baron Adolf De Meyer
1868–1946
born Germany, to U.S. 1914

Green and Silver Leaves. 1925
Gelatin-silver print. 9½ x 7½"
(24.1 x 19 cm). Gift of Anne
Ehrenkranz in honor of Samuel J.
Wagstaff, Jr.
Page 126

David Douglas Duncan
born 1916

Korea. 1950
Gelatin-silver print. 13⁷⁄₁₆ x 9⅛"
(34.1 x 23.2 cm). Gift of the
photographer
Page 201

Harold Edgerton
1903–1990
with Kenneth Germeshausen

Dangerous Weapon. 1936
Gelatin-silver print. 9⅞ x 13" (25.1 x
32.9 cm). Gift of the photographer
Page 165

Philip Elliott
1903–1985

Bar-B-Q. 1952 or earlier
Gelatin-silver print. 8¹³⁄₁₆ x 13¹⁄₁₆"
(22.3 x 33.2 cm). Gift of Virginia
Cuthbert Elliott
Page 222

Elliott Erwitt
born 1928

*Fontainebleau Hotel, Miami
Beach.* 1962
Gelatin-silver print. 13⅜ x 19¼"
(33.9 x 48.8 cm). Gift of the
photographer
Page 239

New York. 1964
Gelatin-silver print. 13³⁄₁₆ x 19⁷⁄₁₆"
(33.5 x 49.4 cm). Gift of the
photographer
Page 231

Walker Evans
1903–1975

Brooklyn Bridge. 1929
Gelatin-silver print. 8⅞ x 5½"
(22.4 x 13.8 cm). Mr. and Mrs. John
Spencer Fund
Page 135

City Lunch Counter. 1929
Gelatin-silver print. 4¼ x 6⅜" (10.8 x
16.2 cm). Gift of the photographer
Page 137

Torn Movie Poster. 1930
Gelatin-silver print. 6⅜ x 4⅜"
(16.2 x 11.2 cm). Purchase
Page 133

Maine Pump. 1933
Gelatin-silver print. 7⅞ x 5¾" (20 x
14.5 cm). Gift of the photographer
Page 138

*Graveyard, Houses, and Steel Mill,
Bethlehem, Pennsylvania.* 1935
Gelatin-silver print. 7¹¹⁄₁₆ x 9⁹⁄₁₆"
(19.5 x 24.3 cm). Gift of the Farm
Security Administration
Page 140

Houses and Billboards in Atlanta.
1936
Gelatin-silver print. 6½ x 9⅛"
(16.5 x 23.2 cm). Purchase
Page 142

*Penny Picture Display, Savannah,
Georgia.* 1936
Gelatin-silver print. 8⅝ x 7" (22 x
17.7 cm). Gift of Willard Van Dyke
Page 144

*Alabama Cotton Tenant Farmer
Wife.* 1936
Gelatin-silver print. 9⅝ x 7⅝"
(24.4 x 19.5 cm). Gift of the
photographer
Page 145

Subway Portrait. 1938–41
Gelatin-silver print. 3⅞ x 5¼" (9.7 x
13.4 cm). Purchase
Page 156

Louis Faurer
born 1916

*George Barrows in Robert Frank's
Loft.* 1947
Gelatin-silver print. 12⅝ x 8½"
(32.1 x 21.6 cm). The Ben Schultz
Memorial Collection. Gift of the
photographer
Page 207

Untitled. 1950
Gelatin-silver print. 9 x 13⅞" (22.9 x
34.1 cm). John Parkinson III Fund
Page 221

Grancel Fitz
1894–1963

Cellophane. 1928–29
Gelatin-silver print. 9³⁄₁₆ x 7⁷⁄₁₆"
(23.3 x 19.3 cm). John Parkinson III
Fund
Page 123

Robert Frank
born Switzerland 1924, to U.S. 1947

Street Line, New York. 1951
Gelatin-silver print. 12¹³⁄₁₆ x 8⁹⁄₁₆"
(32.5 x 21.8 cm). Purchase
Page 208

Parade, Valencia. 1952
Gelatin-silver print. 17¹⁄₁₆ x 25"
(43.3 x 63.5 cm). Purchase
Page 204

U.S. Number 61, Texas. 1955
Gelatin-silver print. 12¹¹⁄₁₆ x 8⁷⁄₁₆"
(32.2 x 21.4 cm). Purchase
Frontispiece

Parade, Hoboken, New Jersey.
1955
Gelatin-silver print. 8⅛ x 12⁵⁄₁₆"
(20.6 x 31.2 cm). Purchase
Page 215

Los Angeles. 1955–56
Gelatin-silver print. 13¹⁄₁₆ x 8⁹⁄₁₆"
(33.1 x 21.7 cm). Purchase
Page 217

Reno, Nevada. 1956
Gelatin-silver print. 8⅜ x 12¹³⁄₁₆"
(21.2 x 32.5 cm). Purchase
Page 216

Lee Friedlander
born 1934

Galax, Virginia. 1962
Gelatin-silver print. 5⅞ x 8⅞"
(14.9 x 22.5 cm). Gift of
Mrs. Armand P. Bartos
Page 247

Cincinnati. 1963
Gelatin-silver print. 9 x 6" (22.8 x
15.2 cm). Purchase
Page 241

New York City. 1964
Gelatin-silver print. 6⅜ x 9¾"
(16.2 x 24.8 cm). Purchase
Page 242

William A. Garnett
born 1916

*Dry Wash with Alluvium, Death
Valley, California.* 1957
Gelatin-silver print. 19¹¹⁄₁₆ x 15½"
(50 x 39.4 cm). Gift of the
photographer
Page 190

Arnold Genthe
1869–1942
born Germany, to U.S. 1895

Chinatown, San Francisco. 1896–
1906
Gelatin-silver print. 7¹³⁄₁₆ x 13⁵⁄₁₆"
(19.8 x 33.8 cm). Gift of the
photographer
Page 72

Laura Gilpin
1891–1979

Ghost Rock. 1919
Platinum print. 9⅝ x 7⁹⁄₁₆" (24.5 x
19.2 cm). Acquired with matching
funds from Mrs. John D. Rockefeller
3rd and the National Endowment
for the Arts
Page 94

L. S. Glover
dates unknown

*In the Heart of the Copper
Country, Calumet, Michigan.*
1905
Gelatin-silver print. 7 x 56⁹⁄₁₆"
(17.8 x 143.7 cm). Lois and Bruce
Zenkel Fund
Pages 68–69

John Gutmann
born Germany 1905, to U.S. 1933

Jitterbug, New Orleans. 1937
Gelatin-silver print. 8⅝ x 7⅝" (22 x
19.3 cm). Barbara Ferry Hooker
Fund
Page 160

Charles Harbutt
born 1935

Blind Boy. 1961
Gelatin-silver print. 8⅞ x 13⁵⁄₁₆"
(22.6 x 33.8 cm). Gift of the
photographer
Page 197

Lewis W. Hine
1874–1940

Coalbreakers, Pennsylvania.
1910–11
Gelatin-silver print. 4⁹⁄₁₆ x 6¹¹⁄₁₆"
(11.6 x 17 cm). Gift of John C.
Waddell
Page 74

Steamfitter. 1920
Gelatin-silver print. 9½ x 7" (24.2 x
17.8 cm). Purchase
Page 129

Charles Hoff
died 1975

*Rocky Marciano and Ezzard
Charles.* 1954
Gelatin-silver print. 7⁹⁄₁₆ x 9⁷⁄₁₆"
(19.2 x 24 cm). The Family of Man
Fund
Page 228

Clifton Johnson
1865–1940

*Barred Door, Rocky Hill Meeting
House.* c. 1910
Gelatin-silver print. 6¾ x 4¾"
(17.1 x 12 cm). Purchase
Page 63

Frances Benjamin Johnston
1864–1952

*Stairway of Treasurer's Residence,
Students at Work, The Hampton
Institute, Hampton, Virginia.*
1899–1900
From *The Hampton Album.* Platinum
print. 7½ x 9⁷⁄₁₆" (19 x 24 cm). Gift
of Lincoln Kirstein
Page 67

Simpson Kalisher
born 1926

Untitled. 1961
Gelatin-silver print. 13⅜ x 9³⁄₁₆"
(34 x 23.3 cm). Purchase
Page 238

Gertrude Käsebier
1852–1934

The Manger. 1899
Platinum print. 12¾ x 9½" (32.4 x
24.1 cm). Gift of Mrs. Hermine M.
Turner
Page 84

The Road to Rome. 1903
Platinum print. 8¼ x 13⁵⁄₁₆" (21 x
33.7 cm). Gift of Mrs. Hermine M.
Turner
Page 88

André Kertész
1894–1985
born Hungary, to U.S. 1936

*Railroad Station, Poughkeepsie,
New York.* 1937
Gelatin-silver print. 9½ x 7¾" (24 x
19.6 cm). Gift of the photographer
Page 158

Darius Kinsey
1869–1945

*Felling a Fir Tree, 51 Feet in
Circumference.* 1906
Gelatin-silver print. 13⁷⁄₁₆ x 10⅜"
(34 x 26.4 cm). Given anonymously
Page 75

Irwin Klein
1933–1974

Minneapolis Fire. 1962
Gelatin-silver print. 9⅛ x 13½"
(23.2 x 34.3 cm). Purchase
Page 244

William Klein
born 1928

Gun, Gun, Gun, New York. 1955
Gelatin-silver print. 9½ x 13⁵⁄₁₆"
(24.2 x 33.8 cm). The Fellows of
Photography Fund
Page 219

Moscow Beach. 1959
Gelatin-silver print. 15⅜ x 19⁷⁄₁₆"
(39 x 49.3 cm). Purchase
Page 224

Dorothea Lange
1895–1965

*Street Demonstration,
San Francisco.* 1933
Gelatin-silver print. 17 x 9¼" (43.1 x
23.4 cm). Purchase
Page 136

*Migrant Mother, Nipomo,
California.* 1936
Gelatin-silver print. 12⁹⁄₁₆ x 9¹⁵⁄₁₆"
(31.9 x 25.2 cm). Purchase
Page 148

Back. 1938
Gelatin-silver print, printed by
James Welcher, 1965. 12⅝ x 8⅞"
(32 x 22.6 cm). Purchase
Page 146

The Road West, New Mexico.
1938
Gelatin-silver print. 9⅝ x 13⅛"
(24.5 x 33.2 cm). Gift of the
photographer
Page 147

San Francisco. c. 1942
Gelatin-silver print, printed by
James Welcher, 1965. 10⁷⁄₁₆ x 9⅞"
(26.5 x 25 cm). Purchase
Page 170

Spring in Berkeley. 1951
Gelatin-silver print. 7¹⁵⁄₁₆ x 10¹⁄₁₆"
(20.1 x 25.5 cm). Purchase
Page 203

Clarence John Laughlin
1905–1985

The Eye That Never Sleeps. 1946
Gelatin-silver print. 12⅜ x 8¾"
(31.4 x 22.2 cm). Purchase
Page 175

The Insect-Headed Tombstone.
1953
Gelatin-silver print. 13⅝ x 10⅞"
(34.6 x 27.7 cm). John Parkinson III
Fund
Page 179

Russell Lee
1903–1986

*Lumberjacks — Saturday Night,
Minnesota.* 1937
Gelatin-silver print. 7⁵⁄₁₆ x 9½"
(18.6 x 24.1 cm). Gift of the Farm
Security Administration
Page 151

Leon Levinstein
1913–1988

Coney Island. 1953 or earlier
Gelatin-silver print. 13⅞ x 13¹¹⁄₁₆"
(35.2 x 34.8 cm). Purchase
Page 223

Helen Levitt
born 1913

New York. 1939
Gelatin-silver print. 7 x 8¼" (17.8 x
21 cm). The Ben Schultz Memorial
Collection. Gift of the photographer
Page 157

New York. 1939
Gelatin-silver print. 6½ x 8⅞"
(16.6 x 22.6 cm). Gift of James
Thrall Soby
Page 159

Jerome Liebling
born 1924

Boy and Car, New York City. 1948
Gelatin-silver print. 10 x 10" (25.4 x
25.4 cm). Mrs. Charles Liebman
Fund
Page 202

Edwin Hale Lincoln
1848–1938

Thistle. 1893–1907
Platinum print. 13⅛ x 10⅛" (33.2 x
25.7 cm). Purchase
Page 66

O. Winston Link
born 1911

*Hot Shot East Bound at Iager,
West Virginia.* 1956
Gelatin-silver print, printed 1976.
10⅝ x 13⅝" (27 x 34.3 cm).
Purchase
Page 232

George Platt Lynes
1907–1955

*Marc Blitzstein, Orson Welles
and Lehman Engle.* 1937
Gelatin-silver print. 10½ x 13"
(26.7 x 33 cm). Gift of the
photographer
Page 164

Self-Analysis. c. 1940
Gelatin-silver print. 9 x 7⁷⁄₁₆" (23 x
18.9 cm). Given anonymously
Page 174

Gjon Mili
1904–1984
born Albania, to U.S. 1923

Cafe Society, New York. 1943–47
Gelatin-silver print. 19¾ x 15⁵⁄₁₆"
(50.1 x 38.8 cm). Purchase
Page 168

Lisette Model
1906–1983
born Austria, to U.S. 1938

Coney Island. 1941
Gelatin-silver print. 13½ x 11"
(34.2 x 28 cm). Photography
Purchase Fund
Page 161

Tina Modotti
1896–1942
born Italy, to U.S. 1913

Roses, Mexico. 1924
Platinum print. 7⅜ x 8½" (18.7 x
21.6 cm). Gift of Edward Weston
Page 107

Worker's Hands. 1926
Gelatin-silver print. 7⅜ x 8½"
(18.8 x 21.6 cm). Given anonymously
Page 109

**Arthur S. Mole and John D.
Thomas**
dates unknown

*The Human U.S. Shield: 30,000
Officers and Men. Camp Custer,
Battle Creek, Michigan.* 1918
Gelatin-silver print. 12¾ x 10⁵⁄₁₆"
(32.5 x 26.2 cm). Gift of Ronald A.
Kurtz
Page 79

Charles Moore
born 1931

Birmingham, Alabama. 1963
Gelatin-silver print. 6⅜ x 9⅝"
(16.3 x 24.5 cm). Anonymous
Purchase Fund
Page 234

Barbara Morgan
1900–1992

*Merce Cunningham — Totem
Ancestor.* 1942
Gelatin-silver print. 18⅜ x 13⅜"
(46.9 x 33.9 cm). Gift of Harriette
and Noel Levine in honor of
Richard E. Oldenburg
Page 162

Wright Morris
born 1910

*Gano Grain Elevator, Western
Kansas.* 1939
Gelatin-silver print. 9½ x 7¾"
(24.1 x 19.7 cm). Purchase
Page 152

Nickolas Muray
1892–1965
born Hungary, to U.S. 1913

*Babe Ruth (George Herman
Ruth).* c. 1927
Gelatin-silver print. 13⁵⁄₁₆ x 10½"
(33.8 x 26.7 cm). Gift of
Mrs. Nickolas Muray
Page 124

Arnold Newman
born 1918

Jacob and Gwen Lawrence. 1944
Gelatin-silver print. 9⅝ x 7⅝"
(24.4 x 19.4 cm). Purchase
Page 163

Paul Outerbridge
1896–1959

Ide Collar. 1922
Platinum print. 4½ x 3⅝" (11.4 x
9.2 cm). Gift of the photographer
Page 122

Gordon Parks
born 1912

Harlem Gang Wars. 1948
Gelatin-silver print. 11 x 10½"
(27.9 x 26.6 cm). Gift of the photog-
rapher in honor of Edward Steichen
Page 199

Harlem Rally. 1963
Gelatin-silver print. 13¹⁄₁₆ x 19⁵⁄₁₆"
(33.2 x 49 cm). Gift of the photogra-
pher in honor of Edward Steichen
Page 235

Irving Penn
born 1917

*George Jean Nathan and
H. L. Mencken.* 1947
Gelatin-silver print. 19¹¹⁄₁₆ x 15⁹⁄₁₆"
(50 x 39.5 cm). Gift of the
photographer
Page 193

Still Life with Watermelon. 1947
Dye-transfer print. 24 x 19⅞" (61 x
50.5 cm). Gift of the photographer
Page 194

Régine (Balenciaga Suit). 1950
Gelatin-silver print. 7⅜ x 7⅜"
(18.7 x 18.7 cm). Gift of the
photographer
Page 195

Eliot Porter
1901–1990

*Trees and Pond, Near Sherborn,
Massachusetts.* 1957
Dye-transfer print. 10¾ x 8¼"
(27.3 x 20.9 cm). Gift of David H.
McAlpin
Page 187

William B. Post
1857–1925

Aspens. c. 1905
Platinum print. 7⅜ x 9⅛" (18.8 x
23.2 cm). The Family of Man Fund
Page 57

William H. Rau
1855–1920

*Picturesque Susquehanna Near
Laceyville.* 1891–92
Albumen-silver print. 17⅛ x 20½"
(43.5 x 52 cm). David H. McAlpin
Fund
Page 64

Robert Rauschenberg
born 1925

Untitled. 1949
Gelatin-silver print. 10³⁄₁₆ x 9⅝"
(25.8 x 24.4 cm). Nelson A.
Rockefeller Fund
Page 210

James Bartlett Rich
1866–1942

Stopping Off for Lunch, Route 143, The Ontelaunee Creek, Near Kempton, Berks County, Pennsylvania. 1931
Gelatin-silver print. 5 x 8" (12.7 x 20.3 cm). Gift of David H. McAlpin, by exchange
Page 131

Jacob Riis
1849–1914
born Denmark, to U.S. 1870

Bandits' Roost, 59½ Mulberry Street. c. 1888
Gelatin-silver print by Rolf Petersen, 1957. 19³⁄₁₆ x 15½" (48.6 x 39.4 cm). Courtesy of the Museum of the City of New York
Page 73

George H. Seeley
1880–1955

Winter Landscape. 1909
Gum-bichromate print. 17⁵⁄₁₆ x 21¼" (44 x 54 cm). David H. McAlpin Fund and Purchase
Page 90

Charles Sheeler
1883–1965

Stair Well. 1914–17
Gelatin-silver print. 9½ x 6⅝" (24.2 x 16.8 cm). Gift of the photographer
Page 102

White Barn, Bucks County, Pennsylvania. 1914–17
Gelatin-silver print. 7½ x 9½" (19.1 x 24.2 cm). Gift of the photographer
Page 101

Cactus and Photographer's Lamp, New York. 1931
Gelatin-silver print. 9½ x 6⅝" (24.1 x 16.8 cm). Gift of Samuel M. Kootz
Page 113

Aaron Siskind
1903–1991

Gloucester. 1944
Gelatin-silver print. 7 x 4¾" (17.8 x 12 cm). Gift of Robert and Joyce Menschel
Page 178

Chicago. 1949
Gelatin-silver print. 14 x 17⅞" (35.6 x 45.3 cm). Gift of Robert and Joyce Menschel
Page 191

Martha's Vineyard. 1954
Gelatin-silver print. 12½ x 16½" (31.7 x 42 cm). Purchase
Page 188

Charles Norman Sladen
1858–1949
born Great Britain, to U.S. 1876

Page from a personal album titled "July 1913," made at Great Chebeague Island, Maine. 1913
Gelatin-silver prints with ink drawings. 12¹⁄₁₆ x 21⅜" (30.7 x 54.2 cm). Purchased with funds from The Richardson Foundation
Page 77

Erwin E. Smith
1886–1947

Mounting a Bronc. c. 1910
Gelatin-silver print. 11¹⁄₁₆ x 14⁹⁄₁₆" (28.1 x 37 cm). The Family of Man Fund
Page 61

W. Eugene Smith
1918–1978

Untitled, from "Country Doctor." 1948
Gelatin-silver print. 13⅜ x 10³⁄₁₆" (33.9 x 25.9 cm). Purchase
Page 196

Welsh Miners. 1950
Gelatin-silver print. 10½ x 12⅞" (26.7 x 32.6 cm). Purchase
Page 200

Frederick Sommer
born Italy 1905, to U.S. 1931

Max Ernst. 1946
Gelatin-silver print. 7½ x 9½" (19 x 24.1 cm). Gift of Nelson A. Rockefeller
Page 177

Moon Culminations. 1951
Gelatin-silver print. 9⅝ x 7⅝" (24.4 x 19.3 cm). Gift of the photographer
Page 176

Edward Steichen
1879–1973
born Luxembourg, to U.S. 1881

Self-Portrait, Milwaukee. 1898
Platinum print. 7⅞ x 3⅞" (19.6 x 9.8 cm). Gift of the photographer
Page 82

Moonrise—Mamaroneck, New York. 1904
Platinum and ferro-prussiate print. 15⅜ x 19" (38.9 x 48.2 cm). Gift of the photographer
Page 81

Midnight—Rodin's Balzac. 1908
Pigment print over collotype, with hand toning. 11⅞ x 14¼" (30 x 36.2 cm). Gift of the photographer
Page 85

Alfred Stieglitz. 1909–10
Platinum print. 11⁵⁄₁₆ x 9⁷⁄₁₆" (28.7 x 24 cm). Gift of the photographer
Page 96

Pillars of the Parthenon. 1921
Platinum print. 19³⁄₁₆ x 13⅜" (48.7 x 34.4 cm). Gift of the photographer
Page 104

Gloria Swanson. 1924
Gelatin-silver print, printed by Rolf Petersen, 1961. 16⁹⁄₁₆ x 13½" (42.1 x 34.2 cm). Gift of the photographer
Page 125

Ralph Steiner
1899–1986

Sign, Saratoga Springs. 1929
Gelatin-silver print. 9⅝ x 7⅞" (24.5 x 19.9 cm). Gift of the photographer
Page 141

American Rural Baroque. 1930
Gelatin-silver print. 7⁹⁄₁₆ x 9½" (19.2 x 24.3 cm). Gift of the photographer
Page 139

Alfred Stieglitz
1864–1946

Flatiron Building. 1903
Photogravure on vellum. 12⅞ x 6⅝" (32.8 x 16.9 cm). Purchase
Page 83

The Mauretania. 1910
Photogravure. 13⅜ x 10³⁄₁₆" (34 x 25.9 cm). Purchase
Page 92

Picasso-Braque Exhibition at "291." 1915
Platinum print. 7½ x 9⅜" (19 x 23.8 cm). Gift of Charles Sheeler
Page 97

Hands and Thimble—Georgia O'Keeffe. 1920
Platinum print. 9⅞ x 8" (24.9 x 20.2 cm). Gift of David H. McAlpin
Page 105

Apples and Gable, Lake George. 1922
Gelatin-silver print. 4½ x 3⅝" (11.6 x 9.1 cm). Given anonymously
Page 114

From the Shelton, West. 1935
Gelatin-silver print. 9½ x 7½" (24.3 x 19 cm). The Alfred Stieglitz Collection. Gift of Georgia O'Keeffe
Page 118

From the Shelton, West. 1935
Gelatin-silver print. 9⅝ x 7½" (24.5 x 19.1 cm). The Alfred Stieglitz Collection. Gift of Georgia O'Keeffe
Page 119

Paul Strand
1890–1976

Untitled. 1915
Platinum print. 10⅛ x 12" (25.7 x 30.4 cm). Gift of the photographer
Page 98

Untitled. c. 1915
Platinum print. 11⅛ x 9⁹⁄₁₆" (28.2 x 24.3 cm). Gift of the photographer
Page 99

Akeley Motion Picture Camera. 1923
Gelatin-silver print. 9⅝ x 7⅝" (24.5 x 19.5 cm). Gift of the photographer
Page 112

Gaston Lachaise. 1927–28
Gelatin-silver print. 9⅝ x 7¹¹⁄₁₆" (24.4 x 19.5 cm). John Parkinson III Fund
Page 115

Leaves II. 1929
Platinum print. 9⅝ x 7⅞" (24.5 x 19.8 cm). Gift of Georgia O'Keeffe
Page 103

Church. 1944
Gelatin-silver print. 9½ x 7⅝" (24.2 x 19.3 cm). Gift of Mrs. Armand P. Bartos
Page 189

John Swope

died 1979

Cap d'Antibes, France. 1948
Gelatin-silver print. 10½ x 13⁹⁄₁₆"
(26.7 x 34.4 cm). Gift of the
photographer
Page 225

John Szarkowski

born 1925

*Column Capital, Guaranty
Building, Buffalo.* 1952
Gelatin-silver print. 10 x 13³⁄₁₆"
(25.5 x 33.4 cm). Purchase
Page 192

Doris Ulmann

1882–1934

Untitled. c. 1930
Platinum print. 8⅛ x 6³⁄₁₆" (20.6 x
15.7 cm). Purchase
Page 95

U.S. Army Signal Corps

*Russian Slave Laborer Points Out
Former Nazi Guard Who
Brutally Beat Prisoners.*
April 14, 1945
Gelatin-silver print. 7¾ x 9⁹⁄₁₆"
(19.7 x 24.3 cm). Anonymous
Purchase Fund
Page 171

U.S. Navy

*Explosion Following Hit on the
USS Franklin by Japanese Dive
Bomber.* March 19, 1945
Gelatin-silver print. 10¹¹⁄₁₆ x 13½"
(27.1 x 34.2 cm). Gift of Edward
Steichen
Page 169

James Van Der Zee

1886–1983

*Baptism Celebration to Maria
Warma Mercado.* April 23, 1927
Gelatin-silver print. 7⁹⁄₁₆ x 9½"
(19.2 x 24.1 cm). Gift of Harriette
and Noel Levine
Page 128

Adam Clark Vroman

1856–1916

*"Pueblo of Zuni" (Sacred Shrine
of Taäyallona).* 1899
Platinum print. 5⅞ x 8" (15 x
20.3 cm). Acquired by exchange
Page 62

Weegee (Arthur Fellig)

1899–1968
born Austria, to U.S. 1909

Harry Maxwell Shot in Car.
1936
Gelatin-silver print. 13¹⁵⁄₁₆ x 10½"
(35.4 x 26.6 cm). Gift of the
photographer
Page 167

*Brooklyn School Children See
Gambler Murdered in Street.*
1941
Gelatin-silver print. 10⁵⁄₁₆ x 13³⁄₁₆"
(26.2 x 33.5 cm). Given anonymously
Page 166

Dan Weiner

1919–1959

*Shoppers Glimpse a Movie Star
at Grand Central Station,
New York.* 1953
Gelatin-silver print. 9¼ x 13⁷⁄₁₆"
(23.4 x 34.1 cm). Gift of Sandra
Weiner
Page 220

El Morocco, New York. 1955
Gelatin-silver print. 9⅛ x 13⅜"
(23.1 x 34 cm). The Family of Man
Fund
Page 198

Edward Weston

1886–1958

Nahui Olín. 1924
Gelatin-silver print. 9 x 7" (22.9 x
17.7 cm). Purchase
Page 108

Torso of Neil. 1925
Platinum-palladium print. 9⅛ x 5½"
(23.2 x 14 cm). Purchase
Page 106

Pepper No. 30. 1930
Gelatin-silver print. 9½ x 7½" (24 x
19 cm). Gift of David H. McAlpin
Page 110

Dunes, Oceano. 1936
Gelatin-silver print. 7½ x 9⁹⁄₁₆" (19 x
24.3 cm). Gift of David H. McAlpin
Page 116

Hot Coffee, Mojave Desert. 1937
Gelatin-silver print. 7½ x 9½" (19 x
24.2 cm). Purchase
Page 153

*North Shore, Point Lobos,
California.* 1946
Gelatin-silver print. 7½ x 9½"
(19.1 x 24.1 cm). Purchase
Page 184

Clarence H. White

1871–1925

Mrs. Clarence H. White. 1906
Platinum print. 9¾ x 7¾" (24.8 x
19.7 cm). John Parkinson III Fund
Page 89

New England Street. 1907
Platinum print. 9½ x 6¼" (24.1 x
15.8 cm). Gift of Mr. and Mrs.
Clarence H. White, Jr.
Page 87

*The Skeleton of the Ship, Bath,
Maine.* 1917
Platinum and gum-bichromate print.
9⅝ x 12¾" (24.4 x 32.5 cm). Gift of
Mr. and Mrs. Clarence H. White, Jr.
Page 93

Minor White

1908–1976

Pacific. 1947
Gelatin-silver print. 6⅝ x 8³⁄₁₆"
(16.8 x 20.8 cm). Gift of David H.
McAlpin
Page 185

Peeled Paint. 1959
Gelatin-silver print. 9½ x 7⅜"
(24.1 x 18.7 cm). Gift of Robert M.
Doty
Page 213

Garry Winogrand

1928–1984

Los Angeles. 1964
Gelatin-silver print. 9 x 13⅜" (22.9 x
34 cm). Purchase
Page 227

Dallas. 1964
Gelatin-silver print. 9 x 13⅜" (22.7 x
34 cm). Purchased with funds from
the International Program
Page 240

Park Avenue, New York. 1959
Gelatin-silver print. 22⁵⁄₁₆ x 14⁷⁄₁₆"
(56.7 x 37.8 cm). Gift of the
photographer
Page 245

Willard Worden

dates unknown

Market Street, San Francisco.
April 18, 1906
Gelatin-silver print. 7⁵⁄₁₆ x 9½"
(18.5 x 24 cm). David H. McAlpin
Fund
Page 76

Photographer Unknown

*Seventh Avenue, 42nd and 43rd
Streets, New York City. View,
Facing North, Along West Side of
Seventh Avenue, Showing
Sidewalk Conditions.* 1914
Gelatin-silver print. 7½ x 9½"
(19 x 24 cm). Gift of Barbara
Foshay-Miller
Page 78

Photographer Unknown

Coronado Beach, California.
c. 1930
Gelatin-silver print. 4¼ x 2⅜"
(10.7 x 6 cm). Lois and Bruce Zenkel
Fund
Page 130

Photographer Unknown

*Film Still for "The Common
Law."* 1931
Gelatin-silver print. 10½ x 13⅝"
(26.7 x 34.7 cm). Purchase
Page 127

Index

Page references to illustrations appear in bold type and are listed together before page references to the text.